Early Medieval Bible Illumination and the Ashburnham Pentateuch

This book focuses on the Ashburnham Pentateuch, an early medieval illuminated manuscript of the Old Testament whose pictures are among the earliest surviving and most extensive biblical illustrations. Dorothy Verkerk shows how the lively and complex illustrations of Genesis and Exodus, which incorporate references to contemporary life, were used to explain important church teachings. She provides a key to understanding the relationship between the text and pictures. Verkerk also argues that the manuscript was created in Italy, thereby solving a mystery that has baffled scholars for the last century and demonstrating that early medieval Italian artists were capable of complex innovations in the field of the visual arts.

Dorothy Verkerk is Associate Professor of Art History and Fellow of the Institute for Arts and Humanities at the University of North Carolina, Chapel Hill. A scholar of early medieval art, she has contributed to *The Art Bulletin, Journal for Medieval and Early Modern History*, and *Mitteilungen zur Christlichen Archäolgie*.

Early Medieval Bible Illumination and the Ashburnham Pentateuch

DOROTHY VERKERK

University of North Carolina at Chapel Hill

CAMBRIDGE
UNIVERSITY PRESS

PUBLISHED BY THE PRESS SYNDICATE OF THE UNIVERSITY OF CAMBRIDGE
The Pitt Building, Trumpington Street, Cambridge, United Kingdom

CAMBRIDGE UNIVERSITY PRESS
The Edinburgh Building, Cambridge CB2 2RU, UK
40 West 20th Street, New York, NY 10011-4211, USA
477 Williamstown Road, Port Melbourne, VIC 3207, Australia
Ruiz de Alarcón 13, 28014 Madrid, Spain
Dock House, The Waterfront, Cape Town 8001, South Africa

http://www.cambridge.org

First published 2004

Printed in the United Kingdom at the University Press, Cambridge

Typeface Adobe Garamond 11.5/18 pt. *System* LATEX 2ε [TB]

A catalog record for this book is available from the British Library.

Library of Congress Cataloging in Publication Data
Verkerk, Dorothy Hoogland.
Early medieval Bible illumination and the Ashburnham Pentateuch /
Dorothy Verkerk.
p. cm.
Includes bibliographical references and index.
ISBN 0-521-82917-8
1. Ashburnham Pentateuch. 2. Bible. O.T. Pentateuch – Illustrations.
3. Illumination of books and manuscripts, Italian. 4. Illumination of books
and manuscripts, Medieval – Italy. I. Title
ND3358.P5V47 2003
745.6′7 – dc21 2003046267

ISBN 0 521 82917 8 hardback

This book is dedicated to Joost

Contents

List of Illustrations

Acknowledgments

⸻∞∞∞⸻

I am deeply indebted to a number of institutions and individuals. Several University Research and Publishing Awards from the University of North Carolina at Chapel Hill helped to bring this book to fruition. I am deeply grateful to François Avril and the staff at the Bibliothèque nationale de France who permitted me to study the Ashburnham Pentateuch. Michelle Brown from the British Library smoothed my research there and for that I am appreciative. The kind assistance from Pat Thompson and Rachel Frew at the Sloane Art Library and from Jennifer Bauer at the Visual Resources Library is valued for easing the process of photo and book researches. I am indeed fortunate to work at a great research institution with colleagues, and former colleagues, such as Pika Ghosh, Jaroslav Folda, Helen Hills, David Ganz, Maura Lafferty, Mary Sheriff, and Richard Pfaff, who were generous with their time, advice, and assistance. Over the years I have had a number of graduate research assistants who retrieved books, checked spellings, and stood for hours at the photocopy machine, all of whom have my thanks. I would also like to thank the following scholars who encouraged, cajoled and applauded when necessary: Elizabeth Lipsmeyer, Katrin Kogman-Appel, Cynthia Hahn, Archer St. Clair, Joseph Gutmann, John Williams, Franz Rickert, John Lowden, and Herbert Kessler. I am fortunate to have not one, but two editors who made this book so much better, Beatrice Rehl and Rosamond McKitterick. Any errors or problems should be laid at my door. Most of all, I thank Joost, to whom this book is dedicated.

1

A Painted Primer

Scripture is like a river, both broad and deep, shallow enough here for the lamb to go wading, but deep enough there for the elephant to swim.

— *Gregory the Great*[1]

The Ashburnham Pentateuch (Paris, Bibl. nat. lat. nouv. acq. 2334) has provoked difficult questions about the nature of late antique biblical illustration, it has challenged long-held art historical methodologies, it has stymied the work of paleographers, and it has defied scholarly attempts to place it in a cultural context. Although it was the subject of a descriptive monograph at an early date,[2] the subsequent failures to agree on its place of origin and the assumption that it was a provincial and peculiar product have tended to push the Ashburnham Pentateuch into the margins of early medieval book illumination studies. Yet no scholar who examines the manuscript denies the exceptional qualities of its illuminations, even though relatively little is published about its iconography. This study, then, by allowing the illustrations to "speak," endeavors to place this enigmatic manuscript in the foreground where it belongs, rather than

relegating it to the shadows because of doubts concerning its origin and iconography.

In the Ashburnham Pentateuch, the retelling of a story is often through pictures that require the viewer to take directives from the pictorial cues provided in the illustrations.[3] Although it may be a fanciful analogy, the illuminations, filled with a variety of characters who often gesticulate wildly against fantastic architectural backdrops, remind me of theater in which the audience is cued to the developing story line by the innuendos of mood and plot created on the stage. It behooves the audience, then, to pay careful attention to all aspects of the play: setting, costumes, gestures, and stage props.

The number of illustrations, the complexity of detail, the sophistication of the iconography, and the clarity provided by the *tituli* suggest that the idiosyncrasies of the manuscript illustrations are intentional, giving the creators of the manuscript far greater artistic and intellectual license than had previously been granted to them. Finally, the cumulative weight of evidence suggests that the codex was intended for an audience whose responsibility was to teach; specifically, the clergy whose mission it was to instruct the clergy so desperately needed to fill the ecclesiastical ranks. Where these clergy members were is something this book aims to establish.

One of the consistent problems that sidelined the manuscript is the piecemeal approach to the script and the illustrations, often the one exclusive from the other. Paleographic studies do not mention, or mention only in passing, the eighteen pages of illustrations and the magnificently decorated chapter lists; on the other hand, few art historians have tackled the thorny problem of the

script, preferring to examine a few of the pages or motifs in isolation from the script and codicological concerns. In this book, I have attempted to rectify these approaches by considering a wider range of illustrated pages, although the sheer number and density of the illustrations preclude a scene-by-scene analysis. By choosing a number of representative pages, I offer a new way of viewing these complex and lively illustrations. The study of codicological and script evidence is also given its due, although it is not the primary focus of the book. Throughout this study various centers of production in Spain, Southern France, and Italy are considered, although the weight of the accumulated evidence tends to point toward Italy.

The research into the Ashburnham Pentateuch has greater repercussions beyond the search for origin, audience, and the investigation of pictorial significance. Gregory the Great's dictum, that art is to remind the "illiterate" [*idiotis*] of biblical heroes and stories,[4] has been the focus of much attention in recent art historical writing.[5] Gregory's two letters contain, outlined in a few lines situated in a specific time and place, the essence of Church teaching that defined the role art was to play in early medieval art. Much of the modern scholarly work has been profitable for our understanding not only of what role Gregory, his precursors, and his followers envisaged for pictures in the explication of biblical and saintly narratives, but also of his estimation of the power of images to transform their viewers. What has been lacking, however, is a comprehensive study that investigates how a contemporary series of pictures was created that implements Gregory's theory of an art that truly teaches. The Ashburnham Pentateuch provides such

an example of Gregory's dictum; indeed, it is much more sophisticated in its visual exegesis than he ever envisaged for the walls of churches. Although Gregory was addressing the destruction of wall paintings by Bishop Serenus of Marseilles, who believed these public works of art had caused his congregation to fall into idolatry, the manuscript presents a series of illustrations that address, albeit in a more private and sophisticated format, the concerns of a clergy responsible for clarifying scripture and Church history. Through the unfolding of history in a pictorial format, the clergy could learn correct teaching.

Scholarship

Two questions have dominated the Ashburnham Pentateuch scholarly dialogue: the place of origin and the influence of Jewish literature and art in the manuscript's iconography. The question of origin is addressed at length in Chapter 6 because it dovetails with the issue of audience and patronage. The question of Jewish literature and art is dealt with here because it is interwoven with the issue of methodology.

Josef Strzygowski was the first scholar to put forth the theory that the Ashburnham Pentateuch was copied from a third-century manuscript made by Jewish Christians from Alexandria or, more generally, the Near East.[6] In an insightful critique of Strzygowski's work, Margaret Olin has highlighted that Strzygowski was contemptuous of the manuscript's illuminations. His perception that

the paintings were crude and anticlassical led him to suggest that they must have been unduly influenced by the art of the Semitic East.[7] Despite the anti-Semitism underlying Strzygowski's work, scholars, dominated by Austrian and Israeli schools, have taken up his thesis and argued that iconographical idiosyncrasies, especially in the Genesis scenes, seem to derive from Jewish sources, leading them to view the Ashburnham Pentateuch as a key witness, along with the synagogue paintings at Dura Europos and in the Roman catacombs,[8] to the existence of late antique Jewish books with narrative picture cycles. According to this school of thought, the Ashburnham Pentateuch is one piece in a larger theory that late antique, illustrated Jewish books influenced early Christian iconography,[9] particularly in manuscripts and Roman catacomb paintings.[10] Proponents argue that the scarcity of detail in the biblical narrative compelled artists to turn to other sources for pictorial information and that Jewish literature and art filled the vacuum. Recently, however, important new archeological examinations of the Jewish catacombs in Rome raise critical questions. Without exception, the surviving examples of Jewish catacomb paintings depict ritual objects; narrative scenes that draw from either the *Tenakh* or later rabbinical literature are notably absent.[11] If the hypothetical, now-lost, Jewish manuscripts with narrative illustrations were circulating in Rome in the third and fourth centuries, they had a curious influence on Christian funerary art while leaving no trace on Jewish funerary art in Rome. Is this a plausible scenario? A genre of Jewish art that left no imprint on Jewish funerary art while making inroads into Christian art – both funerary and book art – stretches, I believe, art historical and archaeological credibility.

At times the scholarly dialogue has become polemical. Serious charges have been leveled against scholars who placed the Ashburnham Pentateuch within a "purely" Christian context. Kurt Schubert, for example, has scathingly attacked Franz Rickert, reproaching him and "Christian archeologists" for not understanding the Jewish literary and pictorial tradition, which Schubert believes lies behind the Ashburnham Pentateuch.[12] Ursula Schubert and Gabrielle Sed-Rajna have suggested that some of the scenes in the manuscript, such as the Oppression of the Hebrews and the Reading of the Covenant at Mount Sinai, would not have been of interest to Christians and therefore indicate a Jewish audience in the prototype.[13] The assumption seems to be that the creators of the manuscript slavishly followed a prototype even though it was no longer relevant to their needs and interests. Obviously the themes were of interest to at least one Christian audience as the Ashburnham Pentateuch, despite one's beliefs about its prototypes, is unmistakably a Christian manuscript. Also, it is difficult, and perhaps foolhardy, for modern scholars to assess, with any certainty, which passages of scripture were *not* of interest to early medieval Christians.

The Ashburnham Pentateuch has suffered considerably in modern scholarship because attention has been given to selected details in order to support a larger theoretical enterprise rather than arriving at a comprehensive understanding of the whole. There are several problems and assumptions that have skewed the manner in which the illustrations are viewed. The isolation of a single motif within a rich and diverse series of pictures is highly problematic. In searching for the lost *Vorlage* [prototype], scholars have

tended to isolate motifs and to justify their appearance in the Ashburnham Pentateuch by use of either a Jewish prototype or the influence of Jewish literature. If a Jewish pictorial tradition influenced the creators of the manuscript, then one would expect more than one or two motifs to appear. The literary sources, for the most part from the *Midrash*,[14] were mined for verbal descriptions corresponding to the illustrative details that cannot be explained by pictorial conventions or the scriptural text. The theory assumes that early Christian artists naturally turned to their roots in Jewish art for models, so that they incorporated motifs from Jewish into Christian art, often without fully understanding the original intention of the Jewish source. Thus, when a particular illustration adds elements that are not described in the Biblical text, one can sometimes find a textual source for the motif in Jewish literature. But does this prove the existence of Jewish artistic prototypes, or does it indicate the interest of Christian authors in Jewish authors?

The art historians who utilize the Jewish legends place far too much confidence in their literary sources, more confidence than do their counterparts in textual studies, who recognize the difficulty, and perhaps futility, of identifying the sources as either Jewish or Christian. The rabbinical literature is at times sporadic, individualistic, and nonbinding so that one homiletic saying may not represent a wider Judaic tradition.[15] A tradition must be established to determine that indeed a certain motif found widespread popularity and would have then entered the vocabulary of Jewish and Christian art. A complication that has not been adequately addressed by this group of scholars is that Jewish legends were widely read, studied, and adapted by Christian leaders, making it

substantially likely that the means of transmission was through the lens of Christian literature rather than a direct Jewish interpolation through Jewish art.[16] To date, only a handful of iconographical instances of Jewish influence have been found in the Ashburnham Pentateuch, a manuscript that contains over 100 scenes; of this handful, most cannot be said with any certainty to derive exclusively from Jewish art and literature.[17] The notion of an extensive body of narrative Jewish art in the late antique period is an attractive one, because it fits into the larger picture of intellectual exchanges between Jewish and Christian scholars; however, the lines are often drawn too rigidly. The brushstrokes of Jewish influence have overshadowed the nuances of the artist making a creative contribution to the illustrations that spoke to a Christian audience.

The dearth of narrative Jewish art does not allow for an adequate framework of comparanda. The late sixth-century manuscript is typically compared with the third-century synagogue paintings at Dura Europos and thirteenth- and fourteenth-century Jewish manuscripts, the earliest surviving illustrated manuscripts because no late antique or early medieval example exists. To reconstruct a Jewish, late antique prototype from fourteenth-century manuscripts and the Ashburnham Pentateuch with any confidence, scholars would have to embrace fully the methodology of Kurt Weitzmann,[18] a methodology that has received harsh criticism in recent scholarship.[19] The theory of pictorial recensions, which attempts to reconstruct lost prototypes from later works of art in a manner similar to early textual criticism, has not been successfully applied to the Ashburnham Pentateuch.[20]

Ursula Schubert, who stretches Weitzmann's theory to its fullest extent, attempts to demonstrate a late antique prototype by comparing Exodus scenes (Figs. 1 and 2) to those scenes in the Aelfric Paraphrase (London, Brit. Lib. Cotton Claudius B. MS lat. iv), a Christian manuscript from the eleventh century, the fourteenth-century Golden Haggadah (London, Brit. Lib. Add. MS lat. 27210), the Barcelona Haggadah (London, Brit. Lib. Add. MS lat. 14761), and the Hispano–Moorish Haggadah (London, Brit. Lib. Or. MS lat. 2737).[21] Although she acknowledges iconographical peculiarities in each manuscript, she insists that they share common motifs, such as the making of straw and bricks. In fact, the scenes are far more dissimilar than similar. Her comparison of the Oppression of the Hebrews in the Ashburnham Pentateuch (folios 56r and 58r) and the Golden Haggadah (folio 11r) elucidates the problem (Figs. 2–4). Schubert is careful to demonstrate that the Ashburnham Pentateuch is dissimilar to other Christian manuscripts, such as an eleventh-century Byzantine Octateuch (Vatican, Bibl. Apost., Vat. gr. 747, folio 78v), the ninth-century Stuttgart Psalter (Stuttgart, Würt. Landes. Stuttgart, Bib. Fol. 23, folio 97v), and the eleventh-century Aelfric Paraphrase (London, Brit. Lib. Cotton Claudius B.IV, folio 79v) from Anglo-Saxon England; thus, once she has established its "non-Christian" pedigree, she can turn to Jewish manuscripts. The Ashburnham Pentateuch and the Golden Haggadah both show the first oppression and the second, crueler oppression, which offer "[T]he most striking iconographic parallels": an Egyptian overseer at the top of a tower, the mixing of clay and the mixing of straw, and a man carrying a bundle of straw.

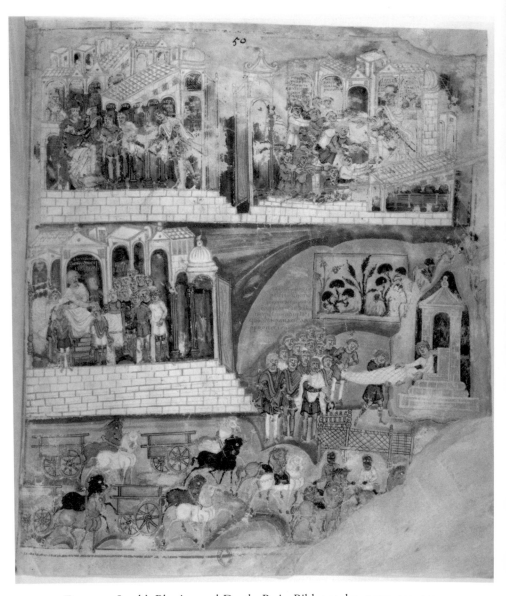

FIGURE 1. Jacob's Blessing and Death, Paris, Bibl. nat. lat. nouv. acq. 2334, folio 50r. (Photo: Bibl. nat. de France)

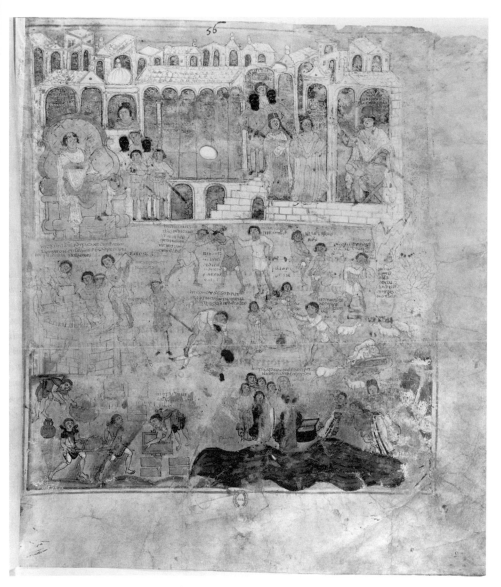

FIGURE 2. Oppression of the Israelites, Paris, Bibl. nat. lat. nouv. acq. 2334, folio 56r. (Photo: Bibl. nat. de France)

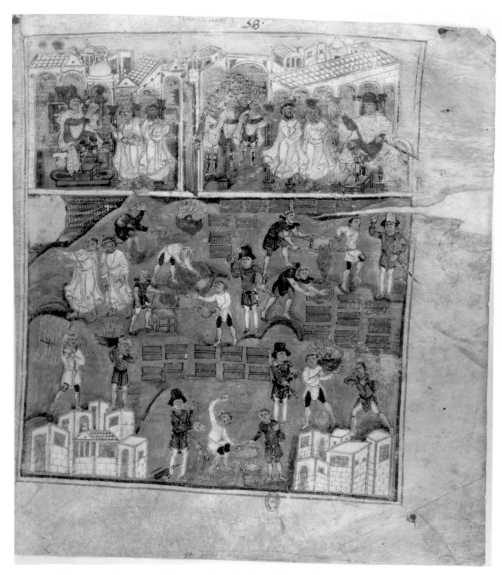

FIGURE 3. Increased Oppression, Paris, Bibl. nat. lat. nouv. acq. 2334, folio 58r. (Photo: Bibl. nat. de France)

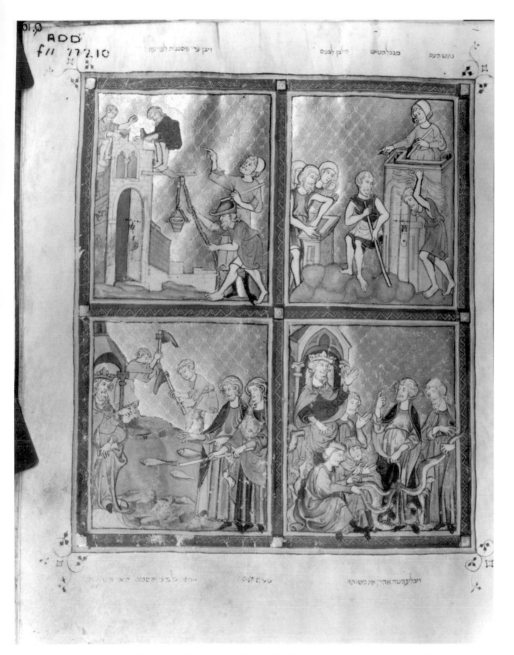

FIGURE 4. Building the Treasure Cities, Golden Haggadah, London, Brit. Lib., Add. 27210, folio 11r. (By permission of the British Library)

A more careful examination shows that the taskmaster in the Pentateuch stands to the right of the city in the first oppression and is shown twice in the second oppression, but in neither page is the taskmaster in a city tower as shown in the Golden Haggadah. In the Ashburnham Pentateuch, the mixing of clay is shown twice as part of an elaborate scene of brickmaking. In both pages, a young man bends over to mix the clay with a short-handled hoe. In the Haggadah, the clay mixer is an older man, indicated by his beard and receding hairline, who stands and stirs the clay with a long stick. The straw gatherer is also quite different in the two manuscripts. On folio 58r in the Ashburnham Pentateuch two young men carry straw bundles slung over their backs by a rope: One strolls in from the left and one strides in from the right. The Haggadah depicts an older man bent over from the weight of his burden, which he awkwardly carries with his arms above his head. The two manuscripts also show a different method of transporting the bricks to the top of the walls. The Haggadah depicts a pulley and bucket, whereas the Pentateuch shows a ladder with a young man carrying a brick on his back.[22] The only unambiguous connection between the two manuscripts is that they both illustrate the first and second oppressions. Thus Schubert's construction of a prototype is based less on convincing visual evidence and more on the confidence of the author in her theory. One late fourteenth-century manuscript, the Padua Bible (London, Brit. Lib. Add. MS lat. 15277, folio 1r) actually provides a better visual parallel to the first oppression (Fig. 5), if one were willing to pursue the Weitzmann method as applied to the Ashburnham Pentateuch.[23]

Como el Re Pharaon si fa murare doe cure Phyron e remedes e per affligere li cudiaco che li no
posselse inceno... fioli e tuto el di li connequira Lauorare ale mie cure a portare paie cal... e
fare ogni altra cos... per stentarli e sempre noguua bastonao.

Como el Re Pharaon comaua a doe femene de Egypto vna aueua nome sefora e latra sua
le quale leuaua i puti e le pute che nascena ale femene gudie che quando el nascesse alguno puto
cauro che lei debia alcure e sela fosse puta chele la debia s...uare queste doe femene remando pi
mio chail Re Pharaon non uolse alcure li puti dei cuter e si se scusa al Re digauro chele femene de
li cuter saueua ben leuare li puti e le pute quando le importunua si chele no negaua chiamate

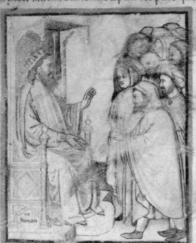
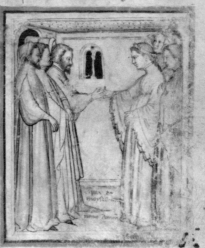

pua aleuare li soi fioli
Como el Re Pharaon comauo al puouolo del... quanco li nascena chelsen g...
mio fiume anegare ele pute che nassen si lea consuruare Capuoh . iii . de Erodo
Como vno homo del tribu e leui el qua aue... me... son ipoia per morire vna semea del
lo tribu de leui la quale aue nome Jocabeth de is qu... di nase u vusen

FIGURE 5. Oppression of the Israelites, Padua Bible, London, Brit. Lib. Add.
15277, folio 1r. (By permission of the British Library)

In her discussion of the Sarajevo Haggadah and other Sephardic manuscripts, Katrin Kogman-Appel presents a tellingly different picture than that provided by Schubert's late antique, Jewish prototype.[24] By placing the Sarajevo Haggadah within its own cultural milieu, Kogman-Appel has shown how illuminators borrowed, modified, and adapted a variety of Christian and Jewish sources to create a new set of illuminations. This approach is far more sound and profitable. To date, the Ashburnham Pentateuch has resisted all attempts to place it within a recension, a family, a branch, or a stemma.

More disturbing than the search for the Ur illustration is the wrenching of manuscripts out of their historical and cultural contexts. Can scholars legitimately compare works of art that are separated by 700 years? Can the fourteenth-century Spanish haggadas be profitably linked to third-century paintings in a synagogue in Syria? Modern photographic databases allow this type of comparison, but the dangers to the historical possibilities of this method should also be recognized. If the only questions asked are about a lost prototype, what other questions are not being asked that would lead to more fruitful and satisfying results?

A small, but growing, number of scholars question the validity of studying the illustrations only for their ability to bear witness to Jewish art and culture. Heinrich Strauss has insisted that the transmission of motifs linked to Jewish cultural traditions was through literary, not pictorial, sources.[25] Joseph Gutmann, who was at one time a proponent of the idea that Jewish art is witnessed in the Ashburnham Pentateuch,[26] has acknowledged that the manuscript's illustrations contain clear references to a

Christian cultural background.²⁷ In his doctoral thesis, Franz Rickert first pointed out the typological framework in the scenes of the Deluge.²⁸ My own research has revealed additional typological and Christian liturgical interpolations in the illustrations, showing how Jewish history was appropriated by Christians through visual means.²⁹ Although I do not seek to deny the larger theory of the influence of Jewish art and literature on Christian iconography, the discussion surrounding the Ashburnham Pentateuch must adopt sounder methodological approaches if it is to be convincing. A clearer picture of the manuscript may, in fact, further the investigation of Jewish and Christian interrelationships. Kogman-Appel has pointed out the necessity to abandon the "either/or" approach and to examine each work of art within its own political and cultural *Sitz im Leben*.³⁰ My criticism is not with the theory of Jewish illustrated manuscripts and Jewish intellectual and literary culture making a large contribution to early Christian art and culture by its absorption into the new religion, but with the overemphasis in scholarship that sidelined this Christian illustrated manuscript from the Latin West.

Ironically, the literary sources previously cited are often the types of literary sources that I want to evoke as being pertinent to the appreciation of the illustrations: homilies, catechisms, folklore, apocrypha, and pseudepigrapha. The difference, however, is that I view the illustrations as coming out of the same intellectual and cultural tradition as their literary counterparts. I am looking for culturally shared patterns, not isolated motifs, which help to define and reconstruct the intellectual and social milieu. I would expect the illustrations to incorporate certain motifs and narrative

structures found in these paraphrases or commentaries, as they are the literary examples of how the Pentateuch was retold, whereas the pictures are the visual retellings of the biblical text.

<div style="text-align:center">⸺∞⸺</div>

Λ Painted Primer

Pope Gregory's letters to Serenus, asserting that pictures were books for the illiterate, exemplify the Church's understanding of how pictures could call to mind Bible stories. Pope Gregory was suggesting not that the illiterate learn the biblical stories from pictures, but that the pictures remind them of stories they had already learned. It was a matter of memory and oral repetition.[31] Gregory, for example, in his second letter to Bishop Serenus urges the clergy of Marseilles to discourage adoration of the pictures, but to learn through the pictures a love of the Trinity.

Traditionally, art historians understand Gregory to refer to church murals such as those that once adorned Old St. Peter's.[32] Herbert Kessler coined the term "painted primer" to suggest that illuminated books were the inspiration for wall paintings.[33] On the other hand, John Lowden suggests that the appreciation of wall paintings led to the illuminated Bible in the fifth century.[34] Whether the "painted primer" inspired wall painting, or vice versa, the emphasis for my argument is that illustrations could inform an audience about the truths found in history and bring them to the adoration of God's work in that history.

I argue that the illustrations in the Ashburnham Pentateuch comprise such a "painted primer." More significantly, the illustrated stories explain the right order of life. For, even more than for their ability to foster recollection, Christians mined the stories for their ethical lessons.[35] The narrative of scripture is frequently difficult to understand, occasionally contradictory, and often horrific in content. Bishops and learned Church Fathers frequently had to explain troublesome references such as the "sons of God" who desired the "daughters of man." Their sexual unions brought about the flood that destroyed the world (Genesis 6:2–4). The requests for clarifications of these puzzling passages often came from deacons who needed to explain the Church's orthodox interpretations. The illustrations, in fact, often contradict the reading of the narrative, and, instead, redirect the audience toward a Christian interpretation. The extensive illustrations, the frequent visual interpolations from familiar contemporary liturgical practice, and the careful manipulation of the pictures suggest that the illustrations were intended to teach clergy, such as deacons, correct and orthodox Church history.

Viewing the Narrative

Of the many questions surrounding the late sixth-century Ashburnham Pentateuch, the idiosyncratic arrangement of scenes on the pages is especially perplexing. Noted for their color

and rich details, the illustrations do not seem to follow any consistent pattern of organization on the page, leading scholars to question the ability of the artist to adapt a model to a new format.

To decipher what may have been the reasoning behind the selection and placement of illustrations, it becomes necessary to abandon modern assumptions. First, one must relinquish the notion of the primacy of the chronology of the biblical narrative. Much of the confusion created by the illustrations' sequence is the result of trying to read them according to the biblical narrative; in other words, in a textual structure that moves in a strict chronological order, one scene leading to the next from top to bottom, from left to right. Pictures are not limited to this meticulous chronology and narrative sequence. On the contrary, the illustrations invite a viewing from a visual and oral structure. The illustrations' layout on the pages becomes more comprehensible when seen from the vantage point of a folkloric structure that imposes a new chronology, or reordering of the characters and sequences of events, on the original narrative to bring out the moral of the story.

The eighteen illustrated pages generally begin chronologically in the upper left, and then revert to a rapid series of compact scenes scattered over the page. To complicate the matter further, this multipartite format is not consistent throughout the manuscript. Single scenes such as the Deluge and the Crossing of the Red Sea occupy the entire, or most of, the page (Figs. 6 and 7). In addition, a combination of text and illustration is found on folios 21r, 30r, and 127v: the meeting of Isaac and Rebecca, Laban searching the tents for his household gods, and Moses conferring his spirit to the seventy elders (Figs. 8–10).[36] The manuscript also contains a

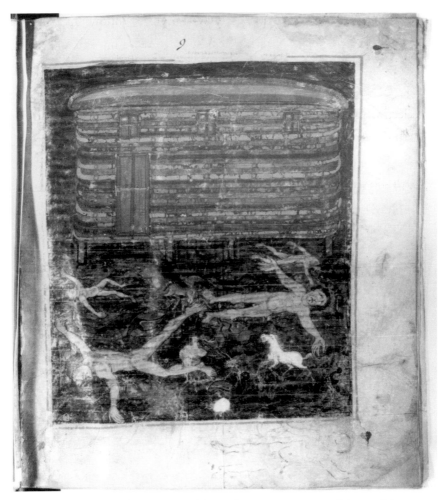

FIGURE 6. The Deluge, Paris, Bibl. nat. lat. nouv. acq. 2334, folio 9r. (Photo: Bibl. nat. de France)

full-page decorated frontispiece and six pages of *capitula* lists that resemble canon tables.[37] Although little more than one quarter of the original illustrated pages survive, it is enough to allow some conception of how the pages were laid out in their varying formats.

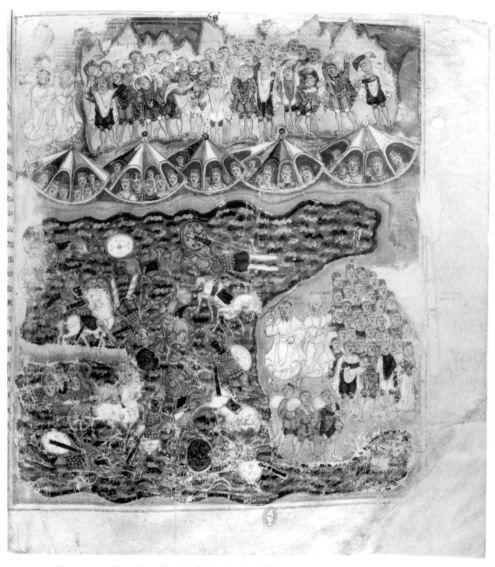

FIGURE 7. Crossing the Red Sea, Paris, Bibl. nat. lat. nouv. acq. 2334, folio 68r. (Photo: Bibl. nat. de France)

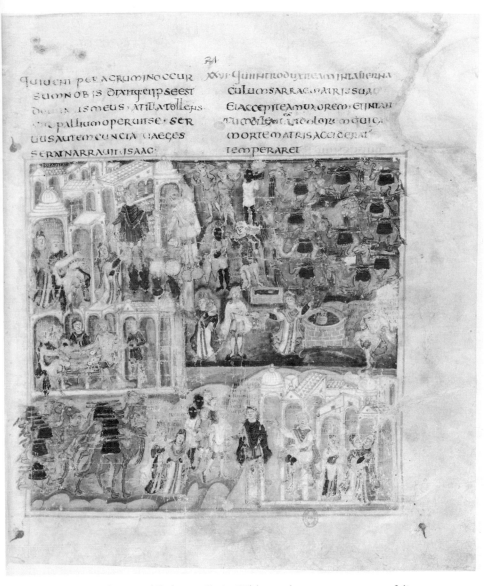

FIGURE 8. Isaac and Rebecca, Paris, Bibl. nat. lat. nouv. acq. 2334, folio 21r. (Photo: Bibl. nat. de France)

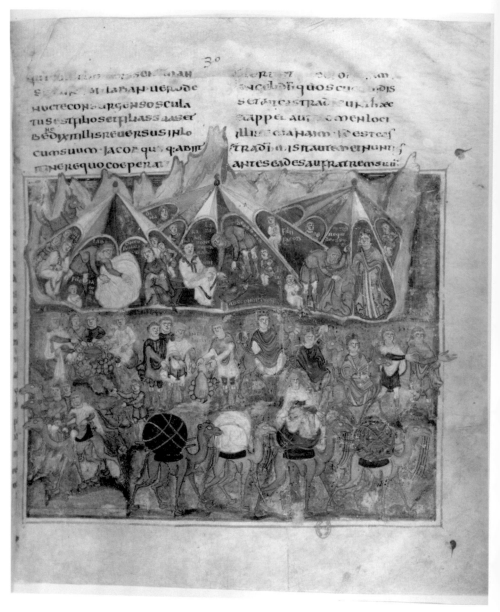

FIGURE 9. Laban's Pursuit, Paris, Bibl. nat. lat. nouv. acq. 2334, folio 30r. (Photo: Bibl. nat. de France)

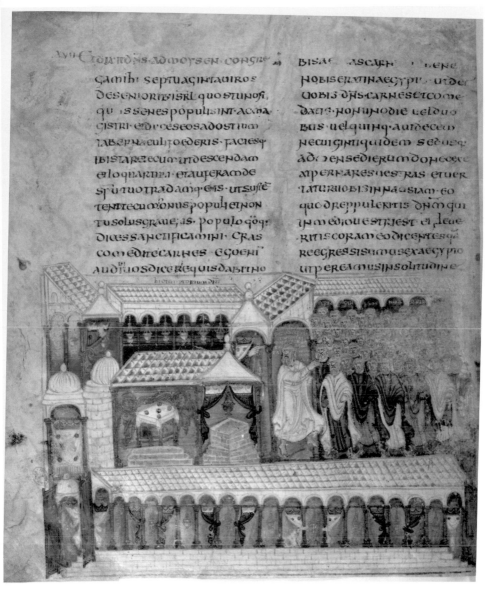

FIGURE 10. Moses Conferring His Spirit, Paris, Bibl. nat. lat. nouv. acq. 2334, folio 127r. (Photo: Bibl. nat. de France)

Although the organization of scenes has been a persistent question, the attempts to account for it are problematic. Within the methodological frame of his recension theory, Weitzmann found the out-of-narrative order puzzling because "the illustrator distributed scenes over the surface in a purely decorative manner with utter disregard for the correct sequence."[38] According to Weitzmann, the artist, working from a larger pictorial cycle, placed the scenes willy-nilly and used an excessive amount of "filler," such as the wheat in the lower right-hand corner of folio 6r (Fig. 11). When confronted with a lengthy series of pictures from which to select and reorganize, the artist of the Ashburnham Pentateuch, according to this theory, resorted to a haphazard jumble, the result of his ineptitude.

Joseph Gutmann proposed a Jewish, Syro–Palestinian prototype for the Ashburnham Pentateuch that dictated the layout of scenes on the pages.[39] Gutmann argued that a model, with either an Aramaic or a Hebraic text, reading from right to left, would explain the narrative movement from right to left in folios 21r, 22v, 25r, and 44r (Figs. 8 and 12–14). In the lower right of folio 22r, for example, Rebecca parts from her family; the action then moves to the left. On folio 22v, Rebecca asks for God's guidance in the upper right and then gives birth to twins in the lower left. Most of the pages, however, do not follow a consistent right-to-left sequence.

Neither Weitzmann nor Gutmann was concerned with the details of each illustrated page. They conceptualized the Ashburnham Pentateuch's illustrations within the framework of larger overarching theses: the evolution of pictorial recensions and the influence

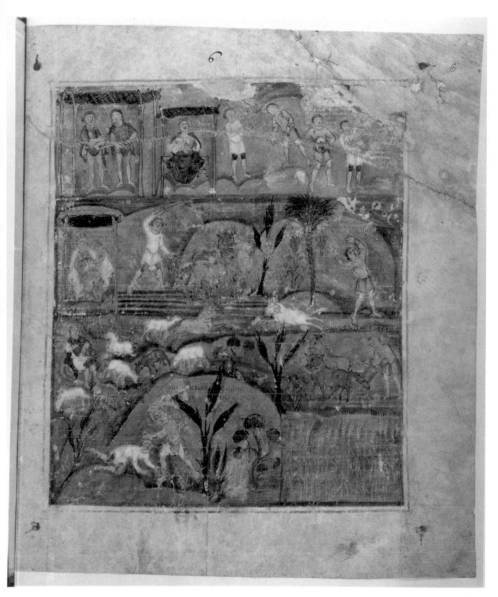

FIGURE 11. Cain and Abel, Paris, Bibl. nat. lat. nouv. acq. 2334, folio 6r. (Photo: Bibl. nat. de France)

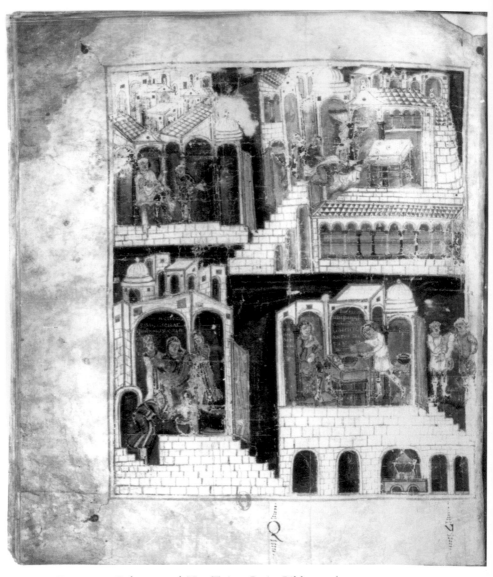

FIGURE 12. Rebecca and Her Twins, Paris, Bibl. nat. lat. nouv. acq. 2334, folio 22v. (Photo: Bibl. nat. de France)

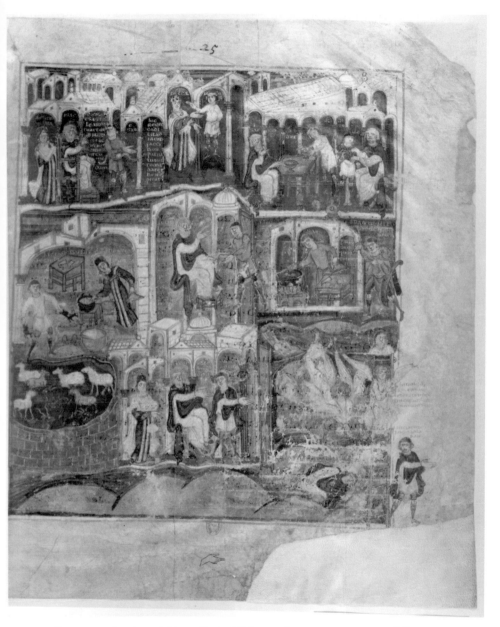

FIGURE 13. Jacob and Esau, Paris, Bibl. nat. lat. nouv. acq. 2334, folio 25r.
(Photo: Bibl. nat. de France)

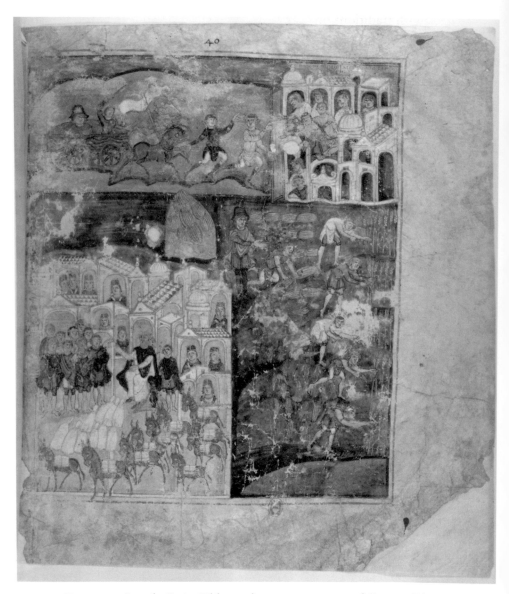

FIGURE 14. Joseph, Paris, Bibl. nat. lat. nouv. acq. 2334, folio 44r. (Photo: Bibl. nat. de France)

of Jewish traditions on Christian art. There are two fundamental problems with these approaches when they examine the arrangement of scenes in the book. First, they look to a previous model for answers without considering the contemporaneous issues that may have shaped the codex. How the manuscript was to be used would determine, in large part, its format. Second, they are based in a textual, or written, structure defined by the biblical narratives, which assumes not only that the chronological sequence of narrative determined the order of the scenes, but also that illustration was subordinate to written text.

It is difficult to accept the underlying assumption that the makers of the manuscript resorted to merely decorative devices or were confined by a model in selecting scenes from a larger cycle and arranging those scenes on a page. They were fully capable of creating sophisticated iconographical meanings. The illustrations show a complex, imaginative, and rich pictorial iconography that does not hesitate to invent by incorporating contemporary imagery. The sophistication of the iconography argues against a less competent handling of format and argues for a more profound structure.

The detailed and lively paintings also argue for more than a decorative or haphazard approach. Rich domestic scenes, such as Rebecca making a savory stew and the architectural backdrops, are among the most appealing aspects of the illustrations (Fig. 13).[40] Illustrators of manuscripts had been creating varied solutions for arranging multiple scenes on a page for at least 200 years.[41] A grid format that accommodated many scenes is featured in the Corpus Christi Gospels (Cambridge, Corpus Christi Coll. MS. 286)[42] and

the Quedlinburg Itala (Berlin, Staatsbibl., MS theol. fol. 485 and Quedlinburg Cathedral Treasury).[43] Considering the number of illustrations on the multipartite pages, it seems impossible to argue that the illustrator did *not* choose the grid format. Another rationale must have been behind the curious configuration. Rather than being decorative or imposed on by a textual model, the organization should be viewed as intentional and creative. The number of illustrated pages, the lavish detail, and the iconographical complexity suggest that the illuminations were valuable and were carefully considered.

Cultural Patterns: The Literary Parallels

The abandonment of biblical chronology and the attention to details are paralleled in literary sources, indicating that the illuminator was working in an enduring tradition of "retelling" the biblical story for purposes of its exegetical instruction.[44] Two literary examples are illustrative of the type of restating for didactic purposes commonly found in early Church teaching. Both St. Augustine and John Chrysostom wrote catechisms, or short pamphlets, on the proper pedagogy of teaching Church history to their constituents. Augustine's *De catechizandis rudibus* was written approximately 400 A.D.,[45] in response to the deacon Deogratias, who had asked for advice on teaching inquirers seeking to enter the catechumenate.[46] In his short treatise, Augustine gives pedagogical advice and two model catechetical instructions: a longer and a shorter version of Church history. Augustine's profound

understanding of human psychology is evident throughout the work. No doubt it was his commonsense advice that has made it the fundamental catechism from the fourth to the twentieth century.[47]

Roughly Augustine's contemporary, John Chrysostom wrote *Address on Vainglory and the Right Way for Parents to Bring Up Their Children*, which dates to the late fourth century.[48] Using specific examples, John Chrysostom paraphrases Bible stories and gleans morals from them for young boys. These two texts contain valuable information about how biblical stories were taught to those unschooled in scripture and Church history. Augustine and John Chrysostom outline the pedagogy and then apply the theory with concrete scriptural examples, such as the creation and the story of Jacob and Esau. Although the Ashburnham Pentateuch does not illustrate these specific literary works, it does seem to put into practice, by means of pictorial narration, the instructive principles. The narrative structure that defined and shaped the catecheses is similar to the conceptual framework that informed the layout of the illuminations.

Although Augustine is traditionally viewed as ambivalent toward the visual arts, he uses a surprising number of visual metaphors in his catechetical instruction. He brings into play a popular Ciceronian metaphor that the development of an idea is like the evolving or unrolling of a manuscript, a metaphor that seems particularly apt for the study of an illuminated manuscript whose pages unfold a pictorial history.[49] Augustine was also pedagogically and psychologically aware of whom the catechumens were likely to be. Students of rhetoric, for example, should learn

humility. They should not scoff at their teacher's mispronunciations; others need further instruction: ". . . it is enough for the more intelligent to be told what [the sacrament] signifies, while with slower minds we should use somewhat more words and illustrations, that they may not consider lightly what they see."[50] Although Augustine may have had in mind verbal illustrations, Gregory's letters indicate that pictures were used to recall the truths found in the biblical stories.[51]

Augustine was acutely aware of the student who could not tolerate a lengthy verbal discourse. Concerning the less gifted person, Augustine exhorts his fellow catechists to pray for the slow-witted student rather than give him too much verbal instruction, "rather, say much on his behalf to God, than say much to him about God."[52] Using another visual metaphor, Augustine reminds the weary and bored teacher that a familiar landscape becomes a delight when seen through fresh eyes. For Augustine the words must become an image in the mind because these imprints aid in memory retention. Anger is a different word, or sign, in Hebrew, Greek, and Latin, but everyone understands the meaning of an angry face.[53]

In his instructional pamphlet, John Chrysostom, like Augustine, invokes mental images to teach parents how to raise their children. Using the metaphor that a child is like a city, he warns parents to guard the gate of their son's eyes. He should not view the theater or bathe with women, but should be shown beautiful things: sky, sun, flowers, meadow, and fair books.[54] The use of fair books as a feast for the eyes suggests that John Chrysostom was keen on the use of correct visual stimuli to induce moral discipline.

In summary, Augustine understands that images in the mind aid the memory.[55] John Chrysostom also refers to visual images, and perhaps even illustrated books, that were suitable for the moral enlightenment of young eyes.

In the works of both John Chrysostom and Augustine, biblical stories function on two levels. Old Testament stories were to be not only interpreted literally as historical accounts, but also taken as prophetic or moral tales.[56] Those Christians unschooled in the meaning of Jewish history needed guidance on how to glean the correct moral instruction, particularly in the face of awkward passages that, when taken literally, seemed to contradict Church doctrine.[57] The early Church Fathers were acutely aware that many of the stories, if improperly understood, could be doctrinal stumbling blocks to the novice reader. Illustrations such as those found in the Ashburnham Pentateuch could guide the reader toward the proper understanding of the stories by using visual references and associations.

The framework that Augustine lays out for Deogratias also offers a way of understanding one of the key questions about the distribution of the illustrations within the manuscript: why the emphasis on certain narratives and not on others? Why does the Deluge, for example, occupy a full page whereas other illustrations are squeezed into the page? Biblical episodes, such as Moses before the burning bush, were typically given prominent and repeated artistic representation in early Christian art.[58] In the Ashburnham Pentateuch, however, Moses and the bush are relegated to the far right of the page (Fig. 2). Why is this scene given such little emphasis considering it is frequently found in early Christian art? Moses

at the burning bush is an outstanding theophany, a specialized moment during which the Deity is made visually manifest to an individual. As a moment in the *history* of God's covenant with the chosen people, however, it is less important. The narratives given prominence are those concerned with Israel's history, which was understood as Church history.

For Augustine, knowledge of Israel's plants and animals was essential in the comprehension of scripture.[59] Just as onomastic sources gave lists of biblical names,[60] Augustine wanted an onomasticon for all the stones, trees, herbs, animals, and metals mentioned in the Bible. Through such humble herbs as hyssop, for example, the student of scripture could learn the love of Christ and the purging of pride (Exodus 12:22; Psalm 51).

Cassiodorus, mindful of the educational limitations of his monks, made accessible Eucherius' *Liber instructiones*, a biblical dictionary similar to that described by Augustine in his *De doctrina christiana*.[61] Eucherius' handbook covers the symbolism of everything from thunder and lightning to dogs and honey. He describes not only the stations in life and their meaning, such as what it is to be a shepherd, a wife, or a poor person, but also the significance of human body parts.[62] Eucherius' work was intended to aid in retrieving the correct interpretation of scriptures. No detail is too small or without significance. This attention to the didactic properties of plants and animals for illustrative purposes is paralleled in the vegetal and animal details found in the manuscript.

Gregory the Great's *Moralia in Iob* takes this type of allegorical method to its fullest extent. Every word, every number, is

twisted around, turned upside down, and scrutinized because a number or a plant or an animal has potential as the signifier for the accurate comprehension of a scriptural passage. This exegetical method often tries the patience and mathematical skills of the modern reader:[63] In Gregory's *Moralia in Iob*, Job's seven sons, for example, represent the twelve apostles because seven is the number of perfection broken down into the numbers three and four that when multiplied equal twelve. Gregory's type of allegorizing was wildly popular. Marinianus, archbishop of Ravenna, ordered portions of the *Moralia* to be read in public until Gregory protested against this practice of public reading;[64] despite Gregory's wishes, the practice was reinstated shortly after his death.[65] Gregory describes his threefold method in the introduction to the *Moralia*: historical/literal meanings, allegorical/symbolical meanings, and moral lessons. Some parts of the biblical text, he explains, require all three methods. The levels of understanding in the audience must also be taken into account; there is something for everyone in Gregory's teaching. This type of symbolic and detailed interpretation of scripture, dictated by contemporary exegetical methods, is also necessary to comprehend the aims of the pictures that accompany the biblical narrative. The truth, rather than the devil, is often found in the details.

Literary Sources: Problems and Guidelines

Throughout this study, I make frequent reference to liturgical works, as well as exegetical books, homilies, catechisms, folklore,

apocrypha, pseudepigrapha, and letters. My treatment of them requires some justification and words of caution. I have eschewed, as much as possible, texts that were for a limited, elite group of scholars. These circulated among such a small number of scholars as to preclude their use as representative evidence. When I have used letters, such as the references to wheat and chaff in Chapter 4, I have used them as an indication of idioms circulating at the time, much as we use them today among our correspondences, as they are signifiers of thought patterns. I have tried to use texts that were readily available to a wider audience. Eucherius' *Formulae*, for example, was a reference book in Cassiodorus' school at Vivarium, a library that is thought to have been brought to Rome during the time of Gregory I. Works such as Augustine's *De civitate Dei*, which I use extensively in Chapter 3, were undoubtedly, if unprovably, well known to biblical scholars.

The most difficult material is the liturgical books because there is a large gap in our knowledge of what was Roman practice after Hippolytus' *Apostolic Tradition* (ca. 215) and what are Gallic and Milanese contributions. The earliest sources are a "mixed bag" of *libelli* and sacramentaries that were made, not in Rome, but in Northern Italy and Frankish Gaul, presenting a complex intertwining of quotations, adaptations, and innovations that do not readily lend themselves to clear demarcation of what is Roman or Gallic practice.[66] Indeed, St. Ambrose's famous instruction to his deacon is perhaps more indicative of contemporary flexibility than what modern scholars allow: When in Rome, do as the Romans. Those surviving liturgical books therefore need some qualification

and clarification about the extent to which they can be used for reference to specific and localized liturgical rites.

Although nothing survives in its "autograph" copy, it is generally agreed by scholars that the period from the fifth to the seventh century was a time of fluidity, when there was a strong movement from improvisation to codification in the liturgical practices of Rome, Northern Italy, and Frankish Gaul. Muddying the liturgical landscape is the problem of Rome itself, which had at least two distinct liturgies: a papal one for use in the stational mass and a presbyterial one used by priests in the Roman titular, or parish, churches.[67] Furthermore, there is the problem of the suburbicarian dioceses that may have used a liturgy adapted for their specific constituencies. There was not a single liturgy called the Roman Liturgy. Although this may seem daunting, it does, in fact, speak to the vibrancy and flexibility of liturgical practice in Rome. The multiplicity of liturgies is very much in keeping with the culture in Rome, where in chant, architecture, and art, there is also great variation.

The earliest surviving liturgical book, the Veronense (Verona, Bibl. cap., Cod. 85, [olim 80]) is not a true sacramentary,[68] but rather is a collection of *libelli* from Rome, which has been erroneously referred to as the Leonine Sacramentary. Thought to have been copied in the first quarter of the seventh century in Verona, its formularies, or prayer sets, reflect the adjustment of papal usage to presbyterial usage, although it is unlikely that it was ever intended to be used by a celebrant in the performance of the mass. The original prayers were probably written in the fifth and sixth

centuries and compiled sometime between 558 and 590. The variety of prayers indicates that they were written in a period when some improvisation and choice was allowed, as several formularies are offered for any one feast day. The cycle of prayers follows a secular, rather than a liturgical, calendar; Roman saints, such as St. Lawrence, figure prominently in the Veronense.

The first, fixed sacramentary, one made for actual use during the mass by the celebrant, is the Old Gelasian Sacramentary (Rome, Vatican, MS. Vat. Reg. lat. 316, folios 3–245 and Paris, Bibl. nat. lat. 7193, folios 41–56), not to be confused with the eighth-century, or Frankish, Gelasian.[69] Written near Paris around 750,[70] it comprised a temporale, a sanctorale, and a canon of the mass. Although it is not completely Roman, the title indicates its pretensions to a Roman pedigree: *Incipit liber sacramentorum romanae ecclesiae ordinis anni circuli.* A sacramentary of the presbyterial type, written for a priest in a titular or a parish church, the Roman model that it claims to follow was probably written in the early seventh century.[71] The surviving Frankish manuscript contains five Gallican insertions: the ritual for ordinations, the consecration of virgins, the dedication of the altar, the blessing of the lustral water, and a ritual for funerals. The canon of the mass has not been challenged as a Gallican insertion, but is generally believed to represent the canon in Rome after the addition of the *Hanc igitur,* a prayer instituted by Gregory during his pontificate.

The so-called Gregorian sacramentary is represented in a number of manuscripts and redactions. One of the most famous is the Hadrianum version, which was sent by Pope Hadrian to

Charlemagne. The original sacramentary was compiled and written in the first half of the seventh century during the pontificate of Honorius I (625–638) and intended exclusively for papal, not priestly, use. Hadrian's copy that he sent north does not survive, but is best represented by the Sacramentary of Hildoard (Cambrai, Bibl. Mun. cod. 164 [olim 159] folios 35–203).[72] Again, the Roman provenance is declared proudly in the title of the codex: *In nomine Domini. Hic sacramentorum de circulo anno exposito a sancto Gregorio papa romano editum. Ex authentico libro bibliothecae cubiculu scriptum.* The papal sacramentary was quickly recognized as unsuitable for use in the parish churches, so it was emended by Benedict of Aniane (+821). It is a good example of the innovative use of Roman material by the Frankish clergy; although the Roman pedigree was sought, it was not an inhibitor to locale adaptations.

In summary, the use of these liturgical books is not without complications and words of caution. These early sacramentaries have sometimes been used as witnesses to Roman practice, without a better appreciation for the time and places where they were written and for whom they were intended. This is not unlike the art historical methods that looked to the miniatures in the Ashburnham Pentateuch for now-lost prototypes. Whenever possible, I have sought collaboration for the sacramentaries in other literary sources in order to establish, if not traditions exclusive to one milieu, a more universal practice. For the most part, I have used them as witnesses to the prayers and actions surrounding the Canon, arguably the most conservative section of the Mass Proper.

Visual Typology and Allegory

The key to understanding many of the illuminations lies in the widespread practice of typology, a way of reading people and events from the Old Testament as prefigurations of Christ and his people. The validity of this practice was instituted by Christ himself after his resurrection when he admonished his followers that his life followed a prescribed script based on the law of Moses, the books of prophecy, and the Psalms (Luke 24:44). Typology, as manifested in art, can often take a direct approach in which an Old Testament scene is paired with a New Testament scene.

Rather than pairing or juxtaposing scenes from the Old Testament with those from the New,[73] the miniatures in the Ashburnham Pentateuch incorporate visual references to contemporary liturgical ceremonies, catechismal instruction, and homilies. By inserting these visual cues into illustrations of the Old Testament narrative, the manuscript conveys the typological meaning of the Jewish history for a Christian community. The importance of typology, as well as allegory, to the Church cannot be overestimated because they were the fundamental methods of instructing catechumens in scriptural interpretation and Church teachings.[74] Also, the lines between typology and allegory, as antithetical methods, have been drawn too rigidly.[75] As these illustrations show, the two methods are often fluid and adaptable. The illustrations function not as mere accessories subordinate to the narrative, but as powerful pictorial expressions of essential Christian teachings

that enhance and enrich the audience's understanding of the text.

The literal sense of the illustration as a reiteration of the text is downplayed in my interpretation of the manuscript. Through allegory and typology, Jewish history is appropriated and transformed into an experience that speaks directly to a contemporary Christian audience.[76]

A careful and considered examination leads me to one conclusion about the audience that the creators of the Ashburnham Pentateuch must have had in mind when the manuscript was created. Proper training of the clergy, who would then put this training into practice, was imperative for the early medieval Church because it was through an "on-the-ground" literacy that the papal administration could "act in the world, to rule, to govern."[77] The format of catechetical instruction, the moral lessons found in the juxtaposition and rearranging of scenes, as well as the references to contemporary liturgical practice indicate one conclusion. The Ashburnham Pentateuch was created to teach, through pictures, the right order of life, the proper interpretation of Scripture, and the typological/allegorical meaning of Old Testament heroes and events.

2

Script, Text, Illuminations, Provenance

The wife of Namatius built the church of Saint Stephen in the suburbs outside the walls of Clermont-Ferrand. She wanted it to be decorated with coloured frescoes. She used to hold in her lap a book from which she would read stories of events, which happened, long ago, and tell the workmen what she wanted painted on the walls.

— Gregory of Tours [1]

The Ashburnham Pentateuch, with its eighteen illustrated pages of pictorial cycles for the Creation, the history of Noah and Joseph, and the Exodus, is pivotal for the history of book illumination. Its late sixth-century to early seventh-century date,[2] which is determined by paleographic and stylistic evidence, makes it the only western illuminated manuscript that bridges the crucial period between late antique and Carolingian narrative, as opposed to purely decorative, or iconic, book illustration.

Known to biblical scholars as "G," or "Turonensis," the Ashburnham Pentateuch is also significant for the history of the

44

Vulgate Bible because it is one of the oldest surviving pre-Carolingian Vulgate manuscripts of Genesis through Numbers. The Pentateuch is one of the precious few pre-Alcuinian manuscripts of the Vulgate, along with the late seventh-century Codex Amiatinus[3] (Florence, Bibl. Med. Laur. MS lat. Amiatinus I) and the Ottobonianus (Rome, Vat. Ottob. MS lat. 66), known respectively as "A" and "O."

In its present condition, the Ashburnham Pentateuch lacks the last verses of Numbers and all of Deuteronomy. The Vulgate text now ends with Numbers 36:6: "*Et haec lex.*" The ornamented *capitula* survives from Deuteronomy. Only 129 of its surviving 142 pages are from the original manuscript, which comprised 208 leaves from Genesis to the beginning of Deuteronomy. Twelve pages are eighth-century additions (folios 3, 4, 8, 37–8, 60–4, 122, 129). Page 33 is a ninth-century restoration in Tours minuscule, indicating that it was certainly in Tours by the ninth century, where it remained until Libri purloined it in the nineteenth century.[4]

Many of the missing pages were illuminated, and it is difficult to determine when these where excised from the manuscript. The pages are gathered in twenty-six quires of eight leaves, which now measure 37.1 cm × 32.1 cm after having been trimmed. Bezalel Narkiss has surmised that 5 cm were cut off when the manuscript was bound in the nineteenth century by Libri, who is also responsible for the current binding when the manuscript was in his possession.[5] An annotation was added to the interior of the cover in the nineteenth century, no doubt when the manuscript was deposited for safekeeping with the Bibiliothèque nationale de France:

"Volume de 142 Feuillets/les feuilletts 11, 39, 49, 50, 55, 94, 96, 139–142 sont mutilés/15 janvier 1889." The quaternions are numbered at the end with a capital Q and a Roman numeral to the right. The vellum is rather thick and quite carefully prepared, although there are the occasional holes and some of the pages have been stitched to repair tears. The ruling is on the hair side of the pages, aligned by a series of points down the middle of the page as well as single points on the right-hand side of the page, which guided the boundary line. Explicits and Incipits are found at the end and beginnings of books. On folio 49v (Genesis/Exodus) and on folio 115r (Leviticus/Numbers) the words *contuli ut potui* [I have corrected] have been inserted.[6] The colophons are embellished with scrollwork and spirals done in black or red ink.

Liturgical readings for Pasch and the ordination of a deacon are noted in the margins: Leviticus 22:1 is marked *lectio pascae* on folio 109r; Numbers 8:4 is marked *lectio ordinationis diaconorum* on folio 125r; Numbers 9:1 is marked *lectio pascae* on folio 126r. Careful examination of the script reveals that the first lection note was traced over with ink at some point, whereas the other two notations have not been modified. The original hand of the these notes can be identified with the hand that wrote the *tituli* in the illustrations, which I take to indicate that the scribe was aware of the manuscript's intended liturgical use. Von Gebhardt concluded that the scribe and the painter were one and the same, for he observed that the text often determined the size of the illustration, as seen on folio 127v.[7] The amount of space allotted to illustration and text on the same page does not, to my mind, indicate the same hand but rather a carefully planned organization,

perhaps between two scribes. The extensive use of the inscriptions within the illustrations does indicate an exceedingly close working relationship, although I hesitate, on this evidence alone, to assign the pictures and script to the same hand.

The manuscript's uncial script is organized in two columns of twenty-eight to thirty lines. A point, or comma, at half height of the letters serves as punctuation. Smaller letters are repeatedly used at the end of the right column to complete the sentence within the column before resuming on the reverse or on the following page. Roman numerals in the margins and large capitals, often highlighted in minium, mark chapter beginnings. The use of minium in the text does not begin until folio 6v. The use of minium is then used sporadically through the text, and the eighth- and ninth-century textual additions omit the use of minium. Beginning with folio 6v, the passages marked in red no doubt refer to lection readings.

Running titles are repeated on the verso and recto of the illuminated pages and are flanked by decorative scrollwork, or flourishes. Although some of the running titles have been lost to the trimming of the vellum, they were not used consistently throughout the manuscript.

Text

The text follows the Vulgate, although with many variations, whereas the correcting hand reveals a familiarity with the

Vetus Latina, or Old Latin, version. In 1907, the Pontifical Commission for the Revision of the Vulgate was charged with studying the texts and their variations of early Vulgate manuscripts. The commission's first editor, Henri Quentin, placed the Ashburnham Pentateuch at the head of the Spanish family,[8] and assigned the Amiatinus and the Ottobonianus to the Alcuinian and Theodolfian stemmae. His methodology, however, was roundly criticized, rendering his assignments dubious at best.[9] In response to Quentin, his fellow Benedictine on the Pontifical Commission for the Revision of the Vulgate, Chapman put forth his own study of these early Vulgate texts. On the basis of spellings and readings that proved to be statistically closest to the Codex Amiatinus, he suggested that the Ashburnham Pentateuch's text belonged to the Cassiodoran family.[10] Chapman was critical of Quentin's methodology, which was based on 91 readings from eight books, whereas Chapman's assessment was based on 2,000 variant readings from ninety chapters. Good statistical analysis must be based on large numbers in the database, rather than on smaller numbers that may not account sufficiently for variables. The early criticism of Quentin's findings has found support through the twentieth century;[11] despite his flawed method, which textual scholars dismissed as too reductive, Quentin's notion of a Spanish origin for the text of the Ashburnham Pentateuch was nevertheless influential. Quentin's classification could still be found in the *Cambridge History of the Bible*,[12] but the fact that Bonifatius Fischer did not attempt to localize the Ashburnham Pentateuch in his fundamental history of the distribution of Vulgate texts makes the textual case for a Spanish origin of the Ashburnham Pentateuch, at the

least, "unproven."[13] Although Narkiss did not publish his textual
studies, he suggests that the text of the Ashburnham Pentateuch
depends on fifth- and sixth-century central Italian manuscripts.[14]
It has never been my intention to undertake a study of the tex-
tual variations of the manuscript, but the consensus, such as it is,
among scholars who have undertaken such studies seems to point
toward a Cassiodoran, or Italian, family of texts. Thus the study
of the Ashburnham Pentateuch text is also inconclusive, neither
supporting a Northern Italian origin, nor firmly placing it in a
Central or Southern Italian center.

Illustrations

The surviving figural decoration consists of a full-page fron-
tispiece and eighteen pages with miniatures.[15] Originally,
there were sixty-nine pages with miniatures: thirty-seven in Gene-
sis, sixteen in Exodus, three in Leviticus, and thirteen in Numbers.
All of the surviving illuminations were painted on the flesh side
of the page. The frontispiece, which was rebound as page 2 and
is preceded by the Creation page, lists the names of the books
in Latin and in Latin transliterations of the Hebrew titles. The
book titles, framed by the curtained arch, are in rustic capitals in a
good script.[16] Besides the frontispiece and the illustrated pages, six
pages of chapter titles for Exodus, Numbers, and Deuteronomy
are arranged under decorated arches of the kind used for canon
tables: three arches under an embracing arch. Each of the chapter

title arches is furnished with a unique ornamental pattern and a rich variety of birds – ducks, pheasants, and roosters that perch on either side of the arches.

Most of the illustrated pages comprise several scenes arranged generally in two or three bands. Although some pages have one or two large scenes, others combine illustration and text. Painted *tituli* that follow the Vulgate accompany the miniatures; however, beneath the painted *tituli* are preliminary inscriptions penned in ink that follow the Vetus Latina, the Old Latin, text.[17]

The illustrations are composed of opaque gouache over brown ink underdrawings. All of the miniatures are finished, although some have lost much of their original paint because of water damage or wear; this is especially true of folio 56r, where the underdrawings are particularly visible (Fig. 2). The artist used a highly sophisticated palette of tertiary colors: dark blue, orange, dark green, salmon, and blackish purple. The wealth of architectural, domestic, and agricultural details in the crowded scenes is an appealing feature of the manuscript. Color is used consistently throughout the illuminations to create a suitable atmosphere for the narrative: The Slaying of the Firstborn, for example, is set against a dark blue background that captures the ominous mood of the night. On the other hand, the Departure of the Israelites from Egypt is set against an exquisite backdrop of salmon pink, which indicates a new dawn. Although an orangish/red band frames the miniatures, the artist had no compunction about breaking through the borders; the figures and landscapes frequently escape the confines of the frame, in a manner that enhances the narrative effect of the scene. The fiery Mount Sinai on folio 76r and the Israelites passing

through the Red Sea on folio 65v, for example, are painted well outside the frame, which enhances the dynamic qualities of fire and the sense of people moving on a journey. The domestic furniture is painstakingly detailed, particularly the wooden furniture, which is typically shown with lathe-turned posts and inscribed ornament. The women's costumes are richly embellished with embroidered *clavi* in a wide variety of colors, accessorized with dangling pearl earrings that match the pearls woven through the coiffures. Although the materials of pigment, ink, and vellum are relatively inexpensive compared with gold leaf and purple dye, attention was lavished on the execution of the pictures. On careful consideration of the astonishingly rich illustration, unparalleled in any contemporary manuscript and rivaled by only a handful of Carolingian manuscripts, it is difficult to maintain a position that the illustrations are the product of a less gifted or provincial artist.

On folio 38v there is a pen-and-ink drawing of the torso of a young man in a tunic, holding a bell-shaped object in his hand, who leans toward a door, which has been copied from the wooden doors found throughout the illuminations. The drawing is a rather crude attempt to emulate the original drawings, as the head is overlarge for the torso and the lower half of the body has been omitted, neither characteristic of the original illustrations in which figures are always completed and the drawing is accomplished. This drawing is in marked contrast to three pen-and-ink drawings found in the margins of folios 1r, 9r, and 25r, where the sketches closely resemble the painted figures they copy.[18] On folio 1r, the First Person at the Creation is carefully copied in ink, both in scale and details. On folio 9r, one of the giants is copied in the lower

margin, again to scale and accuracy with the giant depicted in the painted illustration. On folio 25r, the pointing hand of Isaac is copied exactly in the lower margin. Compared with the later crude drawing, these look to be from the pen of the original artist. What this indicates is difficult to determine, but they do call attention to the key figures and gestures, as I outline in detail in later chapters, that reveal the exegetical sense of the illustrations.

It is prudent to also emphasize what the manuscript lacks in its illustrations. There are no elaborate decorative frames as found in northern manuscripts, nor is there any evidence for gold leaf or ornamental embellishment of any kind. The letters also lack any kind of decorative flourishes, remaining distinct from the illuminations.

The influence of the miniatures on later medieval works of art documents its importance to Carolingian and Romanesque artists working in Tours. The figures were traced with a stylus at some point during the medieval period,[19] and it has been suggested that the Ashburnham Pentateuch may have influenced the format of the illustrated Touronian Bibles,[20] although the Touronian artists have regularized the free-flowing format into neat registers. The arches enclosing the chapter titles seem to have been the inspiration for Touronian arches in canon tables, such as those found in Harley 2795 (London, Brit. Lib. Harley MS lat. 2795, folio 11r).[21] Also, Narkiss has argued that five figures on folio 1 were eradicated in the ninth century at Tours, indicating that great interest was taken in the manuscript (Fig. 15).[22]

The use of the Ashburnham Pentateuch as a model for the late eleventh-century frescoes at the abbey of S. Julien, Tours, is the only surviving, directly demonstrable example of a manuscript that

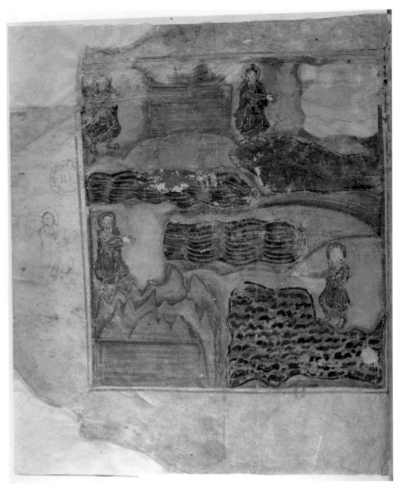

FIGURE 15. The Creation, Paris, Bibl. nat. lat. nouv. acq. 2334, folio 1. (Photo: Bibl. nat. de France)

served as the pictorial model for mural painting in the Latin West. This is comparable with the well-known relationship between the Cotton Genesis and the twelfth-century San Marco mosaics in Venice.[23] A page "widow" with the remnants of illustration is found between folios 133 and 134, although it is not counted as part

of the foliation. André Grabar and Annibelle Cahn have reconstructed the original illumination based on the mural fragments at S. Julien and sketches by Yperman done in 1894.[24] The surviving fragment depicted Moses' Descent from Mount Sinai, the Adoration of the Golden Calf, and the Execution of the Idolaters, scenes from Exodus 32:26–33:18, which means the fragment was originally between the folios currently numbered 83v and 84r. The frescoes indicate that this page from Exodus was cut from the manuscript after it was used as a model for the eleventh-century murals; it is remarkable then that the Ashburnham Pentateuch was an artistic source in both the ninth and the eleventh centuries. It is notable then that the Ashburnham Pentateuch, the Cotton Genesis, and the Gerona Beatus all inspired monumental works of art in various media, indicating that the act of copying manuscript illumination into a public art venue was perhaps an act of homage or respect for a treasured manuscript.[25]

The accumulation of embellishments rewards us with a richer reconstruction of the physical artifact. In this case, the biography of a manuscript acquires significance by its history of accretions. The pastiche character of the surviving manuscript is itself key to understanding the "afterlife" of works of art.[26]

Provenance

In later chapters, I argue that the Ashburnham Pentateuch was created in the environs of Rome, from where it traveled north,

no doubt as part of the general exodus of books from Rome to monasteries in the north.[27] At this point in my argument, however, I would like to set aside the question of origin in order to examine the manuscript's provenance. Restoration of twelve pages, which had been removed at an early point, indicates that the manuscript was in Fleury by the eighth century.

The eighth-century pages include some decorative additions and reveal an interest in the original pictures. The capital letter **I** of the *In Principio* on folio 3r is embellished in a manner similar to the **P** initial found in an excerpt from an eighth-century book of homilies written in Fleury (Paris, Bibl. nat. nouv. acq. MS lat. 1598, folio 1r; Figs. 16 and 17).[28] The stems of both the **I** and the **P** are topped by stylized palmettes over Ionic scroll flourishes, and below the letters split palmettes embrace the letter stem and trail off to the left in a decorative flourish. The decoration of the **P** is less cohesive and shows the adaptation of plaitwork motifs that are not found in the **I** initial, but the overall conception and composition is identical. The transferal of the Ashburnham Pentateuch to Fleury is plausible because Fleury and Corbie are known as Merovingian monasteries that acquired Italian manuscripts at an early date.[29] On this basis, the twelve pages were probably added at Fleury in the eighth century.[30] An additional restored page (folio 33) has been assigned to Tours in the ninth century;[31] therefore, it is assumed that the manuscript resided in Tours until the modern era.

Shortly after the French Revolution (ca. 1825), the manuscript was moved from the library at St. Gatien to the municipal library of Tours.[32] At some point in 1842, the manuscript disappeared from the municipal library. Between March and April of 1847,

FIGURE 16. Frankish script, Paris, Bibl. nat. lat. nouv. acq. 2334, folio 3r). (Photo: Bibl. nat. de France)

FIGURE 17. Frankish script, Homilies, Paris, Bibl. nat. nouv. acq. MS lat. 1598, folio 1r. (Photo: Bibl. nat. de France)

Guglielmo Libri (1802–1869) sold, through a London book dealer named Rodd,[33] a large illustrated Pentateuch to the Fourth Earl of Ashburnham, as one of 1,923 items in Libri's collection that the Earl purchased for £8,000.[34] The ancient Pentateuch was used as an enticement for the Earl to purchase the entire collection. A previous arrangement with the British Museum had fallen through when the Trustees would not pay the asking price of £9,000. The Greek inscription on folio 116v, $\mu o \nu \kappa \rho \upsilon \pi \tau o \phi \varepsilon \rho \rho$., is thought to have been added by Libri in an attempt to assign the manuscript to the Roman monastery of Grotta Ferrata rather than to a French library. Libri also is thought to have erased the "*sancti Gatiani*" from folio 5r. The erasure, alteration, and addition of *ex libri*, as well as outright forgeries, were typical of Libri, who employed forgers for the work.[35] In an effort to stop the sale of the Ashburnham collection to the British Museum by the Fifth Earl, in 1883, Léopold Delisle revealed that the Ashburnham Pentateuch was in reality the Tours Pentateuch stolen from the municipal library some forty-six years previously.[36] Finally, after a complex series of negotiations, on 23 February 1888, Delisle took possession of the remaining 166 manuscripts in the Ashburnham collection, which were deposited in the Bibliothèque nationale de France for safekeeping.[37]

Thus a secure provenance can be established for the Ashburnham Pentateuch. If my arguments for a Roman origin in later chapters are found convincing, it was an early seventh-century Roman manuscript, which traveled north to Fleury, where it was refurbished and given a decorated initial in the eighth century. From Fleury it was taken to Tours where a ninth-century

addition was inserted and where it was studied, amended, copied, and emulated in manuscripts and frescoes. The manuscript was deposited at some point in the library of St. Gatien, and was moved to the Bibliothèque Municipale during the French Revolution from where it was stolen, brought to England, and then finally returned to France in the nineteenth century.

3

Principal Narratives

*These [cardinal points in history] we ought not to present as
a parchment rolled up and at once snatch them out of sight,
but we ought by dwelling somewhat upon them to untie, so
to speak, and spread them out to view, and offer them to the
minds of our hearer to examine and adore.*

— Augustine [1]

Central Points in History

In the quote that opens this chapter, Augustine is instructing the
catechist to make selections from Church history to teach his
student, rather than tiring, or overwhelming, the catechumen with
too much information. The catechist should emphasize the histor-
ical highpoints and move rapidly through the lesser stories,[2] so that
remaining details should be woven into the catechetical narrative
in an abbreviated, and less taxing, survey. The technique of princi-
ple accounts interspersed by lesser stories is a literary parallel to that
used in the organization of the illustrations in the Ashburnham

Pentateuch. As the pages are turned in the codex, the pictures reveal the events of Jewish scriptures as passed through the lens of Christian exegesis and liturgical practice. The pages with more expansive scenes correspond to those narratives that the Church deemed the most significant.

Augustine's metaphor is visually manifested in the manuscript, because the pictures of those central points in history are spread out to view in the codex, allowing the viewer to examine them for their prophetic meaning. Which events were considered fundamental? The Creation, the Deluge, Abraham's Sacrifice, the Crossing of the Red Sea, and the Heavenly Jerusalem are key moments in Augustine's model catechismal instruction. With the exception of Abraham's Sacrifice, which does not survive in the manuscript, these stories are also given the greatest visual emphasis in the Ashburnham Pentateuch. The manuscript's illustrations provide a pictographic counterpart to the pedagogy outlined by Augustine. As the manuscript's pages are turned, the principal moments are given emphasis by their larger format, which gives greater visual weight to the page; the lesser narratives are presented as small vignettes crowded onto the page.

The principal narratives of Church history, as sanctioned by the liturgy, are also found in the readings for the Easter Vigil. The scriptural lessons read during the Easter Vigil varied in number and length, but were drawn from a small group of texts from the Old Testament.[3] The lessons, forming the lengthiest part of the vigil, were interspersed with short prayers, or collects, which were either a petitionary type with references to the lesson as in the Roman and Ambrosian rites, or intercessory as in the Mozarabic

and Gallican rites.[4] The Old Gelasian Sacramentary, for example, provides prayers to be recited after the Creation, the Flood, the Sacrifice of Isaac, the canticle sung after the Crossing of the Red Sea, the Song of the Vineyard, the Second Canticle of Moses, and the *Quaemodmodum* (Psalm 41(42)).[5] The sacramentary collaborates the evidence found in Augustine. The Church indicated what it considered the principal historical events by emphasizing them in catechisms and reading them at the Easter Vigil. The Easter Vigil is charged with typological and allegorical meaning because it reenacts the events of Genesis and Exodus through scriptural readings and liturgical actions for the initiates. Consequently Jewish history was appropriated and reinterpreted as Christian history. The illustrations found in the Ashburnham Pentateuch follow this narrative structure: Not all narratives are given equal weight; some were deemed more central than others. The manuscript and its illustrations correspond to the ecclesiastical framework of Church practice and teaching in the late antique and early medieval world.

Creation

The Creation page illustrates Genesis 1:1–10 verse by verse; unfortunately, it is in a poor state of preservation, much of the *tituli* are obscured, and the imagery has been altered (Fig. 15).[6] Enough remains, however, to grasp the central theme of the Creation illustration. The sequence of episodes is the most orderly

in the manuscript: It moves generally from top to bottom, left to right, against a muted violet backdrop. In the upper left is the Creation of Heavens and Earth [*hic d[omi]n[u]s ubi creauit (caelum et terram)*].[7] The Creator [*omnipotens*] gestures toward the heavens, shown as a pinked striated blue arc and the earth [*terra*] shown as a brown rectangle. Immediately below the Creation of Heaven and Earth is the Spirit of God moving over the waters [*hic sp[iritu]s d[omi]ni ubi superferebatur super aquas*], which are shown as a green striped "cushion." Although Gebhardt interpreted the pink cloud as the Spirit,[8] the original corporeal Spirit was blotted out with pink paint.

The Creation of Light and the subsequent Division of Light from Darkness [*(hic) ubi (creauit lucem) et tenebras*] is portrayed in the upper right. Light is an irregularly shaped square of yellowish brown, whereas darkness [*(te)nebra(e)*] is a puddle of dark blue with black edges. The separation of the water above and below the firmament repeats the green striped "cushion" motif from the scene above, making it difficult to determine whether this is the firmament, or one of the two waters. The *titulus*, however, gives the proper identification: [*hic] ubi [segregauit aq]uas ab aquis*.

The final scene, the Division of the Earth from the Sea, occupies the bottom register of the page. The dry land is shown as a mountain range and as a flat plateau [*hic terra ubi segregata est ab (aquis sub caelo?)*] on the left. To the right, the Creator [*(o)mnipote(ns)*] stands above the rippling waves of the blue seas [*hic ubi segrega(uit ma)re ab arida*]. This ends the illustration in the middle of the third day of creation. The text continues with the description of the earth filled with grass, herbs, and fruit trees.

In its present state, the page shows the Creator four times. In the first two days, he stands pointing to the right wearing a full beard, long hair, a brown garment, sandals, and a halo. On the third day, the posture is reversed: he points to the left and he no longer has his beard or his sandals. Because beards are a common pictorial convention to show age, the Creator appears three times as an older man and once as a beardless young man in the lower right-hand corner.

Bezalel Narkiss discovered, through the aid of ultraviolet light, that the original illustrations depicted two nimbed figures standing side by side: The three figures to the right of the older Creator are clean shaven and barefoot, whereas the figure to the left of the young Creator is bearded and shod in sandals. Narkiss surmises that while the manuscript was in the scriptorium of Tours in the ninth century, the figure on the right of each of the pairs was eliminated by paint. In addition, the Holy Spirit hovering over the waters was also eliminated. The illustration is notable as an early attempt to indicate that all Three Persons were at the Creation.

Early attempts to depict the Trinity often used metaphor and narrative to indicate the Three Persons, for example, the visitation by three "angels" in the scene of Abraham's hospitality at Mamre.[9] The rare depiction of the Trinity as three separate figures, bearded man, youth, and angel, by its very nature indicates that the illustration is creating a visual exegesis that all Three Persons were active in the creation. The artist has taken a literal approach to depicting the Trinity. The removal, or overpainting, of the Son and the Spirit is in keeping with later, early medieval solutions

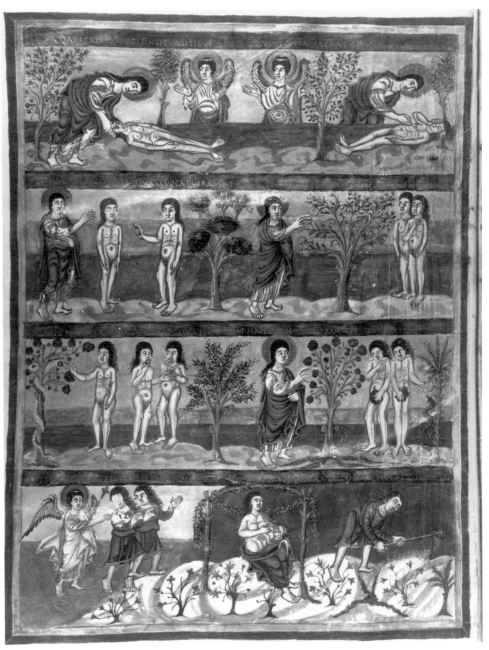

FIGURE 18. Adam and Eve, Moutier-Grandval Bible, London, Brit. Lib. Add. MS 10546, folio 5v. (By permission of the British Library)

that depicted only the *Logos* – Creator at the Creation.[10] In Tours, for example, the ninth-century Moutier-Grandval Bible shows an unbearded, unshod Creator with a halo in the exact manner of the Second Person shown in the Ashburnham Pentateuch (Fig. 18).

Narkiss has pointed out that the illustration is shaped by theological considerations.[11] The original illustration and the subsequent reduction in the number of "Persons" suggest two separate contexts when the nature of the Trinity was a pressing issue. In light of Narkiss's study, it seems that the Ashburnham Pentateuch solution, acceptable at an earlier and more experimental time, became unacceptable some 200 years later when the illustration was altered. This is the only instance of modification, or erasure, evident in the entire series of illustrations.

Although heresies, schisms, and debates about the Second Person are plentiful in the late antique period, the Three Chapters Controversy stands out in the western Church.[12] It dragged on throughout the sixth century, creating schism in the western Latin Church and marring the papacy.[13] At the Fifth General Council of Constantinople in May of 553, Justinian compelled the council to condemn the writings of Theodore of Mopsuestia, the anti-Cyrillene writings of Theodoret, and the *ad Marim* of Ibas for their Nestorian tendencies.[14] Although these three "chapters" were accepted at the Council of Chalcedon (451), Justinian wanted the three writings condemned as heretical, but not the Council of Chalcedon itself. The western bishops were not willing to denounce these writings because condemnation ran the risk of undermining the authority of Chalcedon, a council held in particular reverence by the western bishops. Chalcedon was the one ecumenical

council where the Latin Church shaped doctrine through Pope Leo's influential treatise, the *Tome* (*Letter 28*) of Pope Leo. Leo states eloquently the case for the unity of the First and the Second Persons at the creation:[15]

> For when God is believed to be both "Almighty" and "Father," it is proved that the Son is everlasting together with himself, differing in nothing from the Father, because he was born as "God from God," Almighty from Almighty, Coeternal from Eternal; not later in time, not inferior in power, not unlike him in glory, not divided from him in essence, but the same Only-begotten and Everlasting Son of an Everlasting Parent was "born of the Holy Ghost and the Virgin Mary."

Leo opposed the Monophysite teaching that in Christ there was only his divine nature, his human nature having been absorbed into the divine. Furthermore, Chalcedon was a moment in the papacy at which Leo established that the bishop of Rome was the "voice of St. Peter," making not only Leo's position on the Creation theologically important but also politically. Leo's sermons and the *Tome* were circulated in Rome, as indicted by the Homilary of Agimund (Rome, Vat. lat. 3835, 3836).[16] The colophon states that it was written, in three volumes, by the priest Agimund from the basilica of Philip and James in the early eighth century, making it the only manuscript securely assigned to the city of Rome.

Pope Vigilius (537–555), coerced into attending Justinian's council, exacerbated the controversy by his waffling and his final

capitulation to Justinian. The deacon Pelagius, Vigilius' *papal nuncio* in Constantinople, returned to Rome as Pope Pelagius I (556–561). The capitulation to Justinian's wishes by both Vigilius and Pelagius created a schism between the papacy and the bishops of Northern Africa, Sicily, Northern Italy, and Aquileia. Throughout the papacies of Pelagius I, John III (561–574), and Pelagius II (579–590), all the bishops renewed their communion with Rome, except those in Aquileia and Istria. Gregory the Great finally refused to entertain any more factions by simply stating the papal position and ordering the Aquileian bishops back into the papal fold, but the bishops nevertheless remained defiant.[17]

This summary provides a brief overview of a controversy that overshadowed several papacies, questioned the authority of Rome, and revived Monophysite and Nestorian debates about the nature of Christ. The problem for artists, however, was to translate this theologically elusive notion of One Triune God – a difficult enough notion to verbalize in the Latin of the day – into the concrete language of images. Unlike other narratives from Genesis and Exodus, the creators of the Ashburnham Pentateuch did not have a strong pictorial tradition on which to draw.

The illustration of the Creation seems an early and experimental attempt to portray God the Father and God the Son as both coequals and coeternal, a representation of the orthodox position of Pope Leo and upheld by Gregory the Great.

The question for the artist must have been this: How does one draw all three persons separately but emphasize the unity of the Father and the Son? I believe the artist relied on a technique

that was used throughout the manuscript to establish identity, age, and status. This was successfully done, in other instances, through costume and hairstyle. In this case, God the Father and God the Son are shown almost identically: Both are nimbed, wear a brown garment, and make identical gestures of pointing across their bodies. The only differences are the lack of a beard and sandals in the figure who is identified as God the Son. Their similarity is so close that the unobservant person who obliterated four figures in the ninth century did not distinguish between God the Father and God the Son, leaving three Fathers and one Son, truly an interesting bit of heresy!

As a fully illustrated Pentateuch, the artist could not simply ignore the Creation, and thus the entire problem, as it was one of the "cardinal moments" so central to doctrinal belief. Critical to this pictorial treatment was the Nicene Creed, which emphatically links Trinitarian beliefs to the act of Creation:[18]

> We believe in one God, the Father Almighty, *maker of all things visible and invisible*; and in one Lord Jesus Christ, the Son of God, the only-begotten of his Father, of the substance of the Father, God of God, Light of Light, very God of very God, begotten, not made, being of one substance with the Father. *By whom all things were made*, both which be in heaven and in earth [emphasis mine].

How did the Christian know that God the Son was coeternal with the Father? The illustration makes it clear that he was at

the creation, separating the waters and the light from darkness. The problem is addressed in a straightforward manner, including both the Father and the Son, though indicating their status by the barefeet and the clean-shaven face. At the specific point in the text where the Spirit moves over the waters, the Third Person is introduced.

The reconstruction of the Holy Spirit is highly problematic. Even with the aid of ultraviolet light, Narkiss hints at the difficulty of determining if the Holy Spirit was depicted as an angel or as a dove. Using the angels painted on folios 25r and 65v as models, he inserted an "angel" in the space originally dedicated to the Holy Spirit over the waters in his line drawing that reconstructed the page. As Narkiss recognized, the Holy Spirit as an angel is without precedent in early Christian or early medieval art. Nevertheless, he opted for this choice because it seemed to fit the last remnants of drawings visible under ultraviolet light, which he interpreted as two feet and the tips of two wings. He also offered a line drawing of a parrot copied from folio 10v, which he also inserted into the space reserved for the Holy Spirit. The line drawing of the "parrot" did not fit as comfortably as the line drawing of the angel.

Narkiss's study and reconstruction raises a difficult issue, as one is forced to choose between empirical evidence – the ultraviolet light – and iconographical comparanda. In early Christian art the dove is the symbol of the Holy Spirit, never an angel. The dove, for example, is present in Christ's baptism in the fifth-century ivory bookcover now in the treasury of the Milan Duomo.[19] Notably, however, the dove is not shown in early creation scenes. Here

the issue becomes more complicated, as angels do appear in early depictions of the creation, but certainly not as the Holy Spirit; two angels, for example, witness the formation of Adam in the Moutier-Grandval Bible, folio 5v (Fig. 18). If Narkiss is correct, that this is an angel, not a dove, it represents a unique instance in the history of art. Whether a dove, which I believe more likely, or an angel, the premise from which the Creation page must be approached is that it is a remarkably innovative attempt to make a strong pictorial statement of the presence of the Three Persons at the Creation.

The attempt, however, was not appreciated by the members of the Touronian scriptorium, who were obviously made nervous about this approach to the Trinity at the creation. The debate on the Trinity had shifted slightly. Narkiss suggests the obliteration of the figures was the result of Spanish Anti-Adoptionist heresies of the eighth century. Adoptionists, led by Elipandus, archbishop of Toledo, and Felix, bishop of Urgel, argued that Christ in his human nature was not the true Son of God but an adopted one.[20] The matter was brought to a head when Charlemagne called for the Spanish clerics to answer charges of heresy at the Council of Frankfurt in 794. The Spanish did not recant, a circumstance that galvanized Alciun of York to write his seven books, *Contra felicem urgellensem* and the *Adversus elipandum toletanum*;[21] in 796 he became abbot of Tours, which is perhaps when the three Sons, one Father, and the Holy Spirit were eradicated from the page. The page, although sadly diminished, is no longer ambiguous because it conforms to standard western treatments of the creation, in which typically there is one Creator, the Christ Logos.

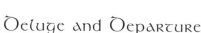

Öeluge and Öeparture

The Deluge is illustrated on two surviving folios (9r, 10r; Figs. 19 and 6). Folio 9r has a unique format within the eighteen remaining pages: One large scene occupies the page, rather than two or several crowded onto the page. The Deluge is a remarkable scene for its relative lack of detail and the simplicity of its composition. The page is evenly balanced between the ark and the waters of the flood. Above the illustrations are the *tituli*: *hic dillubium aquae* and *hic noe inclusus in arca [? cum uxorem et fili]os et nuros cum omnia ubstantia ter[rae . . . p]ecora bestias et uolatilia.* Folio 10r is divided into the releasing of the birds, the departure from the ark, and the offerings of thanksgiving. The Deluge and the Departure are remarkable pendants because they emphasize how the story was a historical watershed for the Church and that a full range of typological and allegorical meanings could be derived from the narrative.

The ark is portrayed as a footed and lidded basket, or chest, with wooden windows and doors secured by metal latches. Five vertical rows of rivets secure the skin of the basket to the skeleton. While the waters are rising, the ark's flat lid is firmly fastened, protecting Noah, his family, and animals within the ark. In the Departure, the ark's lid, door, and windows are thrown open. The footed basket is an unusual rendering of the ark, which is more typically shown as a box, or sarcophagus, in the late antique period. The fifth-century fresco in Bawit marks the beginning

of the ark as a boat, a pictorial tradition that will then domi-
nate, but an iconographic convention that seems not to have been
adopted in the Ashburnham Pentateuch.[22] Renderings of an ark
with feet and a hinged lid survive in the drawings of the early
medieval frescoes at S. Paolo fuori le mura, Rome, and the North
African church mosaic from Mopsuestia.[23] A similar basket stands
on the banks of the Nile in the scene of Moses rescued from
the water by Pharaoh's daughter (Fig. 2). The similarity in the
arks/baskets may be referring to the fact that Noah and Moses
are both rescued from treacherous waters in a vessel lined with
pitch.[24]

The green sea surrounds the ark and the corpses, framing
and uniting the Deluge picture. Two nude, male giants are tossed
about in the water, their postures mirrored in the figures of the
two nude men.[25] The giants' faces are contorted in agony, causing
the mouths and eyes to be misshapen, and indicating that they
are still struggling in the waves. Three blue ducks, two horses, and
two mules drift in the waves. Curiously, the giants, the humans,
and the cattle are all male, no females drown in the waters. The
ark as basket, the giants, and the gender specificity are three distin-
guishing elements of this Deluge illustration. More importantly,
the illustration's emphasis is on the drowning figures: Some are
still struggling as the waters rise.[26] Noah and his family are secure
behind the windows and doors; only the ark and the drowning
giants, humans, and cattle are the subject of this illustration. This
is worth observing because it is a decisive point in understanding
the purpose of this illustration. An early admirer of the illustration
drew a penned copy of the giants in the lower margin, calling

FIGURE 19. Departing from the Ark, Paris, Bibl. nat. lat. nouv. acq. 2334, folio 10v. (Photo: Bibl. nat. de France)

FIGURE 20. Lot and His Daughters, Paris, Bibl. nat. lat. nouv. acq. 2334, folio 18r. (Photo: Bibl. nat. de France)

attention to these large figures and underscoring for modern viewers the importance of these giants.[27]

Giants are rarely included in the surviving illustrations of the Deluge, so it is crucial to ascertain the possible rationale behind their inclusion.[28] The inclusion of the giants is not found in prior depictions of surviving Deluge representations, suggesting that their inclusion was deliberate. Early Christian catacomb paintings and sarcophagi of the Deluge are so abbreviated that they include only Noah, the ark – typically portrayed as a box – and the dove.[29] Giants are found in one later medieval manuscript, the San Sever Beatus (Paris, Bibl. nat. MS lat. 8878, folio 85r) (Fig. 24),[30] where it illustrates a small treatise on Noah inserted after the commentary on the seven churches of Asia Minor. The apocalyptic context of the San Sever giants is an indication that the destruction of the antediluvian giants was related to eschatological themes.

The giants are derived from Genesis 6:2–4, which describes the "sons of God" who desired the "daughters of man."[31] The giants, who are called the Nephilim, were understood to be the progeny of this union.[32] Antique and medieval cultures were deeply antagonistic to giants, who were viewed as barbaric, subhuman, and lacking in higher reason.[33] Polyphemus and Goliath are the most famous of the dim-witted giants, easily outwitted by smaller, more intelligent humans, particularly those favored by God. These giants were effortlessly dispatched; however, the Nephilim and their parentage were not so easily explained by orthodox Jews and Christians. Who were these "sons of God" and "daughters of men?"

Three exegetical traditions developed. Jewish and early Christian commentators variously interpreted "sons of God" as angels,

or the rulers of the earth, or the righteous sons of Seth.[34] I Enoch 6–11, an elaborate visionary account of Genesis 6 that dominated Jewish exegesis until the second century C.E.,[35] told of the wicked angels who lusted after the beautiful daughters of man, taught sorcery and magic to humans, and bred a monstrous race of giants who began to fill the earth with blood. According to this tradition, giants, the products of fornication, precipitated the Deluge.

Jewish and early Christian commentators and apologists followed this exegetical convention until another explicatory tradition eclipsed the "sons of angels" because its overt angelology. Rabbi Simeon b. Yohai, in the middle of the second century C.E., described the "Sons of God" as the sons of the nobles. In very strong language he rejects the angelic interpretation.[36] This marks the beginning of a Jewish rejection of the Enoch interpretation confirmed in the Talmud, which never refers to this giants-as-angels tradition.

By the third century, Christian commentators such as Julianus Africanus also criticize the angelic interpretation and argue that the "sons of God" are the righteous children of Seth, as any one who is righteous is a son of God.[37] Cyril of Alexandria, in responding to Tiberius, a deacon from Palestine asking for answers to difficult questions raised by scoffers in the community, develops his arguments along the same lines.[38] In a spirit similar to that of Rabbi Simeon b. Yohai, Cyril states that Enoch's tale is of doubtful antiquity and dubious authenticity, a tale rejected by sensible people. Both Jewish and Christian exegetes discard the angelic interpretation; the Fathers of the Synagogue will keep to the "sons of nobles" interpretation, whereas the Fathers of the Church will develop the allegorical two-races explanation.[39]

Augustine dedicated two chapters in his *De civitate Dei* to the "sons of God" and the giants.[40] He unequivocally refused to believe spiritual beings could have corporeal relations with women because it would entail a second fall of rebellious angels and, in the context of the debates about the nature of the First and the Second Persons, came too close to the "Son of God."[41] Although Augustine is not the first to question the interpretation of "sons of God" as angels, he gives it the fullest treatment that would then dominate the western exegetical tradition until the nineteenth century.

In his *De civitate Dei* (15.22–23) he attacks this interpretative tradition as a fable, and compares it to ridiculous stories about gods (*incubi*), who take on various shapes to seduce women, or the demons (*dusii*) of the Gaels, who connive to lure women into impure acts. Citing II Peter 2:4, Augustine states categorically that there was one fall of rebellious angels at the beginning and that no holy angel of God could commit such a grievous sin. He must now take a more allegorical tack to explain the problematic "sons of God" and their equally troublesome progeny.

According to Augustine, the "sons of God" are the descendents of Seth, righteous people who live in the city of God. The "daughters of man" are the descendents of Cain, material people who live in the city of man.[42] These two races kept themselves separate until the children of Cain seduced the children of Seth. These *mésalliances* resulted in giants, or monstrous beings, whose great stature came from Seth, but their lack of wisdom and inability to achieve true knowledge came from the evil race of Cain.[43]

The legendary Nephilim were sometimes thought to be of such great height that they touched the sky. Cyril warns Deacon

Tiberius not to take too seriously the notion of giants that reached the clouds. Tall, yes, but not superhuman.[44] Augustine downplays this notion as well, reminding his readers about a certain very tall girl, born to parents of normal height, who caused a sensation when she walked through the streets. Augustine assures his readers that some of the Nephilim were of ordinary stature, whereas some were exceptionally tall, a definition of the Nephilim that seems portrayed in the Ashburnham Pentateuch, in which there are two sets of men in two different sizes, although their postures are duplicated in each size.

What can be gleaned from the story of the giants? Cyril says the wise will learn not to assign a high value to corporeal beauty and size, whereas Augustine admonishes the reader against miscegenation between citizens of God's city and those of man's city.[45] They are unambiguous in that only monstrous and evil things happen when good mingles with bad.

Although early Christian examples of Noah in the ark with a dove are interpreted as a reference to baptism, the giants in the Deluge refer to a second tradition. Within the context of contemporary beliefs, the giants in the Ashburnham Pentateuch would be viewed as monstrous creatures created by the mixing of Seth's race with Cain's and destroyed because of their inability, or lack of wisdom, to know God. The Deluge, especially the narrative that is concerned with the Nephilim, was considered, not a prefiguration of baptism, but a prefiguration of the Apocalypse and the Final Judgment.[46] Augustine is clear that in the Deluge two types were found: one final judgment and one of deliverance of the just by the wood of the ark and the cross.[47] The Ashburnham Pentateuch

represents both of these types in the two surviving pages of the Deluge.

The "righteous children of Seth" exegetical tradition may explain the gender specificity of the giants, men, and cattle in the illustration. By way of contrast, on folio 10r, the animals are carefully paired, male and female [*hic ubi egressi sunt de arca omnia animalia*]. The artist shows gender by size (jackals, camels, donkeys) or by sexual characteristics (ram, ewe), with the larger male usually positioned slightly ahead of the female. This is also true of the creeping things, represented by scorpions and snakes [*hic omina repentia que repunt in terra*]. The lions both display manes, indicating that the artist knew of the animals only by this distinguishing characteristic.[48] Even the birds are paired by gender. The small brown parrot flies out with her larger pink mate. Although the biblical passage tells of one raven, three appear. Noah releases the raven by its wings at the far right window. The raven appears again flying back and forth until it finds dry land, observed by Noah, whose arms and hands are not shown, indicating his passive stance as an observer of the bird's flight in this episode. A third raven flying out of the lid, although the text does not require it,[49] is the mate of the raven described in Genesis 8:6–7, which is shown twice, flying to and fro. Even the dove, which returns to Noah with a tree branch in the central window [*hic Noe ubi ad eum ruersa est columba cum ram[o] olibe*], has a mate flying upward from the opened lid. The artist took seriously the biblical text that stated paired animals, creeping things, and birds of the air left the ark. The mated pairs make a striking contrast to the drowning figures, which are all male and solitary.

The somber tone of the first Deluge page with its dark green sea and pain-wracked figures throws into relief the bright colors and activity of the second Deluge page. The orderliness of the pairings, male and female, suggests that the world is now cleansed, and a new beginning is promised as witnessed by the rainbow peeking out from the clouds [*nubes*] in the top right hand of the page [*iris id est arcum pacis*]. The previous page shows the world in disorder and out of balance, a "cosmic imbalance,"[50] where the children of Cain and their offspring need to be destroyed. Through the ark, a type for the Church, the righteous Noah and his family are safe within the shelter of the ark, while the wicked race of men perishes outside.[51] Ambrose is clear in his instructions to baptizands: "And therefore, in that flood all corruption of the flesh perished; *only the family and pattern of the righteous survived*."[52]

As in many of the pages, the chronological order is difficult to ascertain, indicating that the sequence is less important than the exegetical possibilities of the narrative. The releases of the raven and the dove are shown in the right window, the left, and then the center window. The lid is opened, revealing the paired birds and Noah, his wife, his three sons, and his three daughters-in-law. Noah [*Noe*] stands on the far right listening for the voice of God [*hic dns ubi dicit ad Noe et filiis eius crescite et multiplicamini super terra*]. Below, the animals and the creeping things, in this case snakes and scorpions, leave the ark. In the ark's open lid, Noah and his family are lined up to leave the ark as well. Noah and his sons are to the right [*hic Noe cum bribus fili[is]*], and his wife and daughters-in-law are to the left [*hic nuras Noe exeunt de arca*]. Below, they march out through the open doors [*hic Noe ubi egreditur de arca*]. Their

thanksgiving offering is depicted in the lower left, and in the upper right of the page, Noah gazes at the rainbow from the ark.

Noah and his family stand before a stepped altar of white bricks [*hic Noe ubi immolabit dno ex omni pecore et ex omni [aue] munda*]. He and his three sons, Shem, Ham, and Japheth, are dressed in white robes, which distinguishes them from other men depicted in the manuscript. The white robes of Noah and his sons, as well as the stepped altar, are similar to the white robes of Moses and the seven Levites on folio 76r (Fig. 21). The altar, on which the offerings are placed, acts as a visual prompt to decipher the Christian meaning of Noah's thanksgiving offering after he and his family survive the Deluge. The biblical text (Genesis 8:20) states that Noah offered holocausts of all the clean animals. The *titulus* that accompanies the scene restates the verse. The altar, however, displays three large chalices, filled with red liquid, of the type carried by Cain in his offering to God (Fig. 11) and on the altar of Moses reading the covenant.[53] The viewer is given two, seemingly contradictory, accounts of the thanksgiving sacrifice. The hand of God extends from a blue cloud above the altar in a gesture of blessing [*hic Noe dicit dns ad Noe crescite et multiplicamini super terra*]; Noah reiterates this gesture over the center and foremost of the three chalices. The chalices on the altar indicate that Noah's offering has been given typological meaning.[54]

The Christian interpretation of the Deluge is well known as a *typos* or prefiguration of baptism.[55] Ambrose gives the most eloquent and succinct interpretation: "You see the water, you see the wood, you see the dove, and do you doubt the mystery?"[56] Ambrose is not satisfied to see only prefigurations of baptism in Jewish

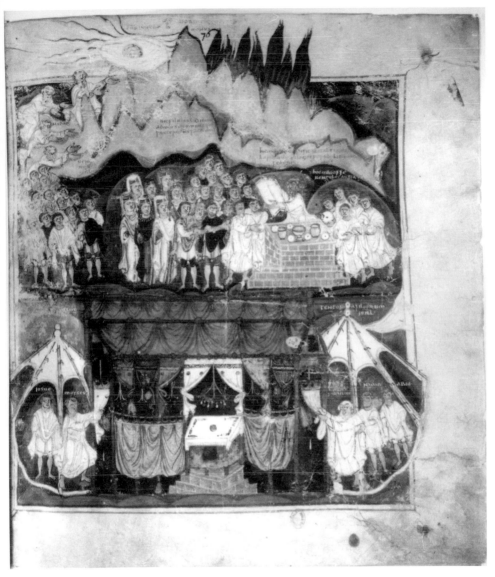

FIGURE 21. Mount Sinai and the Tabernacle, Paris, Bibl. nat. lat. nouv. acq. 2334, folio 76r. (Photo: Bibl. nat. de France)

Scripture, he is resolute in maintaining that the Christian mysteries were "older and more divine" than Jewish sacrifices.[57] Noah's story is key, because it predates the Sacrifice of Abraham; thus, if Noah's sacrifice, sign of God's new covenant, could be shown to be a Christian sacrifice, the "case" would be proven typologically:[58]

> As early as the flood there was also a figure of baptism, and, certainly, the mysteries of the Jews did not as yet exist. Therefore, if the figure of our baptism preceded, thou seest that the mysteries of the Christians are earlier than were those of the Jews.

Ambrose's assertion is an astonishing appropriation of Jewish history and rituals. The artist of the Ashburnham Pentateuch also usurped the sacrifices of ritually clean animals and placed in their stead the chalices holding the wine of the Eucharist.

One curious addition to the thanksgiving offering is problematic, but also indicative of the interpretative puzzles the artist creates. One of the four women standing to the right of the altar is treated in a different manner. She does not wear a veil, she turns away from the altar, and she holds her hands out with her palms turned upward. In all the scenes that have liturgical significance, women are veiled in accordance with Church custom; for example, Rebecca praying for her twins before an altar (folio 22v) and the Israelite women hearing the reading of the covenant (folio 76r). While the women are in the ark, they are not veiled. In all scenes that take place within secular settings, women are not veiled. This is the only occurrence of an unveiled woman standing with veiled women within what is clearly a liturgical site.

Crossing the Red Sea

The Crossing of the Red Sea occupies the lower two-thirds of folio 68r, and the upper third depicts the male Israelites murmuring against Moses and Aaron as the women and children peer out from their tents (Fig. 7). The Crossing illustrates Exodus 14: 26–28, in which Moses closes the waters of the Red Sea behind the fleeing Israelites.[59]

The green waters of the Red Sea dominate the depiction of the Crossing, which are filled with drowning soldiers, chariots, and horses.[60] The ink inscription in the left margin reads *hic que in fugere et non potet*. On a peninsula of dry land, Moses, Aaron, and the Israelites follow the pillar of cloud[61] [*columna nubis*], which is depicted in the right margin as a large candle held in two hands issuing from a white cloud. Moses raises a rod in his right hand to command the closing of the waters of the Red Sea, while Aaron gestures and the Israelites look toward the candle. The artist illustrates the text closely, but when he comes to the strange image of the pillar of cloud, he departs from the text and pictorial tradition.

The earliest depictions of the pillar of fire and the pillar of cloud that guided the Israelites consistently represent it as an architectural column topped by a flame. Examples occur on sarcophagi,[62] in catacomb paintings,[63] and on the wooden doors of S. Sabina.[64] The column with flame remained popular in Byzantine art, especially in the so-called Monastic Psalters,[65] and in Jewish manuscripts.[66] Another standard representation of the pillar of fire is a slender

column of flames, typically found in the Byzantine Aristocratic Psalters, the Octateuchs, and the Exultet Rolls of Southern Italy.[67] The portrayal of the pillar of cloud as a candle held in two hands and issuing from a cloud is unique to the Ashburnham Pentateuch and derives from a liturgical source rather than a pictorial one.[68]

In early medieval liturgical cycles, whether eastern or western, the Crossing of the Red Sea is the primary Old Testament narrative for the Lenten season.[69] After the forty-day period of instruction in the catechism, the catechumens receive baptism on the evening of Holy Saturday, the day before Easter.[70] The actual ceremony is called the Easter Vigil, which Augustine describes as the "mother of all vigils."[71] Following baptism and the donning of white robes, the initiate into the Christian mysteries receives the Eucharist, thereby becoming a fully participating member of the Church.

The Crossing of the Red Sea was typologically associated with baptism at an early stage in Christian thought. St. Paul explicitly makes the correlation in I Corinthians 10:1–2: "You should understand, my brothers, that our ancestors were all under the pillar of cloud and all of them passed through the Red Sea; and so they all received baptism into the fellowship of Moses in cloud and sea." The prefiguration of Christian baptism in the Crossing of the Red Sea was taken up in the writings of early Church fathers and became one of the preeminent types in Christian thought.[72] By the use of types, or examples, from Hebrew Scripture, early Christians reinterpreted the history of the Jewish people as a series of events that foreshadowed the Christian dispensation.[73]

The Easter candle symbolized both the pillars of fire and cloud and the person of Christ;[74] it is the pivotal symbol that links past events to present action and future promise. Although each region developed its own variants on the rite, the basic elements of the Easter Vigil and candle remained constant. The Paschal candle was lit from new fire,[75] and a *laus cerei* [hymn in praise of the candle] was sung.

The origins of the Paschal candle are obscure, but it is evident that in Northern Italy poems to the candle were composed at least by the late fourth century.[76] Praesidius, a deacon from Piacenza, asks Jerome to compose a *laus cerei* praising the Paschal candle. Jerome, a native of Northern Italy, is at his most cantankerous when he refuses to compose the piece because he finds the candle ritual vulgar, perhaps because the praise of the bees who make the wax is derived from Virgil's *Georgics* (4.255).[77] Augustine, while a deacon, composed a *laus cerei,* which he refers to in his *Dei civitates Dei* (15.22). Pope Zosimus (417–418) grants permission to the parish, or suburbicarian churches, to bless the wax of the Paschal candle.[78]

Ennodius, bishop of Pavia in 517, wrote at least two *laudes cerei,* which still survive.[79] Gregory the Great admonishes Marinianus, the bishop of Ravenna, to give up the lengthy *laus cerei* because of his ill health.[80] Ravenna had the unusual custom that the bishop performed it rather than a deacon. Although the *papal* rite performed in S. Giovanni Laterano did not include the Paschal candle until the tenth century, it is clear that the Paschal candle was well known throughout Italy by the late sixth and early

seventh centuries. Even in the papal rite, two vigil candles, the size of a grown person [*staturam hominis habentes*], were carried in procession by two subdeacons, who then stood flanking the altar, as witnessed in the *ordines* that date from circa 600–800.[81] Candles, then, were essential to the performance of the Easter Vigil and associated symbolically with the pillars of fire and cloud as well as with Christ.

The earliest depictions of the Paschal candle are preserved in the Exultet Rolls of Southern Italy, which date from the tenth to the thirteenth century, and they bear a remarkable similarity to the candle in the Ashburnham Pentateuch.[82] Of particular interest is the illustration of the procession to the font in the eleventh-century Bari Benedictional,[83] which, as Hans Belting argued, is modeled after the Crossing of the Red Sea in the Octateuch (Vatican, Bibl. Apost., Vat. gr. 746, folio 186).[84] In the benedictional, the bishop leads a crowd of men, women, and children to the font accompanied by a deacon who grasps the lighted candle with both hands. In the Ashburnham Pentateuch, the pillar of cloud preceding the Israelites, portrayed as a large candle held in two hands, recalls the deacon carrying the candle to the baptistery accompanied by the bishop and the candidates for baptism. The artist inserted a familiar image from one of the most important vigils of the liturgical year. The two illustrations are typological images of each other, demonstrating how the depiction of liturgical action and Old Testament narrative can derive new meaning through the use of visual references.

As part of the *praeconium paschale*, the blessing of the Paschal candle (*benedictio cerei*) is chanted by the deacon who introduces

the sacrament of baptism through allusions to the Crossing of the Red Sea.[85] The standard version of the *benedictio cerei*, which replaced a variety of earlier ones by other authors, has been attributed to St. Ambrose.[86] Although the Gallo–Roman *Exultet* became standard in the West by the eighth century, the early blessings of the candle seem to have taken different forms, following the common theme of praising the candle[87] while repeating certain phrases and ideas.[88] In all of the early *laudes cerei* and in the standardized *Exultet* there is a strong symbolic link between Christ, whose Resurrection illuminates a world in darkness, and the pillar of fire that illuminated the night for the Israelites and guided them by day as a pillar of cloud.[89]

In all of the western rites, the narrative of the Crossing of the Red Sea was invariably included among the lessons.[90] The vigil on Holy Saturday combined the reading of Old Testament passages, the entrance of the Paschal candle into the darkened church, and the *benedictio cerei*, whose typological language made the connection between the pillar of fire and the light of Christ [*lumen Christi*].[91] The visually compelling image of the Paschal candle was easily transferred from liturgical action to the illustration of the narrative that played so central a role in the Easter Vigil.

Covenant

The scene of Moses Reading the Covenant occupies the middle register of folio 76r in the Ashburnham Pentateuch

(Fig. 21). Above and to the left, Moses, accompanied by Aaron, Nadab, and Abihu, approaches the Lord, whose head appears in a cloud at the top of Mount Sinai. Below, in the middle of the page, Moses reads the covenant to the people of Israel, who gather to offer sacrifices, as described in Exodus 24:4–8. Although the biblical narrative requires twelve pillars to represent the twelve tribes of Israel, sacrificial bulls, and the sprinkling of blood on the people and the altar, the artist has deviated from the exact description of the text. The pillars, bulls, and blood have not only been omitted, but the artist has also added extratextual elements.

Moses, standing behind a stepped altar of dressed stone, reads from the book of the covenant, portrayed as a diptych. The *titulus* makes this statement: *hic Moyses edificabit altare ex lapidibus et leget populo librum federis*. A chalice, two pot-shaped vessels, and five loaves of bread are depicted instead of the bulls and the basins of blood demanded by the Old Testament text.[92] The items on the altar clearly indicate a Christian Eucharist, which is similarly represented, for example, in the scene of the Last Supper in the Corpus Christi Gospels, a sixth-century Italian manuscript (Fig. 22).[93] Surrounding the altar are seven young men dressed in long tunics, dalmatics, and paenulae, all in white; three of them carry additional loaves in their hands. The *titulus* describes their actions: *hic ubi offerent olocausta*. The clothing and actions of these seven men suggest that they are deacons, not the Israelites described in the text. To the left and separated according to gender, seven women and sixteen men, representing the Israelites, gather to hear the words of the covenant. The *titulus* reads *hic filii isrl. dicunt ad Moysen omnia que precepit dns faciemus*.

As in the Crossing of the Red Sea, this particular combination of Old and New Testament pictorial elements can be explained in terms of western liturgical practice: specifically, the offertory procession and the recital of names during the memento of the living. Once again, the rendering of the scene emphasizes the typological meaning of the Exodus narrative, depicting actual ceremonies that were performed during the Easter Vigil with all their significance for the newly baptized Christian.

By the fourth century, in the West, the offertory procession took place immediately before the canon of the Mass. In the Roman rite, each member of the congregation and the clergy offered his or her own individual oblation, or offering. The people gathered at the chancel, where priests and deacons accepted their oblations of bread and wine,[94] which were then placed on the altar to be used in the Eucharist.[95] The fourth canon of the Council of Macon of 585 describes the ceremony:[96]

> Wherefore we decree that on every Sunday an offering as well of bread as of wine be made at the altar by all, men and women, that by these oblations they may obtain remission of their sins and may deserve to be sharers with Abel and the rest of just offerers.

The Old Gelasian Sacramentary, in the Supra oblata, the prayer over the offerings for the third Sunday of Lent, provides additional information:[97]

> *Infra canonem ubi dicit: Memento Domine famulorum famularumque tuarum, qui electos tuos suscepturi sunt ad*

sanctam gratiam baptismi tui, et omnium circumadstantium
[After the canon where it is said: Remember, Lord, your
menservants and womenservants, who are to receive your
elect in the holy grace of your baptism, and all those here
present].

The sixth-century account from the Council of Macon is collab-
orated by the Old Gelasian Sacramentary, a sacramentary with
Frankish additions but based on a substrata of Roman prayers,[98]
it becomes clear that there is an emphasis on the participation of
both men and women – *omnium circumadstantium* – all who are
present around the altar.

An interesting variation on the themes in the Ashburnham
Pentateuch depiction is found in the fifth-century Pola Casket.[99]
Under the arch held on the twisted pillars of S. Pietro's ciborium,
a woman offers her gift to a deacon. Flanking the ciborium are
two male orants and two female orants, who are veiled and stand
on opposite sides of the altar.[100]

The depiction of the Israelites in the Ashburnham Pentateuch
conforms to these accounts: Both men and women are specifically
included, and they gather at the altar. The inclusion of women
in the depiction of Moses Reading the Covenant sets the Ash-
burnham Pentateuch apart from other early medieval manuscripts,
which typically exclude women from this scene.[101] The careful de-
lineation of the sexes in two adjacent groups speaks for a conscious
decision to include women; it also reflects actual Church custom
at the time.[102] As early as the third century in Rome, the deacon

attended the entrance for men, while the subdeacon attended the women's entrance.[103]

The women are wearing veils, which further indicates an ecclesiastical setting.[104] The open-handed gestures of the two men and the deacon in the foreground emphasize the corporate participation of the laity and the clergy in the offering of the bread and wine on the stone altar. The three young men on the right can thus be understood as three deacons who bring loaves of bread to the altar as part of the ritual presentation of the oblations.[105]

The gifts of bread and wine were understood by the early Church to be the new oblations, or sacrifices, to be offered to God, replacing the sacrifices of the old covenant.[106] In the Epistle to the Hebrews, the anonymous first-century writer devotes a large portion of his text (Hebrews 9:23–10:18) to the important teaching that under the old covenant the law demanded repeated sacrifices but, because "sin can never be removed by the blood of bulls and goats," Christ "offered for all time one sacrifice for sins" (Hebrews 10:4,12). Quoting extensively from Amos, the Psalms, and Jeremiah, Justin Martyr cites Old Testament authorities who record God's rejection of animal sacrifices.[107] The early fifth-century pope, Leo the Great, in two homilies expresses the continuity of this thought for Holy Week, in which he argues for the superiority of Christ's sacrifice that supercedes the numerous sacrifices of the Israelites.[108] Thus, in the Ashburnham Pentateuch, the substitution on the altar of the Eucharistic chalice and bread for the blood sacrifices of the old covenant reflects a widespread teaching that would have been readily understood in an early medieval Christian context.

Rarely is the book of the covenant depicted as a diptych, although this is not unique to the Ashburnham Pentateuch.[109] Other manuscripts in which it is so represented include the ninth-century Grandval Bible (London, Brit. Lib., Add. MS lat. 10 546, folio 25v) and the Spanish Bible 960 (León, S. Isidoro Cod. 2, folio 46r).[110] Diptychs, composed of two hinged tablets folded together to protect writing on their inner waxed surfaces, were made in a variety of materials such as wood, silver, gold, or ivory.[111] The depiction of the law as a diptych may also derive from literary accounts, which use the term *diptycha* for the tablets of the law. St. Augustine, for example, uses the terms *tabula* and *diptycha* interchangeably.[112] Ezekiel 37:15–20, one of the lessons read during the Easter Vigil, uses the imagery of a diptych to express the reunification of Israel with whom God will make his convenant. The association of a diptych with the covenant between God and Israel seems to have been common in early medieval thought.

Diptychs had powerful liturgical meaning as they were prominent features in the ceremonies of the Mass. The singular use of "diptych" refers to the physical tablet, whereas the plural, "diptychs," refers to the lists of names read during the Greek and Latin liturgies; the inclusion or exclusion of a name indicated whether the person was in communion with, or excommunicated from, the Church. These were generally three types: those listing the newly baptized, the living members of the Church who had offered gifts, and those of the dead who were deemed orthodox.[113] In the early medieval West, the second type was used; the listing and reading of the names of living members commended to God by a special prayer (*Memento*). The list varied from service to service, making

a folding diptych – the physical tablet – the most logical writing surface because it could be erased and reused.[114] The *Memento*, the prayer commemorating the offerers, and the names were recited during the canon itself in the Roman and Ambrosian rites and before the kiss of peace and the canon in the Spanish and Gallican rites.[115] Especially in the Italian rites (Roman and Ambrosian), a direct association was established between the offering, the recital of the names, and the canon of the Mass.[116] It was only natural and logical, therefore, to portray Moses as the celebrant standing before an altar on which the Eucharistic vessels and offering are displayed and reciting the names of the offerers from an open diptych.

In the typological language of the early Church, the Israelites who gathered to listen to the words of the old covenant prefigured the Christians under the new covenant who gather at the altar to offer their oblations, which recall the One Sacrifice. The typological connection, indicated by the artist's substitution of the bread and wine for the animal sacrifices, between the contemporary offerers and Old Testament offerers was spelled out in the canon of the Roman rite itself: "Vouchsafe to look upon them [the offerings] with a favourable and kindly countenance, and accept them as you vouchsafed to accept the gifts of your righteous servant Abel, and the sacrifice of our patriarch Abraham, and that, which your high-priest Melchizedek offered to you, a holy sacrifice, an unblemished victim."[117] The appearance of the diptych as a visual substitute for the book of the covenant was thus a reminder not only of contemporary practice but also of its typological significance, which was reinforced by the readings, prayers, and homilies heard by the late sixth-century Christians.

Physical evidence within the Ashburnham Pentateuch supports the typological connection between the Old Testament offerings and those of the contemporary congregation referred to by the visual cues – altar and diptych – within the scene. On folio 126v the notation in the margin indicates that Leviticus 23 was read for a Paschal lesson (*lectio pascae*). Significantly, the passage concerns the offerings of first fruits that the Israelites were obliged to present. Thus the theme of Old Testament offering was part of the Paschal cycle of lessons in the milieu in which the Ashburnham Pentateuch was written and used.

The typological theme in this scene is further evident in the seven young men, who correspond in number to the deacons selected by the Apostles: "It would be a grave mistake for us to neglect the word of God in order to wait at table. Therefore, friends, look out seven men of good reputation from your number, men full of the Spirit and of wisdom, and we will appoint them to deal with these matters" (Acts 6:2–3). The exact number of seven deacons was carefully observed in Rome and was a distinguishing characteristic of the Roman discipline; the city of Rome was divided into seven regions for the care of the poor.[118]

The white costumes, which distinguish these seven young men from the other Israelites in their brightly colored clothes, confirm their identification with deacons and the typological implications of that office. Isidore of Seville speaks of the white garments worn by the clergy who assist at the altar: "*Quique propterea altario albis induti adsistunt, ut coelestem vitam habeant, candidique ad hostias immaculatique accedant, mundi scilicet corpore, et incorrupti pudore*" [And who approaches the altar robed in white, in order that they

may have heavenly life, let them approach the host in white and without stain, that is pure in body and unspoiled in modesty]. In the same passage Isidore makes it clear that the "*Diacorum ordo a Leui tribu accepit exordium*" [The order of deacons takes its beginning from the tribe of Levi].[119] The ordination prayers for the office of deacon also underline this typological connection between Levites and deacons;[120] the word Levite was even substituted for deacon.[121] That the creators of the manuscript shared this understanding of the Levites as precursors of contemporary deacons is indicated on folio 125, where *Lectio ordinationis diaconorum* is penned in the margin of a passage describing how the altar should be cared for by the Levites.[122] Deacons and priests in Rome were ordained on the Saturday vigils in the Ember Weeks, the Sunday *in Mediana*, and the Easter Vigil.[123]

The significance of the omission of Moses sprinkling blood over the Israelites, which is included in other pictorial cycles,[124] is now clear: Under the new covenant, represented in the Ashburnham Pentateuch by the Eucharist, the priestly act of splashing the blood over the people was no longer necessary because "our guilty hearts [are] sprinkled clean" (Hebrews 10:22).[125]

Heavenly Tabernacle

Below the scene of Moses Reading the Covenant, the tabernacle of God dominates the lower half of folio 76r (Fig. 21) Composed of slender wooden columns and beams that support a

dark blue curtain attached by wooden rings, this makes no attempt to reproduce the tabernacle and its furnishings painstakingly described in Exodus 25:10–30:38; 36:8–38:31. In the center of the tabernacle is a square wooden altar on a stone base. A jewelled crown hangs over an altar covered with a white cloth decorated in gold trim that matches the white curtain above. The altar has a square cavity in the front, indicating that it is a reliquary altar.[126] Pitched against either side of the tabernacle are tents of white material supported by wooden poles, similar to the tents in the scene of the Israelites Murmuring Against Moses (Fig. 7) and identified in the *titulus* on the right as *tentoria filorum isr[ae]l*. Standing in the left tent are Joshua [Josue] and Moses [Moyses] in white clothing, and in the right tent Aaron, with his sons, Nadab, and Abihu [Aaron, Nadab, Abiu], also dressed in white. Both Moses and Aaron grasp the white curtains on either end of the tabernacle and pull them back as if to expose the interior. Above the right Israelite tent is a white cloud from which emerges – in the space between the red background and the red frame – a large, lighted white candle held by a pair of hands, identical in conception with the pillar of cloud depicted on folio 68r.

The unusual appearance of the Israelites' tents pitched against the sides of the tabernacle[127] and the appearance of the pillar of cloud – represented as the Paschal candle and symbolic of Christ – can be explained in terms of Exodus 33:7–11, 40:34–35; Numbers 1:50–2:2; and Ezekiel 37:26–28.[128] The texts of Exodus and Numbers describe the "tent of the presence" as the portable, wilderness tabernacle in the Israelites' camp (e.g., Numbers 2:1), and the pillar of cloud (e.g., Exodus 33:9; Deuteronomy 31:14–15), which

hovered above the tabernacle to signal the presence of the Lord.[129] The prophetic text of Ezekiel, however, foretells the new covenant that will be made with Israel and signified by the presence of the Lord's sanctuary in the midst of his people (Ezekiel 37:26–28). Significantly, Exekiel's reference to God's dwelling among his people is an excerpt from the prophet's vision of the valley of dry bones. The valley of dry bones narrative was one of the standard Old Testament lessons read during the Easter Vigil.[130]

The tabernacle conforms to the Old Testament descriptions up to a point, but the artist has again introduced extratextual elements into the scene. The tabernacle, for example, contains pictorial cues that it represents the tabernacle of the Christian Church, prefigured in the wilderness tabernacle.[131] This is made obvious by the omission of all the furnishings described in Exodus and by the central position of the altar, which is substituted for the Ark of the Covenant and is prominently displayed between open curtains in the middle of the tabernacle. Altars, especially those containing relics in or beneath them were considered the "arks" of the Christian Church.[132] Once again, the Epistle to the Hebrews elucidates the relationship of the old tabernacle to the new. Under the first covenant the material sanctuary, or tent, contained the Ark of the Covenant and the furnishings described in Exodus. The Holy of Holies could be entered only once a year by the high priest, who took with him the blood, which was offered for the sins of the Israelites (Hebrews 9:1–12).[133]

The altar represents Christ's sacrifice, and the Church's teaching that the altar is now accessible to all is demonstrated by the open curtains and the inviting gestures of Moses, Aaron, and Nadab.

Once again, a familiar image, the reliquary altar, is inserted to connect the Exodus narrative to contemporary realities. This tabernacle represents not only the material tent of the Old Testament, but also its fulfillment in the New.[134] Although the white garments worn by Moses and the deacons in the scene of Moses Reading the Covenant are easily understood in terms of liturgical vestments, the white garments of Joshua, Nadab, and Abihu reflect another liturgical use of white clothing. Lay people throughout the manuscript wear their knee breeches, short tunics, and paenulae. The shift to white from the colorful costumes of the Israelites above is abrupt, indicating a specific intention on the part of the artist. But if Joshua, Nadab, and Ahibu are to be understood as priests or deacons in white, why are they not wearing the long dalmatics and tunics of the clergy shown above? Here it seems that the white garments represent the clothing donned by those who belong to the tabernacle, which is the New Testament Church, the "tent of the priesthood not made by men's hands."[135] White is chosen for the gowns that the newly baptized put on when they reenter the sanctuary from the baptistery.[136] Augustine makes this clear in an Easter Vigil sermon.[137] Ambrose anticipated Augustine's theme in his explanation of Christian rites and doctrines to the catechumens who were just baptized during the Easter Vigil: The tabernacle, once open to only the high priest, is now the baptistery and every baptizand a priest.[138] For Christian viewers, the white garments of Joshua, Nadab, and Abihu would have served as a visual reminder of their baptism and the white robes they wore to symbolize their new status as fully participating members of the Church with access to the mysteries of the Eucharist.

The tabernacle scene would have also had strong implications for the Christians anticipating their own resurrection, the Heavenly Jerusalem, and Christ's Second Coming. The themes of cleansing, the donning of white robes, and the serving of the baptized in the new tabernacle are set out in Revelation 7:9–16.[139] The typological content spoke to events in the past as prefiguring contemporary events, but it also spoke to events in the future. By the use of typological interpretation, the tabernacle was simultaneously the Jewish Tabernacle, the Christian Church, and the Heavenly Jerusalem.

The pillar of cloud/Paschal candle, like the pillar of cloud in front of the wilderness tabernacle, serves as a visual reminder of the earlier scene of the Crossing of the Red Sea, with its connotations of baptism and of the liturgy of the Easter Vigil. Another lesson for Pasch, indicated in the margins of folio 126, begins with Numbers 9:15–23, which specifically mentions the pillars of fire and cloud that signal the Lord's presence and the required attendance at the tabernacle on the part of the people.

The assembling of the evidence indicates that the tabernacle scene visually portrays the fulfillment of the promises of baptism and the participation in the new covenant through the Eucharist: The newly baptized Christian, dressed in the white robes, which symbolize the brightness of his soul, is now a fully participating member in that "royal priesthood" and worthy to approach the Lord.

The Creation, the Deluge and Departure, the Crossing of the Red Sea, the Covenant, and the Heavenly Tabernacle are given special treatment in the manuscript in several ways. The format has

been altered to visually halt the movement through the manuscript. The viewer is then invited to dwell on the image and to examine in detail the illustration that offers cues to the viewer to the proper interpretation of this significant moment in Church history. Within these cardinal moments in history the viewer is given specific references to mull over and call to mind the meaning of the narrative as interpreted by Church teaching. The cues are often liturgical, such as the altars holding Eucharistic vessels, or the handheld candle, or the white robes of the deacons; or the visual cues are to exegetical treatises that explicated the meaning of the Trinity at creation or the destruction of the world that was due to the wickedness of the antediluvian giants. The peculiar iconography that characterizes this manuscript is that the illustrations do not hesitate to address difficult doctrines because they refer to typological and allegorical interpretations. The illustrations deviate from the pictorial tradition because the "authors" were addressing essential issues of their time as retold through pictorial methods.

4

The Right Order of Life

Do not think, therefore, O people of God who hear this, as we have now often said, that stories of the forefathers are read to you. Think rather that you are being taught through these stories that you may learn the right order of life, moral teachings, the struggles of faith in virtue.

— Origen[1]

The "right order of life," or the adoration of the Divine, determines the conceptual framework for much of the pastoral exegesis in the early Church. The authors of homilies, catechisms, explication of the Creed, and scriptural handbooks strove for an interpretation of scriptures to effect the transformation that brings one "to the love of neighbor and the love of God."[2] Essential to any pastoral teaching, these works concerned themselves with all levels of understanding, both of scripture and of the audience to whom they were speaking. Augustine knew that the catechist coped with the uninstructed and illiterate from the countryside as well as the lettered from the city.[3] Gregory the Great likens some members of his flock to lambs, which

must stand in the shallows of the river; others he likens to elephants, which can swim in the deeper waters.[4] Gregory states that he paints the fabric of his exegesis in fair colors, deeper mysteries as well as simple stories. Gregory's metaphor, I would argue, is the starting point for understanding one of the most puzzling aspects of the Ashburnham Pentateuch: Whereas the deeper mysteries of baptism and the heavenly kingdom are found in the large scenes, the smaller series of pictures contain the teachings that emphasize the rewards of the Christian life.

As I discussed in Chapter 3, the pages with single or larger scenes with liturgical interpolations in the Ashburnham Pentateuch lie on the level of symbolical exegesis: Augustine's "cardinal moments" described in his *De catechizandis rudibus* and the key historical narratives read out during the Easter Vigil lections. The majority of the manuscript's illustrated pages do not show the crucial historical moments, but rather detailed illustrations of lesser known stories. These pages are filled with small vignettes crowded onto the page, often in a chronologically disturbed manner. With the evidence that the artist intentionally interpolated visual cues to interpret the typological content of the major scenes, it seems reasonable to inquire whether the smaller illustrations might also be carefully crafted to elicit responses from a contemporary audience. There are far too many scenes with meticulous detail to suppose that the designer of the manuscript reverted to simple illustrations that only reiterated the facts of Jewish history as laid out in the scriptural narrative. The exegetical milieu of the late sixth century argues against any discussion of scripture,

whether textual or visual, being left at the literal, or historical, levels.

To show how this level of interpretation may have worked, I have followed John Chrysostom's lead and chosen two pages depicting the story of two sets of brothers: Cain and Abel and Jacob and Esau (Figs. 11 and 13). John Chrysostom, in his treatise on unwarranted pride and raising children, gives two stories about two brothers as moral exemplars for young boys.[5] His treatise is particularly pertinent to this study, as he gives line-by-line instructions on how to teach a biblical story to extract from it the moral teachings. He urges the parents to play memory games and to make associations so that the child, when he hears the story read in church, will be proud of his accomplishments because he knows the story and its moral repercussions. It is a model discourse on pedagogical and exegetical practice.

Rather than beginning with the birth of the brothers, John Chrysostom begins as in a fairy tale: "Once upon a time there were two sons of one father, even two brothers . . . one was a shepherd and one was a farmer."[6] Like the illustrator of the Ashburnham Pentateuch, John Chrysostom takes liberties with the narrative order of the biblical text. The aim, both of John Chrysostom and the artist, is not to retell verbatim the chronological sequence of events, but to paraphrase the stories for their ethical lessons. Often this requires a reordering of the events. Regardless of the biblical accounts, of which many are troubling and the heroes difficult to discern, the biblical exegete constructs a clear picture that one brother is good, the other is evil, a practice derived in part from

New Testament interpretations of the brothers[7]:

> For the message you have heard from the beginning is this:
> that we should love one another; unlike Cain, who was a
> child of the evil one and murdered his brother. And why
> did he murder him? Because his own actions were wrong,
> and his brother's were right.

This passage from John's letter shows the didactic, moralizing in-
terpretation that is typical of the early Church's use of the Cain
and Abel story. The sharp juxtapositions of the two brothers are
vital to convey, in unambiguous terms, virtuous behavior.

What are the visual cues for this moral interpretation? Most
readily apparent are the broad swathes of color that organize and
group the scenes. Kurt Weitzmann noted that the scenes on folio
6r, which show Cain and Abel, were arranged according to areas
of color.[8] The vignettes are not arranged in a grid pattern as in
the contemporary Corpus Christi Gospels (Cambridge, Corpus
Christi Coll. Cod. 286),[9] where one or two scenes are placed in a
box (Fig. 22). A comparison with the Genesis frontispiece in the
Touronian Moutier-Grandval Bible (London, Brit. Lib. Add. MS
10546, folio 5v) makes clear the compositional issues (Fig. 18).[10] In
the Grandval Bible, the artist used color bands as compositional
devices to create a neat, orderly page: The color is more subdued
and the registers are aligned with frames containing *tituli*. By com-
parison, the artist's use of color in the Ashburnham Pentateuch is
seemingly irregular in contours and at times intrusive in hue, dom-
inating the pictorial space.

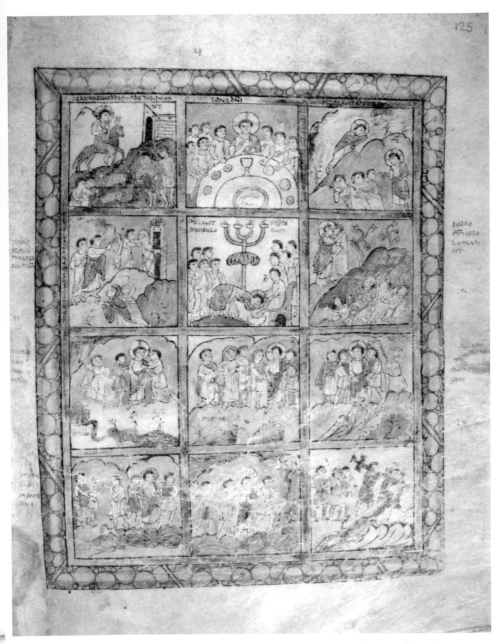

FIGURE 22. St. Augustine's Gospels, Cambridge, Corpus Christi Coll. Cod. 286, folio 125. (Reproduced with permission of The Masters and Fellows of Corpus Christi College, Cambridge)

That color was an exegetical device is well documented in the medieval period.[11] The color swathes on folio 6r, for example, of orange, green, and purple dictate the grouping of the figures and scenes on the page (Fig. 11). It is, I would argue, a clear visual cue as to how the artist intended the viewer to read the page, as to read it in a customary, or textually driven, manner is unsatisfactory. If the color is understood as only a formal device, then the literary convention of reading from left to right and top to bottom becomes dominant and the sequence of scenes incoherent.[12] If the left-to-right, top-to-bottom structure is abandoned and the color is allowed to dictate the grouping of episodes, the meaning of the entire page falls into a coherent pattern. In other words, if the viewer follows the visual prompts of the artist, not the lineated, written text of the scribe, the illustration can tell its story, a "rewrite" imposed on the biblical narrative by pictures.

Cain and Abel

The dominant purple area on folio 6r sets the stage for the pictorial representation of two brothers, one a farmer and one a shepherd. Abel watching his flocks on the left [*hic Abel ubi pascet gregem suem*] and Cain tilling the fields on the right [*hic Cain colet terram suam*] flank the fratricide (Genesis 4). Cain grasps Abel's hair and raises an ax to strike the deathblow [*hic Cain ubi occidit Abel fratrem suum*].[13] In medieval artistic conventions, the central protagonist typically occupies the compositional center. Kurt

Schubert observed correctly that the two confronting rams at the top of the purple swathe and in the center of the page underscore the conflict between the two brothers, resulting in the shedding of Abel's innocent blood.[14] Kurt Schubert interpreted the white and brown rams as ultimately reliant on a Jewish *Midrash* in which the fight between the two brothers was due to Abel's ram wandering into Cain's field.[15] Although the scene does not depict Abel's ram destroying Cain's field, the two rams as a clue to understanding the story's conflict and the color areas as clues for organizing the figures are worthy of further study. Schubert is correct to identify the purple swathe as setting the stage for the conflict between the protagonists.[16] Whenever the stories of the brothers are retold, the theme is one of opposition: Cain is evil whereas Abel is good.[17] The confronting rams and their position in the center of the page, the natural "epicenter" of the composition, demand attention and set the stage. The purple color field dominates almost half the page, yet contains only the two brothers at their work and the fratricide. Thus the theme of the page is determined by the paired figures of the just Abel and the wicked Cain, two brothers, one a shepherd and one a farmer.

The strip of green in the upper middle of the page presents three scenes: Eve under a booth with Cain, her son [*hic Aua sub casa feret Cain filium suum*], Adam tilling his ground [*hic Adam colet terram suam*], and Cain questioned by God about Abel [*hic Cain interrogatur a dns de Abel*]. These three scenes are compositionally parallel to the series above in the orange strip: Adam and Eve in their clothes of animal skins under another booth [*Adam cum (uxore) sua cum tonicis pe(l)lic(eis)*], Eve nursing Abel under a

third booth [*hic Aua sub casa*], the acceptance of Abel's gift and the rejection of Cain's, and, to the far right, Cain and Abel offering to God their gifts [*Hic Cain ubi fe . . . hic Abel ubi offeret*).[18] These figures are more densely grouped than the figures in the purple area, and a greater amount of detail is lavished on the individual figures, their clothing, and their tools. The same principle of polarity, however, informs the reading of the groupings. Although the green and the orange swathes contain comparable figures, they are emphatically demarcated from each other. Although the figures in the orange swathe do not cross over into the green area, the purple and the green share the rams and Cain's feet. The artist has allowed these two areas to merge in small details.

Once the broad areas of color have arranged the figures, the second clue to interpretation is the rich domestic and vegetative details. Although described as merely decorative filler or a distinguishing hallmark of the manuscript's peculiar character, reading the vegetation and animals with meaning is fully in keeping with contemporary exegetical practice.[19] The abundant animal and plant life is the great visual appeal of the manuscript. It is also more than mere artistic whimsy.

Adam and Eve after their expulsion from paradise are depicted in the upper left corner of folio 6r. Dressed in animal skins, they stand in a booth consisting of wooden sticks and a thatch.[20] Although the animal skins are mentioned in the Genesis text and received various interpretations,[21] the booth is not; it is, however, described in the *Vita Adae et Evae*, a pseudepigraphon that rewrites the story of Adam and Eve as told in Genesis 3.[22] The opening verses of the *Vita* relate how Adam and Eve, the protoplasts, built a

booth where they stayed after the expulsion, weeping and lament-
ing, for seven days before going in search of food.

The primary versions of the Cain and Abel episode in the *Vita
Adae et Evae* survive in Greek,[23] Latin, Church Slavonic, Armenian,
Georgian, and a fragment in Coptic. All of the surviving manu-
scripts date from the ninth to the seventeenth century.[24] Questions
of origin, date, and transmission are exceedingly problematic.[25]
Complicating this knotty problem is the secondary Adam litera-
ture that was widespread and vastly popular.[26] The pervasive Adam
and Eve legends in Jewish folklore were circulated widely between
Jews and Christians and became part of Christian legend and lit-
erature. Suffice it to say, by the late sixth century, the legends and
folklore of Adam and Eve were well known in Christian circles.[27]

One aspect of the *Vita Adae et Evae* that should be seriously
considered is the "rewriting" of the biblical narrative. The Adam
legends were moralized tales, but they were not an exact reiter-
ation of Genesis. The stories, often told in deathbed flashbacks
[*testimonia*], explore issues of loss, guilt, death, redemption, and
hope. They are about the troubling aspects of the Genesis story
and the possible morals that could be derived from them. The il-
lustrations in the Ashburnham Pentateuch can best be understood
within this intellectual tradition; they are a visual "rewriting" of
the Pentateuch.

The *Vita* can also be used to explain more than just the ap-
pearance of the first booth. It can explain the appearance and
arrangement of all three bowers: the first with Adam and Eve, the
second next to it with Eve suckling Abel, and the third below with
Eve holding Cain. Chapter 18 of the *Vita* explains that Eve, after

a second betrayal of Adam, leaves for the West, builds herself a booth, and gives birth to Cain. The angels who come to act as midwives can only lessen her awful childbirth pains. After Cain's birth, the angels give Adam seeds and show him how to work the ground. Eve then gives birth to Abel; and the brothers live together. A few lines later, in Chapter 22, Eve dreams that Cain is drinking Abel's blood. She tells Adam her dream and they agree to separate the brothers and to give each his own dwelling, from where each carries out his respective tasks of farming or shepherding. Although the angels are not included in the scene,[28] the three booths probably refer to those found in the *Vita Adae et Evae*: those of weeping, of Cain's birth, and of a separate dwelling for Abel. Whereas the brothers once lived together, the two huts emphasize their separate states.

The two depictions of Eve with her sons are curiously represented, especially because the difference in her dress is evident. In the second hut Eve, simply dressed in her rough, dark purple cloak, is suckling her naked son Abel.[29] In the third and more distant hut Eve, now dressed in jewels and a pink gown with blue *clavi*, holds Cain who is also fully clothed. The sharp distinction between the two representations is a pictorialization of I Timothy 2: 9–15. In his letter to Timothy, St. Paul argues that women should dress modestly, eschewing braided hair, gold, pearls, and expensive clothing.[30] Invoking the protoplasts, he reasons that women are in subjection to men because Adam was formed before Eve. Eve, because of her transgression, will be redeemed through childbearing. The inference seems clear: Eve nursing Abel in her humble

clothes has conformed to the virtuous woman described in the letter of I Timothy. The materialistic and well-dressed Eve, who plays with Cain rather than feeding him, has pursued the things of this world.[31]

The two brothers continue to be contrasted in the vignettes in the top right corner of the page. Reading from right to left, we see Cain and Abel offering their gifts to God, who is depicted as a hand emerging from a cloud. Abel, wearing a white tunic and blue breeches, holds a lamb in his left arm and a large chalice in his right hand. Next to him, Cain, in a fawn-colored tunic and white breeches, carries a round loaf of bread. Here again, small details have been inserted that shift the scene from illustration to visual commentary. The chalice in Abel's hand and the round loaf of bread in Cain's hand are divergences from the biblical text, which states that only a lamb and a sheaf of wheat were offered. Abel's gift, along with Abraham's and Melchizedek's, were the pre-Mosaic offerings that harmonized with the Christian beliefs and were given special status by being incorporated into the Canon of the mass.[32]

The next vignette to the left is the acceptance of Abel's gift and the rejection of Cain's gift. The acceptance and rejection are indicated by Abel's arms that stretch toward the Hand of God and by Cain's arms, which hang listlessly at his side in a classic posture of rejection. The Hand of God now separates the two brothers, with Abel on God's right hand and Cain to the left, a reversal of their previous positions. The chalice and the round loaf of bread, which are also depicted in the scenes of Noah offering sacrifices, and Moses reading the covenant, are clearly a reference to the

Eucharistic wine and bread. The biblical text calls for the fruit of the land and the firstborn of the flock (Genesis 4:3–4), which the artist has interpreted as a loaf of bread, a lamb, and a chalice. This is, no doubt, an interpretation based on Hebrews 11:4, "By faith Abel offered a sacrifice greater than Cain's, and through faith his goodness was attested, for his offerings had God's approval; and through faith he continued to speak after his death."

The green swathe in the page's upper middle contains three scenes of punishment: Eve's holding the baby Cain, Adam's toiling in the soil, and Cain's banishment. Eve's and Adam's punishment for disobeying God is linked with Cain's punishment for murdering his brother. Eve will give birth in pain and Adam will toil for his food (Genesis 3:16–19). Cain will wander as an outcast (Genesis 4:9–16). The placement of the "worldly" Eve, the hard-working Adam at his plow, and Cain links them to the pain and toil of life outside of Eden.

Appearing twice in the green swathe, the adult Cain now appears alone without his brother. In all the other vignettes, Cain and Abel are shown paired: the two separate booths, the offerings, the rejection of offerings, and their callings as shepherd and farmer. If the reward for disobedience is pain, toil, and death, what is the reward for obedience? What has Abel reaped for his unblemished offering?

In Abel's place next to Cain, who bends backward and throws up his hands, is the fruitful palm. The palm tree acts as substitute for Abel and is, as will be shown, a signifier of both paradise and martyrdom. Thus the palm recalls to the mind that Abel's reward, as the first martyr, is heaven.

The palm tree calls attention to itself because the artist normally depicts vegetation in a stylized manner customary for sixth-century art;[33] this type of simplified tree is depicted, in two versions, at the bottom of the page. The date palm does not appear in any of the other surviving illustrations, suggesting that it was not used as decorative filler, as stylized trees typically fulfill that function. The palm tree as a sign of paradise had enjoyed a long artistic tradition on a variety of media, so it is doubtful whether it would appear randomly and without significance in an early medieval illustration.[34] Especially notable is the association of the palm with deceased saints who have achieved their reward in the heavenly Jerusalem.[35] Jesus himself relates that Abel's blood was that of a martyr.[36] John Chrysostom reports that in Abel, the first mortal to suffer death,[37] Christians learn that God takes the just to heaven. This linking of saints, palms, and paradise was a well-known apsidal theme in Italy and especially in Rome.[38] The palm tree as a signifier of paradise was also popular in funerary art in Rome and Ravenna.[39]

Palms were also used in scripture to illustrate a moral. Psalm 91(92) contrasts the evildoers who will be scattered and "The righteous [who] flourish like a palm tree."[40] This psalm is referred to in Matthew 12, where Jesus refers to good trees and bad trees as a metaphor for good and evil men.[41] Eucherius in his handbook for interpreting scriptures reiterates the symbolism of the palm as indicating the victorious martyr and the just man.[42] The contrast between the straight palm tree and the bent figure of Cain echoes the psalm and the parable. Abel was taken to paradise after his martyrdom, while Cain was cursed and forced to wander

in the wilderness, one of the evildoers who is scattered without protection.

The significance of the palm tree was not lost on the maker of the Moutier-Grandval Bible, which was produced in the ninth-century scriptorium at Tours where the Ashburnham Pentateuch was kept (Fig. 18). On folio 5v, in the second register, the fruit-ful palm tree is placed to the right of the figures of Adam and Eve, who are reproached by God. In this illustration as well, the palm is the only identifiable tree, as the others are stylized repre-sentations. The placement of the snake between Adam and Eve and the tree suggests that the palm exemplifies the paradise that is lost.

The wheat ripening in the lower right corner of the page con-tinues the theme of reward and punishment. Placed directly below Cain tilling in the fields, it provides a visual clarification on Cain's work and the fratricide to the left. The field of wheat solicits in-terpretation that is due to the amount of space dedicated to a seemingly innocuous grain.[43] Compare it, for example, with the mosaic of Lord Julius from Tunisia.[44] In the upper right of the mo-saic another field of wheat ripens. Although occupying a smaller portion of the composition than the wheat in the manuscript, Julius' wheat is not a decorative motif but an indication of the seasonal activities for the *dominus* of the estate. The grain is an indicator of wealth and seasonal cycles.[45] Considering the promi-nence of the wheat in the page and the prominence of the wheat metaphor in contemporary literature, it is sensible to pursue the potential of this motif as a bearer of multilayered meaning.

Augustine in his catechetical instructions repeatedly refers to wheat and chaff as signs of the believer and the unbeliever.[46] In the New Testament chaff symbolizes those who are burned as worthless after the righteous [wheat] are gathered into the granary.[47] Eucherius expands on the metaphor in his handbook of scriptural symbolism. According to Eucherius, the harvest is the faithful gathered into bundles and brought to the Church, which is the threshing floor where the tares, or sinners, are separated from the God's elect, the wheat.

The harvesting motif and the bundles of wheat, with a venerable tradition of association with the dead, also have funerary implications. Bundles of wheat are, for example, a prominent decorative device on the ceilings of the Via Latina catacombs.[48] No doubt it was a reminder that the Christian dead are like wheat gathered to their heavenly reward. Christians are encouraged to be wheat, not chaff, a metaphor that permeated the catechisms, biblical stories, and homilies.[49] The lowly grain may indicate only a decorative motif to the modern viewer, but it seems to have held an important truth to the early medieval viewer.

In the Ashburnham Pentateuch, the seemingly inconsequential details – booths, rich clothing, wheat, palms – are actually visual clues that help an audience, steeped in folklore tradition and pictorial conventions of the time, interpret the story. Abel's death by the hand of his evil brother is not the end of the story as it is related in Genesis. The wheat and the palm assure the viewer that Abel, because of the righteousness of his offering, is one of the faithful gathered to his heavenly reward.

Jacob and Esau

In the page illustrating the story of Jacob and Esau, the artist has taken a different tactic from the Cain and Abel page, although the principle of juxtaposition and detail remains key to reading the scenes. The color backgrounds are particularly unusual for the illustrations on folio 25r (Fig. 13). The color areas are not horizontal, suggesting registers, but irregular in formation, suggesting intention. The complete breakdown of the register format is especially evident in this illustration. The red frame surrounds a green background color out of which three interior spaces emerge. The traditional register format is abandoned, and swathes of color direct our understanding. The reading of the scenes in biblical narrative order is difficult to maintain throughout the page because the color swathes, once again, array the scenes out of chronological sequence.

Although the biblical text states that Isaac pitched his tents in a place called Beersheba, named after a nearby well (Genesis 26:23), the artist chose to depict the story of Jacob and Esau against an expansive and detailed architectural setting, which is in conflict with the wilderness setting outlined in the biblical text. Domes, gables, tiled roofs, colonnades, marble columns, tiled roofs, and wooden doors create a stage for the figures. Most of the scenes take place within this architectural frame. The use of architecture as a framing device is unlike contemporary, surviving representations of cities; miniature, self-contained walled cities are found

throughout late antique art. This type is also found on folio 18r in the Ashburnham Pentateuch. Sodom and Gomorrah, depicted as small walled cities, are engulfed in flames (Fig. 20).⁵⁰ The majority of the architecture in the manuscript, however, frames and acts as a setting. The stories unfold as if on an elaborate architectural stage. Because of this cityscape backdrop, the stories are urban in character rather than pastoral.

Framed by white architecture [*bersab[e]e*], the brown backdrop contains four episodes that move from left to right. On the far left, Rebecca [*Rebecca*] eavesdrops on Isaac instructing Esau [*Esau*], who wears a brown tunic, to hunt for venison [*Isac dicit ad Esau tolle arma tua et vener[e] et fac mihi cibos ut comedam*]. Rebecca [*Rebecca*] then bids Jacob [*Iacob*], who wears a white tunic, to obtain the blessing instead of his elder brother Esau (*hic Reuecca dicit ad Iacob fac cibos patri tuo ut comedat et benedicat*). Moving to the right, Jacob serves Isaac the savory dish and then receives the blessing from Isaac (*Isac Iacob indutus pelle*).

The second grouping of scenes is also placed within a white architectural frame, but against a salmon-colored background. Jacob, clad in his white tunic, carries two black kids for the pot that Rebecca [*Reuecca*] is stirring [*hic Iacob ubi tulit duos edos de caula ut faceret cibos patri suo*]. Below is a brick-walled pen containing sheep and goats. To the right, Isaac gestures to Esau who brings in his dish which will be rejected [*sed et adtulit [fi]lius suus Esau cibos ut comedat postquam ei adtulit Iacob et benedixit ei*]. Below, Rebecca [*Reuecca*] and Isaac send Jacob away, fearing Esau's wrath, and urge Jacob to find a proper wife among his mother's people [*Isac dicit ad Iacob fuge ad laban ab (Esau)*].

The final group is placed against a green backdrop containing minimal reference to architecture. Walking in from the right margin, Esau carries a slain deer on his shoulder [*Esau uenit de uena(tione)*]. He then cooks the venison for his father, Isaac [*Esau coquet patri suo comedat*]. Below, Jacob dreams. The angel ascends and descends [*hic angeli[i] ascendunt et descendunt et in caput sca[lae] dnm innixum*], and the head of God is contained within a blue swathe of color at the top of the ladder. Finally, Jacob, turning back with his head while pointing ahead with his hand, walks out of the red frame and into the wilderness of the margin to join his kinsman in the country [*hic Iacob fugit ad laban*].

The biblical narrative is intentionally interrupted; Jacob feeding Isaac and receiving the blessing, for example, should either follow Rebecca stirring the pot or these two scenes should be grouped together. The artist has chosen to follow neither pattern, suggesting that chronology, or biblical narrative, is not the underlying motivation for the placement of scenes.

As in the story of the first two brothers, Cain and Abel, the illustration directs our viewing by color groupings, by juxtapositions, and by visual signs.[51] The central scenes, delineated by the salmon color, are once again a conspicuous comparison of two disparate brothers: Esau and Jacob.[52] Paired together, one above the other, the posture and dress of Isaac are identical in both episodes; only the position of Isaac's hand is varied, a telling detail. Attention is drawn to Isaac's two hands because they are disproportionately large for his body.[53] Isaac raises his hand to reject Esau's dish, and below he sends Jacob away with his blessing.[54] The hand gestures are a meaningful mechanism for correctly interpreting the

FIGURE 23. Separation of Sheep and Goats, sarcophagus lid, New York, The Metropolitan Museum of Art. (Rogers Fund, 1924 [24.240])

narrative. The key is Romans 9:13, in which St. Paul quotes Malachi 1:3: "Jacob have I loved and Esau I hated."[55] The page is a complex visual acting out of this theme.

Within the salmon-colored group, the brick pen occupies fully one quarter of the compositional field. Curiously, the pen contains three black goats, two brown sheep, and four white sheep. The juxtaposition of sheep and goats, especially black goats, suggests the parable of the blessed and the damned (Matthew 25:32–33).[56] The parable, which is interpreted as a metaphor for the Last Judgment, is given its fullest visual expression in a sarcophagus lid from Rome (Fig. 23). Christ, flanked by processions of goats and sheep, raises his left hand to reject the goats and lowers his right hand to bless the sheep.[57] This same emphasis on hand gestures to imply spiritual status is found in Paulinus of Nola's written description of the apse painting in the basilica at Fundi, halfway between Naples and Rome. Paulinus emphasizes that Christ welcomes the lambs with his right hand and turns aside the goats with his left.[58]

Within the salmon-colored grouping in the Ashburnham Pentateuch, Isaac is shown with similar gestures. As in the sarcophagus

where Christ's gestures are pivotal, so also in the manuscript Isaac's gestures tell the story. By circumventing the chronological, or textual, sequence of the scenes, the illustrator is able to create a meaningful juxtaposition between the two brothers.

Expounding on this story of two brothers, John Chrysostom finds that the moral lessons are plentiful. In the biblical text, it is never clear whether Jacob is acting morally or reprehensibly by deceiving his father and stealing his brother's blessing. No such ambiguity is allowed, and all is made clear in the retellings. Once again, the opposing dyad of two brothers provides the structure. John Chrysostom contrasts, with great relish, the behavior of the two brothers: From Jacob a child learns to strive for his father's blessing, to despise the belly, and to obey his parents by making a proper marriage. From Esau, on the other hand, a child learns the foolishness of greed, the wickedness of hatred, and the folly of marrying against a parent's wishes.[59]

The story of Jacob and Esau, as retold in exegetical literature, is about making unwise decisions.[60] Ambrose, in his letter to the Church at Vercelli, portrays Esau as a lover of leisure and food, rather than the virtuous and hard-working Jacob who dutifully followed his mother Rebecca's plan.[61] Rebecca's plan of deceit is actually God's plan to bring about his chosen people. Caesarius of Arles, in a Lenten sermon on the lesson for the day, argues that Isaac and Rebecca are symbolic of Christ and the Church who give birth to two types of Christians. The good Christians are like Jacob, who is humble, chaste, meek, kind, and merciful. The bad Christians are like Esau, who is proud, adulterous, angry, and envious.[62] Isaac's two gestures of acceptance and rejection, placed

one above the other, suggest to the viewer that Jacob receives his father's approving hand, but Esau his father's disapproving hand.

Another conspicuous juxtaposition that bears out this theme of Jacob as the good brother relying on God, as opposed to the evil brother relying on worldly things, is found on the right half of the page. The relationship of Esau and Jacob to the right margin of the page is a curious one, but shows how the artist has fully used the visual props to tell this morale tale. Esau, in the middle right, strides in from the margin wearing his large sword and proceeds to cook up the slain deer. Curiously, he is isolated from the other figures by the small, independent architectural structure. He is, literally and figuratively, alone and self-reliant. Jacob, on the other hand, is sent out by his father into the wilderness without human aid. Without weaponry and wearing only his blue cloak, he must rely on divine help – his needs will be met by God. Jacob's dream, in which angels from God descend and ascend a ladder, demonstrates that Jacob has received the aid of God. In other words, Jacob does not rely on human agency, but on divine. The artist, through the language of color, gesture, and counterpoint, constructs comparisons and provides clues to discern Jacob's good to Esau's evil.

Conclusion

These simple stories provide a wealth of detail and visual exegetical material that directly parallels the literary exegetical traditions of teachers such as Augustine, John Chrysostom,

Eucherius, and Gregory the Great. The exegesis is not profound in its theological implications, such as the nature of the Trinity, but rather it is useful for the clergy who must instruct their parishioners in the meanings of these Old Testament stories. The pictures, when placed within the context of contemporary artistic conventions and signs as well as the textual tradition of instruction, provide a window into the pastoral concerns of the early medieval Church.

5

The Italian Origin Considered

DEMOVIT DOMINVS TENEBRAS VT LVCE CREATA HIS QVONDAM
LATEBRIS SIC MODO FVLGOR INEST ANGVSTOS ADITVS
VENERABILE CORPVS HABEBAT HVC VBI NVNC POPVLVM
LARGIOR AVLA CAPIT ERVTA PLANITIES PATVIT SVB MONTE
RECISO ESTQVE REMOTA GRAVI MOLE RVINA MINAX PRAESVLE
PELAGIO MARTYR LAVRENTIVS OLIM TEMPLA SIBI STATVIT
PRETIOSA DARI MIRA FIDES GLADIOS HOSTILES INTER ET IRAS
PONTIFICEM MERITIS HAEC CELEBRASSE SVIS TV MODO
SANCTORVM CVI CRESCERE CONSTAT HONORES FAC SVB PACE
COLI TECTA DICATA TIBI[1]

Rome in the Time of the Great

The history of Rome in the sixth and seventh centuries, as related in existing textual documents and in less recent modern scholarship, is a bleak picture of the Gothic Wars, famine,

plague, and death. For artistic production, modern art historians paint an even bleaker picture; the sixth and seventh centuries in the Latin West are often characterized as a period of stagnation between late antiquity and the reforms of the tenth century when art and architecture are once again on the ascendancy. Without doubt, there is little that survives that would rival the artistic production of the courts of the late Roman emperors or even those of the Carolingian emperors, but this should not overshadow the artistic and literary output that did occur. Richard Krautheimer's highly influential *Rome: Profile of a City* (1980) continues to characterize for modern scholars an early medieval Rome that was almost abandoned, whose infrastructure was crumbling through neglect, a once-glorious city that was at the nadir of its 1000-year history. Particularly damning for Rome in the time of Gregory the Great is Krautheimer's use of sketches and prints that "illustrate" the floods and the *disabitato* of the late sixth century. Unfortunately, Krautheimer's use of sixteenth- and nineteenth-century prints for his illustrations are accurate portrayals of only an abandoned and flooded Rome 1000 years in the future, but these prints tell us nothing of Gregory's Rome. Krautheimer's profile for the city follows an organic, or biological, model – births, declines, renascences, rebirths – a model that needs great lows in order to achieve great heights. This is not to say that Rome was not under great economic and political stress, but rather that the city, despite its troubles, remained capable of remarkable achievements.[2] Within the past twenty years, scholars have revisited early medieval Rome and have given a very different, more balanced picture than that described by earlier scholars.

Since the 1980s archaeologists working in Rome and its surrounding areas have uncovered material remains that challenge Krautheimer's "picture of utter shabbiness," indicating that a reassessment of early medieval Rome is much needed.[3] Recent work has disputed the notion of the *disabitato*, in which major sections of the city were completely abandoned and settlements huddled in the Campus Martius area around the bend in the Tiber River. Rather, excavations and a reassessment of the literature suggest that secondary dwellings – homes, rentals, hostels, monasteries – grew up around the churches that were scattered throughout the city; more like a loosely connected parish system than wholesale abandonment of the city.[4] In the light of this, the population estimates most frequently cited, a low of 10,000 during the Gothic Wars and an increase to 90,000 that was due to the pilgrims swelling the city of Gregory I, need to be seriously questioned. These numbers, which most scholars quote from Krautheimer's *Profile*, were derived, as Coates-Stephens has noted, from the Instituto della Enciclopedia Italiana.[5] I point this out, not to criticize Krautheimer's use of their numbers, but to raise a red flag about out how readily one can accept population figures, which are nebulous at best in a city that seems characterized by a fluid population of pilgrims.

Archaeologists are not alone in altering the perceived landscape of Rome in the sixth and seventh centuries. The late James McKinnon, in his posthumously published *magnum opus*, outlines a groundbreaking theory on the origins of Gregorian chant and the vibrancy and vision of the men who laid the foundation for the establishment of the *schola cantorum* in the first half of the seventh century. Taken collectively, the work of musicologists and

archaeologists have begun to fill in some of the lacunae, thereby yielding clues toward a dramatic alternation in the portrait of Rome and its suburban territory so eloquently, yet so erroneously, outlined in one short chapter in Krautheimer's book.

An important question for my Italian thesis is whether Italy, and especially Rome, had the resources – that is, the economy, culture, and patronage – to produce a manuscript such as the Ashburnham Pentateuch in the years at the close of the sixth century and the beginning of the seventh. I believe that it did have these resources as well as a tradition of narrative painting that was unprecedented in other regions of the Latin West. I question a prevailing trope among art historical narratives that only politically and economically stable centers with recourse to vast discretionary funds produce great art. Although it is indisputable that there are periods of great patronage when the arts flourish, it is not true that periods of economic and political duress do not produce art. Medieval Italy, in particular, seems vulnerable to this type of marginalization, sandwiched as it is between the Empire and the Papal Renaissance. The premise assumes that artistic or literary endeavor is relegated to an arena of leisure and luxury. Despite overwhelming pressures in sixth- and seventh-century Italy, literary and artistic production did not cease. The tale of a notary in Naples is a case in point. In December of 582 A.D., even as the Lombards besieged Naples, the scribe Peter of the Neopolitan Cathedral corrected a new edition of the *Excerpta* by Eugippius from Augustine's letters.[6] For Peter, who records the siege in a colophon, the work of God was carried out despite the enemy at the gates of the city.[7]

Building Activity

Although the periods before, during, and after Gregory the Great's papacy, are represented as a period of decline, stagnation, and destruction in the art historical scholarship to date, I should like to examine more closely the architectural, artistic, and literary culture of Rome between the papacy of Pelagius II (579–590) and Honorius I (625–638). My choice of the careers of these two popes as historical bookends of patronage lies in the fact that their building projects are firmly attested to in both literary sources, such as the *Liber pontificalis*, and archaeological data. My assumption is that, where there is building activity, there is secondary artistic activity in such areas as inscriptions, mosaics, frescoes, and church furniture; an assumption corroborated by the surviving remnants of mosaics and marbles.

Ironically, Krautheimer's magisterial corpus of early Christian building in Rome provides both literary documents and material remains that attest to the building activity in Rome between Pelagius II and Honorius I.[8] Pelagius ascended to the bishopric of St. Peter's during the height of the Lombard offensives, reminding us that sieges, famines, flood, and plagues were sporadic in Rome during this period, one which was, however, equally punctuated by building activity and artistic endeavor. Beginning in 585 A.D., a four-year truce with the Lombards no doubt provided an opportunity to erect the eastern basilica of S. Lorenzo fuori le mura.[9] A new structure was needed because of the collapse of a hill over

the site and the desire for better access to the saint's tomb. The new structure was a three-aisled single-apse basilica with galleries that measured 31.7 m × 20.65 m. The inscription, which was once over the apse, states that Pelagius' new basilica, built on the insistence of the saint, brings light where there was once darkness and beseeches St. Lawrence to bring peace to a people besieged by hostile armies. The mosaic around the triumphal arch remains intact, but the apse mosaic is now lost and its subject matter is unknown. Despite the hostilities and their concomitant strains on the city's resources, the great deacon saint of the city exhorts the people to continue their building activities for the saint and the accommodation of pilgrims coming to the saint's shrine, a shrine that will bring peace to a troubled city.

Krautheimer has also identified an active workshop of masons who laid pavements in S. Lorenzo fuori le mura and whose work can be found in S. Crisogono (after 500), S. Clemente (523–526), S. Maria Antiqua (after 563), and Ss. Quattro Coronati (late sixth to early seventh century);[10] if Krautheimer is correct, his findings indicate at least one Roman workshop that enjoyed a 100-year period of employment. Pelagius is also credited with substantial alterations of S. Ermete.[11] By the late sixth century, St. Hermes replaced St. Basilla as the primary martyr saint, and an older structure was altered to create a basilica ad corpus, whose three bays created a rectangular hall. Cultic necessity seems to have motivated Pelagius to promote building activity on both a large and a small scale.

Gregory of Tours writes in his *Historiae Francorum* (10.1) that, in 589 A.D., when the Tiber River overflowed its banks in a flood

of biblical, diluvian proportions, the city of Rome experienced a subsequent plague that brought about the death of Pelagius II.[12] The young Roman deacon Gregory was elected pope and immediately organized a legendary procession of prayer and penitence. Not enough emphasis has been placed on the apocalyptic nature of Gregory's writings and the impact they had on our perceptions of the cultural picture that they sketch out for this period. Robert Markus has astutely observed that Gregory saw himself in Augustine's sixth age, an age of preparation for the end of time and a time at which security was not guaranteed in this life.[13] War, plague, famine, and death were the harbingers of the end of time and a call to repentance and penitence; thus, the darker the picture, the faster the approaching end. To speak of church building and to commission large public works of art would seem inconsistent with the preparations for the end of the world. Thus Gregory speaks of desolate fields, ruined monasteries, wild beasts roaming, and empty towns in order to indicate that the end of the world is not a remote event in the distant future, but one that is already upon them. In Gregory's imagination, populated with burning churches, there is little scope for church building. Archaeological evidence, however, indicates that Gregory was involved in the patronage of art and architecture, thereby reminding us that a balanced picture is necessary that considers the apocalyptic tenor of Gregory's writings with the fact of his commissions and projects that were firmly rooted in the needs of the times. Here, archaeological evidence is perhaps a better indicator of the health of the material culture of the times rather than Gregory's dire observations of a world coming to a close.

Gregory's efforts at welfare and provision for the citizenry of Rome is legendary, but less well known are the *diaconiae*,[14] or ecclesiastical welfare centers, which are an architectural hallmark of this period. Attributed to this period are the *diaconiae* of S. Maria in Cosmedin, S. Teodoro, S. Giorgio in Velabro, and S. Maria in Via Lata.[15] S. Maria in Cosmedin was an early (ca. 550) and relatively simple structure with a single hall flanked by low rooms or aisles on either side, and measured 17 m × 7.4 m.[16] S. Teodoro, at the foot of the Palatine Hill, was a sizable structure based on the apse, which is the only surviving piece of the *diaconia*.[17] Marble revetments are all that remain of S. Giorgio, located near the Forum Boarium.[18] A Roman granary made the transition to Christian *diaconia* at S. Maria in Via Lata when cellae were joined together and an apse added to two parallel halls.[19] Murals decorated the interior, where an early seventh-century fragment of the Seven Sleepers remains visible.

The ability of the newly established *diaconiae* to feed the hungry of Rome was no doubt linked to the persisting capability of Rome to maintain, although less robustly, its trading ties to Sicily, Sardinia, Northern Africa, and the Eastern Mediterranean.[20] On the feast days of Easter, St. Andrew, the Holy Apostles, and Gregory's own feast day, charitable gifts were distributed to the citizenry. On the first Sunday of each month, fish, oil, wine, cheese, bacon, meat, and vegetables were doled out to the poor, while the rich received luxury goods and pigments.[21] The list of goods distributed indicates not only foodstuffs from the environs of Rome, but also the importation of luxury goods into the city and hence available economic surplus of the kind that might also be directed

toward artistic production. The reference to pigments is ambiguous, perhaps referring to fabric dyes or to pigments for art production; nevertheless, a system for the acquisition and disbursement of these types of goods is indicated. At a time when other urban centers were developing new regional sources of food supplies, Rome continued to import from around the Mediterranean until the middle of the seventh century.[22] Archaeological excavations at the Crypta Balbi on the Campus Martius revealed a great number of glass, metalwork, gems, ivory, and bone artifacts that demonstrate a large and active workshop producing high-quality items from raw materials imported into the city.[23] As archaeologists continue to unearth new evidence about Rome in the early medieval period, the notion of an idle, if not broken, city without economic, artistic, and trading mechanisms will have to be constantly recalibrated.

At the instigation of Gregory, significant structural alterations were made to both S. Pietro and S. Paolo fuori le mura.[24] At S. Paulo archaeological evidence shows that the transept level was raised 90 cm over that of the nave and aisles, which essentially buried the shrine, necessitating the need for a crypt. At S. Pietro the new sixth-century annular crypt drastically altered the approach and access to the shrine,[25] requiring a remodeling of the transept and the architectural features around the shrine. In addition to these improvements at the large basilicas, less radical alterations were also made at S. Crisogono, where the east end was altered by the addition of a rectangular choir area, along with minor changes to the confessio.[26] New architectural construction took place at the martyr's shrine of S. Pancrazio, where the monastery of S. Vittore was built near the small church built by Pope Symmachus

(498–514).[27] In 594 Gregory seems to have given the small church over to the Benedictines, and it is from here that he preached one of his homilies.

Pope Honorius (625–638) not only continued the embellishment of S. Pietro, but also undertook the complete renovation of S. Agnese fuori le mura, and erected a new, large basilica, S. Pancrazio, which replaced Symmachus' small and cramped church at the martyr's tomb. At S. Pietro, sixteen large roof beams were installed, presumably to replace those in need of repair. The resources needed to replace the huge timber beams indicates that levels of technical skill remained high.[28] Expensive metalwork trappings were added in the form of bronze tiles for the roof and a silver covering for the main door.[29] Inscriptions found at the north and south doors suggest not only mosaic decoration associated with Honorius' patronage, but also a gilded roof.

Pope Honorius sponsored the complete renovation of S. Agnese fuori le mura, which replaced the older basilica ad corpus, on the Via Nomentana.[30] The three-aisled basilica had galleries on its upper levels, which were decorated with sculptured parapets. Spolia, notably porphyry and fluted marble columns, were used in the upper gallery arcades. Including the narthex on the west end, the basilica measured 25.58 m in length.

The most ambitious project was the building of the new S. Pancrazio, a basilica whose size, 55 m long, recalls the great late fourth- and fifth-century basilicas such as Santa Sabina, S. Clemente, and S. Pietro in Vincoli.[31] This is a significant shift from contemporary building practices because smaller foundations and renovations to existing structures mark this period.[32] S. Pancrazio's relatively large

size was necessary to accommodate pilgrims who came because of the increasing importance of the saint's tomb in the sixth century; such ambitious projects are indicative of an optimistic patron who was able to meet the challenges of the day. The church's floor plan seems to have deliberately referenced the great basilica of S. Pietro, both in its floor plan that included an annular crypt, no doubt borrowed from Gregory's renovation, and a transept that emulates the fourth-century footprint of the basilica. Despite the almost complete destruction or loss of any decoration or church furnishings from S. Pancrazio, the degree of the scale of this building project would suggest with some certainty that the church was outfitted with proper furnishings and wall decorations, whether the less expensive fresco or the more costly mosaic.

Less ostentatious construction took place in the early part of the seventh century with the more imposing renovations and constructions of the large basilicas. Although its origins are obscure, Krautheimer has assigned the small convent of S. Maria in Tempulo to the first third of the seventh century.[33] The only claim to fame for this humble house was that it reputedly owned a seventh-century copy of the famous Hagiosoritissa icon from Constantinople. Although the style of masonry suggests a date contemporary with the Honorius' building projects, the plan of SS. Nero ed Achillo ad Via Ardeatina suggests an earlier date in the late sixth century.[34] The surviving record of building and remodeling suggests that, when necessary, large building projects could be undertaken, such as when the popularity of a martyr's cult demanded larger structures to accommodate pilgrims. Most of the well-established cult basilicas, such as those for St. Peter

and St. Paul, had large structures that were adequate to house the early medieval pilgrims, so new construction would not have been necessary, only renovations and upkeep. The dominant pattern of erecting smaller structures, while maintaining and renovating the larger edifices of an earlier papacy, indicates a need to serve monastic communities, and the deacons who ran the welfare centers. The cases of SS. Lorenzo, Agnese, and Pancrazio, however, show that when the cultic need arose for larger structures, the resources of Rome were often adequate to meet the demand.

To augment the renovations and new construction, some ancient buildings were converted into churches, thus adding to the body of religious architecture in Rome.[35] The most famous are the conversion of Gregory's family *domus* into the monastery of St. Andrews and the Pantheon that was rededicated to S. Maria ad Martyres (609). Gregory's home, whose early foundations dated to the first century C.E., was one of several homes converted to churches; Pope Honorius I would follow this practice by transforming his ancestral home into the monastery of SS. Andrea e Bartolomeo. The Curia Julia, or Curia Senatus, was converted into S. Adriano al Foro Romano sometime between 625 and 630. The secular public buildings may have been allowed to fall into disrepair, but those converted into churches were well maintained, as were the great fourth- and fifth-century basilicas.[36]

As already noted, the renovations and new construction would have spawned an accompanying artistic production of secondary work in frescoes, and mosaics. Of frescoes there is next to nothing that survives, but the more durable, and more expensive, mosaic does survive in a quantity and quality that hints at what was

possible in this period. Frescoes from a slightly later period, ironically, do bear witness to the rich church furnishings that could be expected in these early Roman churches in the form of textiles.[37]

San Lorenzo fuori le mura retains its beautiful triumphal arch mosaic, depicting Pelagius, without a nimbus, offering a model of his new church to Christ.[38] St. Lawrence and St. Peter usher him into Christ's presence. On Christ's left stand St. Paul, St. Stephen, and St. Hippolytus. Below, the cities of Jerusalem and Bethlehem flank the triumphal arch. Although some of the figures display a tesserae technique typically associated with eastern mosaics, the figures of Hippolytus and Lawrence, as well as the festoons of flowers, fruits, and vegetation, are in a Roman technique, characterized by the use of glass and a more loosely composed arrangement.

Despite heavy restorations, the mosaics in the apse of S. Teodoro that do survive attest to a high quality of workmanship in the late sixth century. The heads of Sts. Peter, Paul, and Theodore have been closely associated with both the apse mosaics at SS. Cosma e Damiano and S. Lorenzo fuori le mura.[39] A similar combination of eastern and western elements are found in the mosaics from S. Agnese fuori le mura, where the overall composition arranges the figures of Pope Honorius I, St. Agnes, and Pope Symmachus in symmetrical isolation, and the figures themselves are rendered in a graceful naturalism.[40] The vibrancy and high quality of mosaic workmanship continues into the seventh century with the mosaics in the chapel of S. Venanzio, in San Giovanni in Laterno.[41] Cecelia Davis-Weyer has noted that, of the surviving mosaics from this period, no two mosaics can be identified as coming from the same workshop. A limited number

of workshops can be established in the later seventh century, a fact that she interprets as indicating a number of mosaic workshops that were active in this early period.[42]

Manuscript Production

L ike architectural and mosaic enterprises, manuscript production did not stop in sixth- and seventh-century Rome. Manuscripts from Rome were in demand because of its role in disseminating books requested from Spain, Gaul, and England, particularly the works of Gregory the Great. It is reasonable to assume that at least some of these requests were fulfilled by books made in Rome, rather than a plundering of the papal library's precious resources without any renewal of its collections. Gregory the Great's letters are a valuable source for these types of book requests. Gregory had a habit of expressing allegiances by giving books to women in positions of influence. He sent Queen Brunhilde a volume, the type is not spelled out in the letter, which she was to pass on to the priest Candidus.[43] Gregory also gave Queen Theodelinda a Gospels book, bound in a Persian case [*Lectionem sancti evangelii theca persica inclausum*].[44] Although some scholars have been tempted to associate the gold covers adorned with semi-precious stones and antique cameos, now in the Monza treasury, with the case described in Gregory's letter, it seems unlikely.[45] The term *theca persica* is most simply translated as a walnut box.[46] Paul

the Deacon states that Theodelinda received, in addition to this Gospels book, a copy of his *Dialogues* from Gregory.[47]

Gregory's same letter states that the queen also received three rings with semiprecious stones from Gregory as a token of his esteem. Here it is difficult to determine if the rings were part of the treasury of gifts to the popes or created in a Roman workshop for the express purpose of a gift to the queen. This gift may be an extension of the types of largesse given by Gregory to the wealthier citizens of Rome. As discussed previously, Gregory had at his command the considerable resources of the Mediterranean, both through trade and through gifts brought to the city of Sts. Peter and Paul. An inscription, for example, in the Monza cathedral records states that a priest named John brought seventy lead ampullae, collected from the tombs of martyrs, to Rome, which Gregory in turn sent on to Queen Theodelinda as a gift. The relic status of the ampullae could not be created in Rome and may have been part of Gregory's willingness to export material relics rather than the bodies of the Roman saints.[48]

The demand for books, particularly those patronized by Gregory for consolidation of his political alliances, would suggest the presence of a support network that met the demand.[49] During his own lifetime requests came in for his *Moralia in Iob*. The African Innocent, for example, requests a copy of his commentary, although Gregory humbly replies that Augustine may be a more suitable and inspiring distraction from secular cares.[50] His friends Liciman and Leander received copies of Gregory's books that were shipped to Spain at their requests.[51] On the other hand,

Taio of Sarragossa, writing to his fellow bishop Eugenio, complains that he was unable to obtain the necessary works by Gregory the Great.[52] The interest in Gregory's library, however, remained consequential as it is listed in the Einsiedeln Itinerary as one of the points of interest on a tour of Rome's great sites.[53]

Those requests that were fulfilled indicate that exported books served two purposes: to further the cause of Orthodox Christianity, as in the case of the queens, and to further learning, as in the case of his Spanish and African friends.

Gregory's literary output was not the only genre that required the production of codices. The very necessity of administering the city and the holdings of the papacy ensured the demand for manuscripts and *libelli*. Although the traditional classical education and literati of the Roman Empire may have been eclipsed, the work of lawyers and doctors remained intact, if much diminished.[54] Salaries were still paid to lawyers, doctors, and teachers of rhetoric and grammar. Right into the seventh century, literary gatherings took place in the Forum of Trajan.[55] If paleographers are correct, the elegant manuscripts of Canon (Oxford, Bodl. e museo 100–102) were copied around 600 in the city of Rome.[56] The businesses of law, medicine, and teaching were part of the daily life of the city.

Scholars of the Old Testament Vulgate agree that, until the eighth century when production lessened, Italy was the source for good copies of the Vulgate.[57] Italian texts played an essential role in the transmission and dissemination of the Vulgate Old Testament to France, Spain, England, and, to a lesser extent, Ireland and Germany. We know that the Irish, for example, brought back books

from Rome in the early seventh century. Cummian's Irish delega-
tion of 631 A.D., in addition to determining the Catholic Church's
system for determining the Easter celebration, also brought back
relics and books from Rome. According to Cummian, the Roman
books and the relics performed miracles in Ireland, thereby testi-
fying to their God-given power and the prestige of their Roman
provenance.[58] It seems unlikely that the demand for manuscripts
could have been satisfied through pillaging of Roman libraries;[59]
thus, active scriptoria must be deduced.

The production and exportation of manuscripts from Rome
seem well established, although the existence of illuminated
manuscripts is harder to ascertain because of the scarcity of surviv-
ing materials, no doubt the result of a smaller number created. The
so-called St. Augustine, or Corpus Christi, Gospels have tradition-
ally been assigned to an Italian source,[60] a place of origin based
on paleographical evidence, that has remained undisputed.[61] The
Gospels book was in England by circa 700 and known to have been
at the monastery of St. Augustine's, Canterbury, by the first half of
the tenth century. Close stylistic links between the two manuscripts
are difficult to delineate, although the two manuscripts share gen-
eral affinities. Both manuscripts, as compared with contemporaries
from Merovingian and Insular scriptoria, are devoid of ornamen-
tation, eschewing elaborate frames and decorated letters and flour-
ishes. The emphasis in both manuscripts is on simple frames that
enclose densely packed narrative scenes. In each, bands or swathes
of color circumscribe individual narrative scenes; in the Corpus
Christi Gospels the color bands are more sharply defined, a hard-
ening of the technique found in the Ashburnham Pentateuch.

The two manuscripts, however, share an emphasis on lengthy narrative illustrations that is not found in western manuscripts until two centuries later, with illuminated manuscripts such as the Utrecht Psalter (Utrecht, Bibl. der Rijksuniver. MS 32).[62] Francis Wormald has surmised, on codicological and iconographical evidence, that the Corpus Christi Gospels originally contained as many as seventy-two scenes and three additional evangelist portraits, now lost.[63] Even so, it is a relatively modest accomplishment compared with the number of scenes in the surviving folios with illustration in the Ashburnham Pentateuch.

In the seventh century, documentary evidence indicates that Rome continued to be a center for the exportation of books, particularly to the British Isles. Bede (+735) documents six trips that Benedict Biscop undertook to Rome; his primary goal was to visit the tombs of the apostles and to procure books for the monasteries Biscop founded in 673 in Northumbria at Wearmouth and Jarrow. The trip to Rome was necessitated, states Bede, by the fact that Biscop could not obtain the books he wanted in Gaul [*nec in Gallia quidem reperiri valebant*]; when he stopped in Vienne he recovered some books he had purchased in Rome that he had left there for safekeeping.[64] Although Bede does not specify illuminated manuscripts, they are implied in the description of the walls of the churches and chapels of Monkwearmouth, which he stipulates were derived from the *picturas imaginum sanctarum* and *picturas sanctarum historiarum* Benedict Biscop shipped in from Rome. The most archaeologically sound explanation for these pictures would be illuminated books rather than panel paintings.[65] Extended narrative panel paintings on such as large scale do not

exist in the West until after the fall of Constantinople, when Italian artists adapted wooden panel painting from eastern sources; although it is an interesting, if fruitless, speculation to envision an early medieval Rome with workshops capable of producing works on a scale of Duccio's Maestà. Single panel paintings of an iconic type are known, though highly rare; for example, the miniature panel paintings of Sts. Peter and Paul from the Sancta Sanctorum treasury.[66]

From Bede's account we can deduce, if we set aside the notion of wooden panels, that Benedict Biscop, on his fifth trip to Rome, brought back illustrated series from the Apocalypse [*imagines visionum apolaypsis beati Iohannis*] and the Gospels [*imagines evangelicae historiae*]. On his sixth trip, he acquired paintings of the Life of Christ [*Dominicae historiae picturas*] and a typological series showing the concordance between the Old and New Testaments [*imagines . . . de concordia vteris et novi Testamenti*].[67] Whether the "sacred history pictures" were copied from a panel or a manuscript format, the fact remains that series of narrative paintings were found in Rome in the seventh century and Benedict Biscop benefited from this resource.

Although the documentary evidence states only that the pictures and books were brought back from Rome, it is likely that they were also produced in Rome. A different scenario would require that other hypothetical centers of manuscript and picture production were shipping books to Rome, where they were then distributed to other centers. In summary, the exportation of books from Rome, established from the period of Gregory I through the seventh century with the books acquired by visitors to Rome, such

as Benedict Biscop and Cummian, challenge prevailing claims to Rome's paucity of artistic production. The surviving archaeological record, in buildings and mosaics, and the continuing discoveries in the field, particularly in the area of trading ties to the Mediterranean, argue against Krautheimer's notion of an isolated, provincial backwater lacking in resources.

Music

Arguably the most outstanding, most resonant, and lasting achievement from early medieval Rome was chant. Significant strides have been made toward delineating the circumstances of the *schola cantorum*'s foundation and the dissemination of its music. James Dyer has made a convincing case that the papal school was not the brainchild of Gregory the Great, but rather was established sometime after the papacy of Gregory I and before the papacy of Adeodatus II (672–676).[68] The *schola cantorum* has its origins as an orphanage for boys, a charitable organization under papal patronage. The documentary evidence points toward a location at the beginning of the Via Merulana, between St. Mattheo and St. Bartolomeo. Dyer suggests that its transformation into a music school was due to the musical talent of the boys it sheltered rather than Gregory's ban on the singing of deacons, as some have suggested. Gregory's denial of the deacons to sing in the papal mass is an indication of their status, not an indication, as Dyer has argued, of Gregory's antipathy to music or deacons with fine

voices. Rather, the duties of the deacons, particularly the seven in charge of the regions and the stational mass,[69] were far too burdensome and vital for them to be wasting their time singing, when this could be done by clerics from the lower orders.[70] Like Dyer, McKinnon does not credit Gregory with the founding of the *schola cantorum*, but rather praises him for setting the social, political, and ecclesiastical groundwork that would allow the Roman Church to launch an ambitious project. McKinnon argues for an ecclesiastical prosperity and commitment, characterized by optimism and pride that could envision itself as a great center of liturgical enterprise.[71]

Before the founding of the *schola cantorum* in the first half of the seventh century, there is evidence that the great surge of musical ambition, as described by McKinnon, was not without its roots in the monastic choirs. Gregory of Tours' deacon, Agiulf, gives a dramatic account of the disastrous flood of 589 and the penitential procession Gregory the Great organized as his first act as the newly appointed bishop of Rome. Gregory arranged that choirs of clerics would sing for three days; at the third hour, all the choirs gathered, singing the *Kyrie eleison* as they processed through the streets.[72] The physical stress on these singers, as reported by Gregory, took the lives of eighty men, no doubt already weakened by the plague. Agiulf's story reiterates for us, as does Pelagius' inscription, the triumphal arch of S. Lorenzo fuori le mura, that in a dire moment when flood and plague had wreaked havoc in the city, the response was to seek the aid of the Roman saint and to gather choirs to sing God's praises, even at great personal cost. Although Agiulf's story is no doubt exaggerated by modern standards in order to convey

the disaster of the flood and the glory of Gregory's achievement, it is a cautionary tale in which, when read from a certain angle, the underlying resources in Rome are made evident.

In this rapid survey of early medieval Rome between the papacies of Pelagius II and Honorius I, I have attempted to gather disparate examples of what the city was capable of maintaining, restoring, building, and even initiating during a period of change and turmoil. In architectural activities, this period is characterized by renovation work and meeting the needs of the communities with smaller projects. Economically, the city remained an important trading center, as seen in such material remains found at the Crypti Balbi. Although sketchy, there is sufficient documentary evidence that Rome was looked to for books and was certainly a center for liturgical initiatives, particularly in church music. Although one must be cautious not to underestimate the strains on the city, it would also be erroneous to underestimate the tremendous accomplishments in this period when the clergy of Rome was laying the groundwork for later periods of prosperity and greatness.

6

An Italian Manuscript

―∞∞∞―

*The glorious library of a very great store of books which he
had brought with him from Rome (and which in regard of
instruction in the Church could not be spared) he commanded
to be diligently kept whole and complete, and not marred by
neglect, nor broken up and scattered.*

— Bede[1]

Paleographers, textual historians, and art historians have
struggled for more than 100 years, without a consensus,
to establish the origin of the Ashburnham Pentateuch.
The proposed places include Southern France, Spain, Northern
Africa, Syria, Dalmatia, Illyrium, and Northern Italy,[2] but the as-
sumption of a Spanish or Northern African origin has dominated.[3]
The Spanish origin has lingered by default in recent studies, as no
other origin has been put forward with any thorough discussion
of the evidence.

Similar methodological problems have weighed down the
search for an origin as the scholarship that sought to assign the
Ashburnham Pentateuch as a primary witness for illustrated, nar-
rative Jewish manuscripts. The dearth of comparanda has hindered

paleographers from constructing a framework of scripts that would allow a secure localization. The place of origin for many of these early manuscripts are often disputed, leaving a shaky scaffold on which to build an argument based simply on paleographic evidence. Art historians, especially in the early days of the Ashburnham Pentateuch studies, have tended to use the manuscript illuminations to construct stylistic or iconographical links that prove a larger theory. Hence the codex and its illuminations played a supporting role. One or two motifs, for example, hairstyles and architecture,[4] were excerpted out of the entire series of pictures. The illustrations lend themselves to this enterprise because they are so rich in pictorial motifs. The ability to find motifs that connect to various artistic traditions of the late Roman empire should, in fact, clue the scholar that the illustrations were at the hub of a fertile and diverse artistic center of many pictorial traditions. Italy, if not Rome, between the pontificates of Gregory I and Honorius I (590–648) offers this melting pot of various traditions because of its cultural heritage and its increasing importance as a pilgrimage center for the devout, who came from all corners of the Christian world to adore the relics *ad limina apostolorum*.[5]

Script

To date, there has been little success in assigning the script to any one center, let alone a region or country. Paleographical

comparanda are sadly lacking, hampering a truly thorough investigation of the script; furthermore, the few Latin manuscripts that do survive from the sixth and seventh centuries are rarely assigned an origin with any certainty. For his Spanish argument, for example, Samuel Berger cited "general" paleographic similarities between the Ashburnham Pentateuch and a seventh-century palimpsest of Augustine's *De baptismo parvulorum* (El Escorial, Camarín des las Reliquias S.N.) that he assumed was Spanish.[6] Berger's argument was brief and included such details as Spanish "betacisms" in the lengthy inscriptions that accompany almost every scene.[7] He further connected the two through the presence of the scribal term *contuli* [I have corrected].[8] In fact, the Escorial manuscript came to Spain from Hungary in the sixteenth century, and both Lowe and Bischoff were reluctant to localize it.[9] The correcting *contuli* seems,[10] on the other hand, to be a clue for an Italian rather than a Spanish origin; Lowe believed that the Tironian *contuli* indicated Italy.[11]

Most paleographers are reluctant to place the origin of the script to any one region, including Bernard Bischoff who, in one short sentence and without rationale, thought it possibly came from Spain.[12] Spanish paleographers also simply listed the Ashburnham Pentateuch as *Códices unciales de degura o posible precedencia espanola*,[13] again without any reasons for this assignment, except perhaps for scholarly trope. E.A. Lowe attempted the most serious study of the script and linked it, however tenuously, with the Valerianus Codex (Munich, CLM 6224) on the basis of similarities in the letters **a**, **B**, **g**, and **R**. He assigned the Valerianus Codex to North Italy or possibly Illyrium.[14]

The reluctance to assign this specific manuscript on the evidence of its script is but a microcosm of a larger paleographical impasse in early Latin manuscript studies. Only one manuscript is firmly assigned by a colophon to Rome, the two-volume homiliary (Rome, Vat. lat. 3835, 3836) copied by the priest Agimund at SS. Filippo e Giacomo in the first half of the eighth century,[15] nearly 100 years later than the Ashburnham Pentateuch. Although Petrucci in 1971 sought to gather a modest list of books and scraps he identified as Roman uncial,[16] a recent summarization by David Ganz does not commit to Petrucci's list, but rather, with characteristic caution, warns us that "...we must accept that we cannot readily distinguish manuscripts copied in other Northern and Central Italian centres."[17]

There is little reason therefore to look for a confident assignment of origin based on paleological evidence because of the scarcity of surviving manuscripts, the lack of consensus among paleographers, and the tenuous scaffold of securely assigned manuscripts on which to hang an origin. Indeed, the state of early medieval paleography is fraught with frustrating questions and open-ended origins that makes looking to scripts for answers a dubious exercise.

There are, however, general paleographical traits and characteristics that do link the Ashburnham Pentateuch to a group of manuscripts that are currently assigned origins to Italy, although even these are open to question. There are a number of manuscripts that have similar scribal characteristics that connect them to the Ashburnham Pentateuch, but the question of their origins remains

fluid until paleographic studies can be completed, if that is indeed possible.

In looking for comparanda, I limited my search to sixth- and seventh-century manuscripts that shared general characteristics found in the Ashburnham Pentateuch: generous spacing between letters; rounded, blocklike uncial letters, an avoidance of decoration in and around the letters, as well as the use of minium to begin the text sections. Approaching it as an art historian, rather than as a paleographer, I believe it seems sensible to start with a few stylistic guidelines before moving toward a more formal analysis of the manuscripts and their scripts.

A seventh-century palimpsest (Rome, Vatican, Reg. lat. MS 2077) of St. Jerome's writings against heresies shows a series of formal characteristics similar to those in the Ashburnham Pentateuch.[18] In both scripts the upper bow of **B** is left open whereas the lower bow is broad, the ascender of **L** is long, the bow of **R** is open, the descenders of **P** and **F** are also long and turn to the left in a flourish, and both scripts share the combination of leaving the eye of **E** either open or closed. The uncial script is assigned by Lowe as "probably Italy."

The less gifted scribe of London (Brit. Lib. lat. Add. MS 15350) shares similar habits with the Ashburnham Pentateuch scribe.[19] The loop of **a** is narrow and slanted and the **LL** combination is run together. Here too is found the combination of open and closed eyes in the **E**, the descenders of **F** and **P** that turn to the left, and the bow of **R** that is often left open. The beginnings of first lines are written in minium with an unpretentious initial. Lowe

assigns this seventh- or eighth-century script to an origin mostly likely found in Italy.

Although the scribe of Ancona (Arch. Capitolare MS S.N.) displays a more handsome and cleaner pen than that of the Ashburnham Pentateuch, the hand reveals similar quirks:[20] Most notably, the top, rounded sections of **M** in both scripts are often omitted, resulting in three "comma" marks to construct the letter. Here too the descenders turn to the left in **F** and **P**, the bow of **R** is open, the **B** is broad, and the loop of **a** is narrow and slanted. This sixth-century Gospel book (John is missing) is traditionally associated with St. Marcellinus, Bishop of Ancona (ca. 550).

Finally, Turin (Arch. di Stato, MS lat. IB.II.27) and Verona (Bibl. Cap. MS lat. XVII(15)) share only a few similarities to those just outlined.[21] The letters **P**, **B**, and **a** in the Turin manuscript share the characteristic markings of descenders that turn to the left, broad bows, and narrow, slanted loops with those found in the Ashburnham Pentateuch. **P**, **F**, **E**, and **a** in the Verona script also have the attributes of left-turning descenders, the combination of open and closed hastae, and narrow, slanted loops.

Thus the peculiar combination of scribal traits points to a general style of script found in Italy from the sixth through the seventh century, with some of the comparanda, such as the Ancona codex, suggesting a Northern Italian origin. This is not to say, however, that all scripts from Italy share these characteristics, but there are a few that do show a peculiar combination that allows the Ashburnham Pentateuch to join them in their general assignment to Italy.[22] Even then, I recognize that assignment on script alone is fraught with problems of archaizing tendencies,

scribes moving from one scriptorium to another, and individual
idiosyncrasies.

Iconographical Arguments

B erger adduced dubious if not trivial reasons for making the
Ashburnham Pentateuch North African or a Spanish copy of
a North African manuscript, such as the presence in the illustra-
tions of black men, palm trees with dates, scorpions, tents, camels,
and pack saddles as unusual and exotic details to be assigned to
an African scriptorium for the manuscript or its model.[23] These
elements are far from being unique to the Ashburnham Penta-
teuch, and they are not exclusive to African works of art. Palms
are found in the mosaics of Ravenna and the catacomb paintings
of Rome, for example, and black Africans are found throughout
in the Mediterranean in mosaic, wall paintings, and sculpture.[24]
In 1265 Nicolas Pisano sculpted black Africans riding camels on
the pulpit for Sta. Maria Assunta, Sienna; yet no one would assign
this work of art to Africa based on this evidence. The appearance
of black people in Greek, Roman, and early Christian art as a
referent to Egypt enjoyed a long history.[25] Because of medieval il-
luminators' working methods, details of this type cannot be taken
as evidence of a locale, for they are part of an artistic tradition
accumulated from different times and sites.[26]

Berger's may have influenced Quentin's opinion as he too
scoured the manuscript looking for details that could be linked,

in his mind, to geographic places; for example, the lions in the Noah and the Ark scene were linked to those found in the Atlas Mountains of Northern Africa.[27]

Wilhelm Neuss was another proponent for the localization of the Ashburnham Pentateuch in Visigothic Spain. Accepting Quentin's dubious art historical analysis based on two lions in the scene of the Embarkation from the Ark, he argued that the Ashburnham Pentateuch represented a tradition of late antique manuscript illumination that predated the Beatus manuscripts, giving it the status of the only surviving illustrated Visigothic manuscript.[28] Neuss viewed the Ashburnham Pentateuch as a near contemporary to what he believed was the autograph Beatus manuscript complete with illustrations. He needed the Ashburnham Pentateuch as a witness to the ability of Spanish artists to create illustrations in a late antique style, and the giants seemed the strongest iconographical link.[29] Neuss's reasoning was that the San Sever Beatus (Paris, Bibl. nat. lat. 8878),[30] in his opinion the most faithful representation of the Ur-Beatus, and the Ashburnham Pentateuch shared the unusual depiction of the giants floating in floodwaters (Fig. 24).

Otto Werckmeister pursued Neuss's assertion that the Ashburnham Pentateuch's illustration of the Deluge was a link to Spain (folio 9r; see Fig. 6). In a careful analysis of the two illustrations, he rejected Neuss's common model theory of the giants on iconographical arguments.[31] The San Sever Apocalypse has clothed figures, a woman with her child, and the raven pecking at a giant's eye. Also, the Ashburnham Pentateuch's ark is closed, unlike other Beati in which the ark is shown, and in the San Sever manuscript

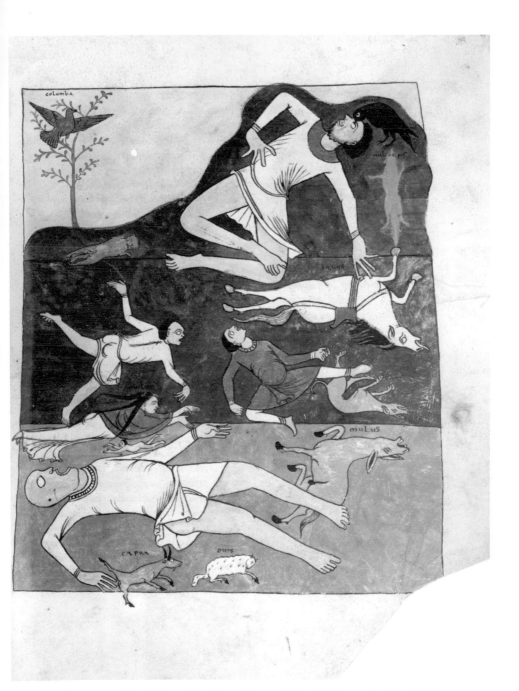

FIGURE 24. The Deluge, San Sever Beatus, Paris, Bibl. nat. lat. 8878, folio 85r. (photo: Bibl. nat. de France)

the ark is omitted. Furthermore, the two manuscripts illustrate two different moments in the narrative: The waters are rising in the Ashburnham Pentateuch, whereas the waters are receding in the San Sever Beatus.[32] Werckmeister suggested that the San Sever illustration deviated from the original Beatus recension by adding a non-Beatus element, the giants, which were derived from the Ashburnham Pentateuch. According to Werckmeister, the motif was possibly taken from the Ashburnham Pentateuch, not the Ur-Beatus. Considering that the Commentary on the Apocalypse is thought to have been created for Abbot Gregory Muntaner of the monastery of San-Sever-sur-l'Adour in Gascony when the Ashburnham Penateuch was in St. Gatien, Tours, Werckmeister's theory has some geographic credibility.[33] John Williams has characterized the San Sever Beatus as an evolved manuscript that shows some reworkings on the part of the illuminators.[34] The Beatus manuscripts from Spain do not include the Nephilim in Deluge illustrations, a strong indication that giants were not part of the Spanish tradition. In light of the well-known exegetical tradition discussed in Chapter 2, the giants do not support a Spanish origin for the Ashburnham Pentateuch, but rather attest its influence on a later French commentary on the Apocalypse. Thus, no matter how appealing the notion of a Visigothic or African Pentateuch, the art historical evidence is insubstantial, based on assumptions and methodologies that are no longer tenable.

In his 1883 joint publication with the Paleographic Society, Otto von Gebhardt and the Society suggested a North Italian origin, although von Gebhardt thought there were North African elements in the pictures, motifs such as those endorsed by Berger,

Quentin, and Neuss.[35] Lowe provisionally endorsed this early preference on paleographic grounds.[36] Less vocal than the scholars who prefer a Spanish or Nothern African origin, a number of scholars have opted for an Italian origin.

<div align="center">⚬⚬⚬</div>

Evidence For Rome: Codicological

The quire signatures offer yet another clue to the possible origin of the manuscript. The gatherings of eight in the Ashburnham Pentateuch are consistently marked by a handsome capital **Q** in the center of the lower margin, followed by a Roman numeral to the right (Fig. 12). The **Q** and the numerals are set off by decorative, diminishing lines. The Carolingian scribe who amended the manuscript copied this quire signature on folio 64v, which is original to the manuscript. In Lowe's corpus of surviving Latin manuscripts before the ninth century, forty-one manuscripts use the capital **Q** with Roman numerals to mark the quires. Of these forty-one manuscripts, eighteen are from Italian scriptoria,[37] with three more related to the Italian tradition through their models.[38] Of the remaining twenty manuscripts,[39] four are from Tours where the Ashburnham Pentateuch was by the ninth century,[40] suggesting that it may have been the vehicle for the quire signature transmission into Touronian practice. The borrowing has precedence in a fragmentary sacramentary, bound up as part of the Old Gallican Missal (Rome, Vat. Pal. lat. 493), which also uses the distinctive **Q** and Roman numeral quire numbering.[41]

This section of the Old Gallican Missal, dated to the first half of the eighth century and thought to have been produced in one of the nunneries in the Seine Valley,[42] is further linked to the Ashburnham Pentateuch by the script, which has been associated by Lowe to the eighth-century insertions in the Ashburnham Pentateuch.

If the parameters of centuries are narrowed to those most frequently cited for the Ashburnham Pentateuch – the seventh century and earlier – there are only eighteen manuscripts with this type of signature: Of these, fifteen are Italian,[43] two are seventh-century Spanish,[44] and the last is the Codex Amiatinus, which no doubt copied the quire signature from the Cassiodoran, or Italian, model. There survive no seventh-century and earlier examples of this quire signature in Southern France. The two Spanish manuscripts are dated by Lowe to the seventh century. Twelve of the fifteen Italian manuscripts with the **Q** quire signature are from the fifth and sixth centuries. In other words, the earliest manuscripts with this quire signature are all from Italy; by the seventh and eighth centuries it begins to appear in manuscripts from Spain, Gaul, and the British Isles. The chronology and the number of surviving examples strongly suggest that the origin for this scribal tradition of using **Q** with Roman numerals for quire signatures was Italy. As Italian books traveled north, the signature was copied, as was perhaps the case with the Ashburnham Pentateuch and the Old Gallican Missal as well as the Touronian manuscripts. Although the evidence is not conclusive, the pattern just outlined suggests that the late sixth-century Ashburnham Pentateuch was produced in an Italian scriptorium.

⟨⟨⟨

Evidence For Rome: Liturgical

The Reading of the Covenant on folio 76r portrays an actual moment in the Roman Canon of the Mass: the reading of the names of those who offered gifts (Fig. 21). If the inclusion of deacons/Levites at Moses' side is atypical, their number offers a motive for their inclusion. Sozomen, the Greek historian writing in the middle of the fifth century, mentions the curious fact that the Roman Church never had more than seven deacons, a number sanctioned by the Apostles in Acts 6:2–4.[45] Especially notable for the arrangement of the deacons in the manuscript is the record stating that Pope Evaristus (ca. 100–ca. 109) ordained seven deacons to observe the bishop when he recited the mass.[46] Pope Fabian (236–250) divided the seven regions of Rome among seven deacons and created seven subdeacons and seven notaries to record the acts of the martyrs.[47] The number of deacons in Rome had apostolic origins, despite the fact that the early medieval Roman clergy employed at least a hundred deacons.

J.G. Davies argued that the six acolytes and the subdeacon, as a kind of head acolyte, were the seven assistants to the deacon assigned to one of the seven ecclesiastical regions in Rome.[48] The restriction in Rome of the deacons to seven, Davies implies, led to the creation of the subdiaconate and the acolytes in order to assist the expanding duties of Roman deacons. Eusebius in his *Ecclesiastical History* confirms the number for the time of

Cornelius (251–253), who succeeded Fabian: one bishop, forty-six presbyters, seven deacons, seven subdeacons, forty-two acolytes, fifty-two exorcists, readers, and doorkeepers.[49] The limited number of deacons in Rome gave them special prestige, so much so that St. Jerome and Ambrosiaster complained bitterly about the arrogance of the Roman deacons, who viewed themselves as superior to the presbyters, who were numerous.[50] Although the Council of Neocaesarea (314–325) tried to determine that all episcopal cities should have seven deacons,[51] the number was not observed; for example, Constantinople had one hundred and Edessa had thirty-eight. The *Liber pontificalis*, compiled in the sixth century and contemporary with the Ashburnham Pentateuch, also records that the Roman deacons numbered seven, the number St. Peter ordained in the December before his martyrdom.[52] One of Rome's most famous deacons was Gregory the Great, who was assigned by Pope Benedict I to the seventh region and who was one of the seven deacons who counseled the bishop of Rome.[53] In reality, by the late sixth century, deacons were assigned to the stational churches and the tombs of martyrs, so that the number of deacons greatly exceeded the seven assigned to the seven regions of Rome.[54] Even so, the association of Rome with its seven deacons was an apostolic tradition and completely identified with the great stational mass at Rome. Thus the rendering of Moses' sacrifice in the Ashburnham Pentateuch is a ceremony in which the celebrant is attended by seven deacons points to Roman practice, or one heavily influenced by the seven deacons of Rome. Here the theater of the liturgy would have provided the inspiration for the scene.

The pillar of fire and cloud shown as a large candle held in two hands provides another clue for a Roman milieu. The use of the Paschal candle in Rome is obscure and not without problems of documentation.[55] The blessing of the candle probably began in Northern Italy in the fourth century and quickly spread throughout the western rites.[56] The only possible exception was in Rome, which had two rites for the Easter Vigil. The blessing, and thus the candle, was not used in the papal rite because there is no evidence until ca. 950, when the Lateran began using a Paschal candle. The candle and a blessing of the candle, however, were known from an early period in Rome, even though the papal mass did not use the candle. The first reference is St. Jerome's letter to Deacon Praesidius of Piacenza (written in 384) in which he disparages the versions of the blessings he has heard as nonbiblical and owing too much to the pagan authors, in particular Virgil's *Georgics*.[57] The second reference is Pope Zosimus (417–418) who gave permission for the *benedictio cerei* to be sung in the parish churches that made use of a separate rite.[58] The third reference is the *Gelasian Sacramentary*, which contains the *Deus mundi conditor*, a benediction over the candle, with the standard references to Christ as the Light of the World and the praise of the bees who made the wax.[59] Although the *Gelasian Sacramentary* is Frankish in origin, Italian sources were no doubt the inspiration for the Gelasian blessing as it reiterates their themes and motifs. The benediction over the candle suggests that the candle was present in the Roman titular churches by at least the seventh century. The introduction of this candle into the Crossing of the Red Sea must have been prompted by a vivid and compelling visual image on the most important and beautiful vigil

of the year. The manuscript may provide a key visual witness to the introduction of the candle into Rome in the late sixth to early seventh century.

<div align="center">✵</div>

Evidence for Rome: Pictorial Links

The foundation of the argument for an Italian origin is essentially iconographical, based on works of art that are known to have been created in Rome. The close links between the manuscript and the Roman works of art that are subsequently outlined suggest that Roman models were used. The most practical conclusion is that they came from the same milieu where artists would have had ready access to these Roman models. On the other hand, sketchbooks must also be assumed, carried by artists who traveled to Rome and returned home with Roman images as the source for new, local works of art.[60]

Arguing for an Italian origin for the manuscript, André Grabar was the first to point out the connections between the Ashburnham Pentateuch and the paintings in the Via Latina catacomb.[61] Cubiculum C (Fig. 25) of the catacomb and folio 76r in the manuscript show a remarkable correspondence in iconography, suggesting a point of origin in Rome.[62] Both the manuscript and the tomb painting combine the relatively rare scene of Moses on Mount Sinai with a temple structure below, a pairing found in only these two works of art. In his book on the Via Latina catacomb, William Tronzo identifies the scene as Joshua entering the

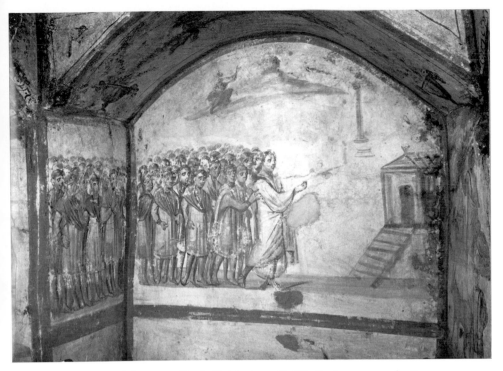

FIGURE 25. Moses on Sinai, Cubiculum C, Via Latina catacomb, Rome. (Photo: Pontificia commissione di archeologia sacra, Vatican)

Promised Land, led by the Pillar of Fire and Cloud as signs of God's presence.[63] Tronzo puts forth an interesting thesis that the paintings in the catacombs were based on a series of pictures in a Roman baptistry. Both Grabar and Tronzo recognized the architectural column as the Pillar in the fresco. In his comparison, Grabar did not recognize that the similarities included the Pillar next to the tabernacle in the Ashburnham Pentateuch illustration of this episode. In the manuscript, the Pillar of Fire and Cloud is portrayed as a large candle, rather than the more traditional architectural column, as seen in the fresco. This detail makes the connection

between the manuscript illustration and the catacomb fresco much closer: Moses, tabernacle, pillar, albeit depicted by two different motifs.

Another iconographical link between the two pictures is the inclusion of an adjacent sacrifice scene with Eucharistic significance. In the tomb painting, Abraham's offering of his son is portrayed on the wall to the right of Moses on Mount Sinai and the crowd approaching a tabernacle. Abraham's sacrifice had Eucharistic associations, especially in the context of a Christian tomb, as the patriarch was invoked whenever the Christian participated in the Mass. Abraham's sacrifice is referred to in the Roman canon of the Mass: ". . . Accept them [the offerings] as you vouchsafed to accept the gifts of your righteous servant Abel, and the sacrifice of our patriarch Abraham."[64] The reference to the Eucharist is appropriate in the tomb because the deceased person would have received the *viaticum*, the last partaking of the Eucharist, in the moments before death.[65]

The Canon of the Mass is also referred to in the Ashburnham Pentateuch in the scene to the right of Moses on Mount Sinai and above the tabernacle. The altar bears a chalice, bread, and a pitcher. In summary, both the Roman fresco and the manuscript include Moses on Mount Sinai, the pillar, the tabernacle, and an Old Testament sacrifice with typological references to the Eucharist.

Grabar also noted that the iconographical similarities between the Via Latina frescoes and the Ashburnham Pentateuch extended beyond Cubiculum C and into Cubiculum B. The painting in Cubiculum B shows Jacob blessing Ephraim and Mannassas, a scene found on folio 50r. In both scenes Jacob crosses his arms to

bless the brothers.[66] Although he is on his bed, in the catacomb painting he reclines, whereas in the Ashburnham Pentateuch he is sitting up. The Roman painting and the manuscript are also the only two surviving works of art that share the unusual scene of Adam and Eve in their animal skins and next to them Cain and Abel carry their gifts. This pairing opens folio 2r in the manuscript: Adam and Eve on the left, and on the far right the brothers offer their gifts. The catacomb painting, as is typical of narratives in these burial chambers, simplifies the scene; the protoplasts are seated, not under a booth, and the biblical text is adhered to in the offerings of a lamb and a sheaf of wheat. Thus the Ashburnham Pentateuch and the Via Latina catacombs share the scenes of the Pillar, Moses on Mt. Sinai, the Eucharistic scene, the Blessing of Ephraim and Mannassas, and the Cain and Abel/Eve and Adam combination.

As I mentioned briefly in the scene of Noah and the Ark, there is a strong iconographic affinity between the Ashburnham Pentateuch and the frescoes at San Paolo fuori le mura that links the manuscript more firmly to Rome: the rendering of Noah's ark with a hinged lid *and* with feet.[67] Another singular aspect of the manuscript's iconography has its counterpart in only a Roman monument. The First Person of the Trinity is represented in three different modes within the same pictorial cycle: the Hand of God, a half-figure/bust, and a full figure. The Hand of God is by far the most common portrayal; for example, in the scene of Moses and the Burning Bush on folio 56 (Fig. 2). The bust portrait is depicted twice, once in the scene of Moses and Aaron on Mount Sinai on folio 76r (Fig. 21) and once in the scene of Jacob's Ladder on

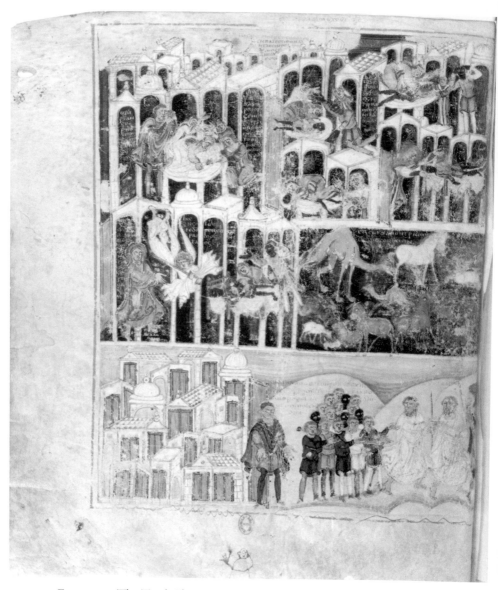

FIGURE 26. The Tenth Plague, Paris, Bibl. nat. lat. nouv. acq. 2334, folio 65r. (Photo: Bibl. nat. de France)

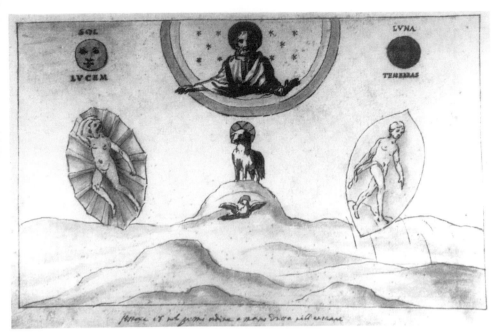

FIGURE 27. Separation of Light from Dark, San Paolo fuori le mura, Vatican, Barb. lat. 4406, folio 23. (Photo: Bibl. Apost. Vat.)

folio 25r (Fig. 13). The full-length figure of God the Father appears in the Creation (Fig. 15) and in the Tenth Plague (Fig. 26). The use of three formulas for the representation of God the Father in one pictorial cycle is found in the now-lost frescoes of San Paolo fuori le mura. Stephen Waetzold published seventeenth-century drawings of the frescoes, which had been restored by a Cavallini workshop in the thirteenth century. The veracity of the iconography, then, is open to question because we cannot determine if the thirteenth-century workshop altered the depiction of the Trinity in the frescoes, although the Genesis scenes are thought to be

FIGURE 28. God Accuses Adam, San Paolo fuori le mura, Vatican, Barb. lat. 4406, folio 27. (Photo: Bibl. Apost. Vat.)

iconographically intact.[68] Depicting the Trinity has always been a risky business, and the variety of solutions, or nonsolutions, indicates the problems.

The drawings also interchange the Hand, the half-length figure of the First Person, and the full-length depiction of the First Person (Figs. 27–29).[69] As in the Ashburnham Pentateuch, the Hand is used in narrative scenes, the full-length figure in the Creation, and the bust in scenes of the Trinity.[70]

Additionally, the frescoes and the Ashburnham Pentateuch show all three persons at the Creation. The fresco depicts the Trinity in the forms of the bearded figure of God the Father, the

FIGURE 29. God Speaking to Noah, San Paolo fuori le mura, Vatican, Barb. lat. 4406, folio 33. (Photo: Bibl. Apost. Vat.)

dove of the Holy Spirit, and the *Agnus Dei*. The Ashburnham Pentateuch, as I discussed in Chapter 3, represents the Trinity in more unified forms: a bearded and shod man (God the Father), a clean-shaven and unshod man (God the Son), and a dove (God the Holy Spirit), of which five figures were painted over in the ninth century.[71] In both pictorial cycles, the Trinity is depicted in three corporeal representations, rather than a single Hand or a Christ-Logos. Few early medieval works of art depict, or even attempt to depict, the Trinity. One example is the Codex Amiatinus, created a century after the Ashburnham Pentateuch, which depicts in three medallions the bearded Father, the *Agnus Die*,

and the Dove. Lawrence Nees argues that the Amiatinus Trinity is a Northumbrian invention, and not copied from Cassiodorus' Codex Grandior. He suggests, rather, that the "Byzantine Christ" that represents God the Father in the codex is based on Anglo-Saxon coins, which copy Merovingian coins, which in turn emulate those minted by Justinian II; the "Byzantine Christ" as God the Father was, in Nees's estimation, an appeal to the sensibilities of the pope who has recently returned from Constantinople.[72] Although I have no answer to Nees's arguments, I prefer a more straightforward approach that sees the Codex Grandior's Trinity copied in the Codex Amiatinus, as the Italian milieu had a history, albeit a small one, of Trinitarian iconography in the fifth-century frescoes of San Paolo fuori le mura and the illuminations of the Ashburnham Pentateuch. In fact, the bust in the Codex Amiatinus on folio 6r[73] more closely resembles the bust of God the Father found in Jacob's Ladder and Moses on Mount Sinai (folios 25r and 76r), as all three representations eschew the two locks of hair on the forehead typically found in the Byzantine Pantocrater type of Justinian II's coins.

If the Italian origin of this iconography can be established, it prompts questions about the theological implications for visually representing the Trinity in an Italian milieu.[74] The Three Chapters Controversy was a theological debate that shook the papacy and its relations with the churches of Italy, particularly those in the north. The tradition of sophisticated pictorial exegeses, or visual commentary, is not unique to the Ashburnham Pentateuch, but was established early in such works of art as the mosaics of S. Maria Maggiore, Rome.[75]

The iconographic combinations of Old Testament scenes and the First Person that I have just outlined suggest that Italy, if not Rome, should be considered as the original home of the Ashburnham Pentateuch. One such combination might be taken as coincidence or the influence of a portable work of art which contains some of these pictorial elements, but these eccentric combinations that are both physically linked to Rome, however, are less easily dismissed.

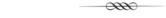

Evidence For Rome: Stylistic

Although format and figure style have no counterparts in surviving Roman manuscripts, the Ashburnham Pentateuch contains ten surviving lists of chapters that are arranged between three arches under an encompassing arch, as well as the title page that carries a decorated arch (Figs. 30–32). Because the formula is no doubt derived from that used for canon tables, Italian examples of the canon table tradition offer further evidence that the Ashburnham Pentateuch was produced in Italy, not to exclude Rome. Vieillard-Troiekouroff was the first to mention an Italian origin for the Ashburnham Pentateuch chapter lists, noting that the marbled columns, the key pattern, the birds, the flowers of three or four petals, and the rinceaux and pearl decoration were probably derived from Italian Latin models.[76] David Wright explored this further in his exhaustive and meticulous examination of the Codex Beneventanus (London, Brit. Lib. Add. MS lat. 5463) canon

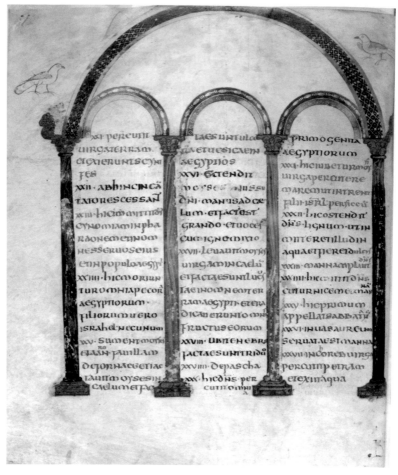

FIGURE 30. Chapter Lists to Numbers, Paris, Bibl. nat. lat. nouv. acq. 2334, folio 51v. (Photo: Bibl. nat. de France)

tables (Figs. 33 and 34).[77] The floral patterns, many of them versions of the vine scroll and the bead-and-reel molding, and the handling of the Corinthian capital and column bases are persuasively compared by Wright not only to the Codex Beneventanus,

FIGURE 31. Chapter Lists to Numbers, Paris, Bibl. nat. lat. nouv. acq. 2334, folio 115v. (Photo: Bibl. nat. de France)

which he would date, along with the Ashburnham Pentateuch, to the sixth century, but also to Rome, Vat., MS lat. 3806 (Fig. 35) and Vat. MS lat. 5465 (Fig. 36). If these four canon/chapter tables are compared with examples from Merovingian or Irish centers, the

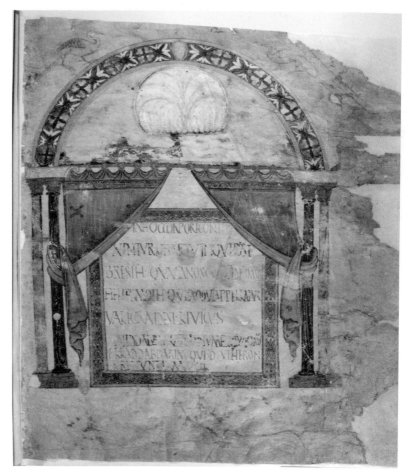

FIGURE 32. Title Page, Paris, Bibl. nat. lat. nouv. acq. 2334, folio 2r. (Photo: Bibl. nat. de France)

similarities between them are even more striking. The comparisons Wright and Vieillard-Troiekouroff make with these canon tables are convincing[78] and provide a stylistic link to Italy for the Ashburnham Pentateuch.

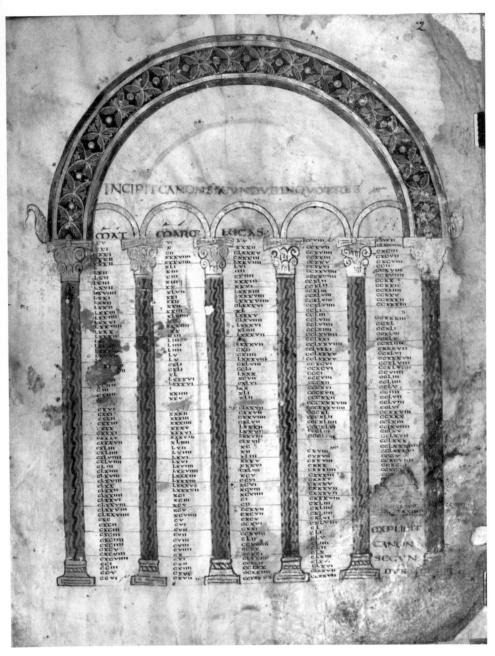

FIGURE 33. Canon table, Codex Beneventanus, London, Brit. Lib. lat. add. 5463, folio 2r. (By permission of the British Library)

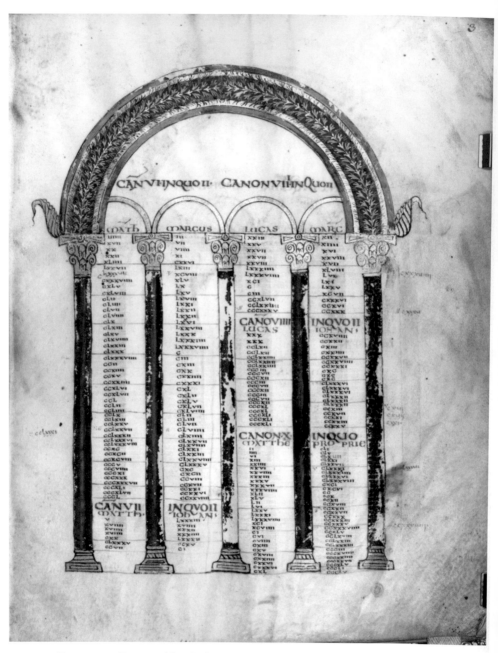

FIGURE 34. Canon table, Codex Beneventanus, London, Brit. Lib. lat. add. 5463, folio 3r. (By permission of the British Library)

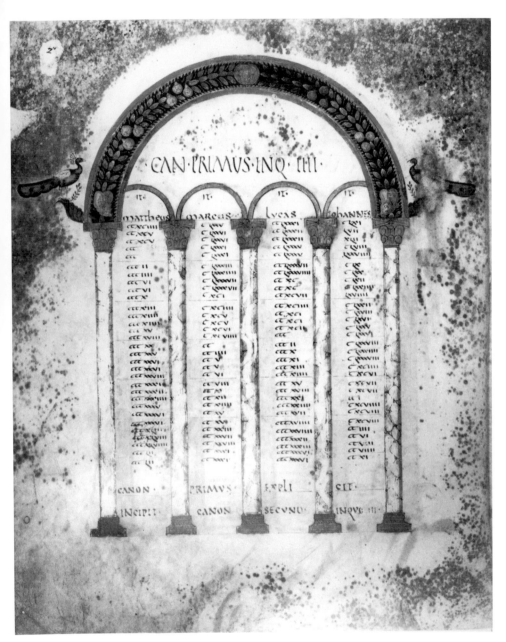

FIGURE 35. Canon table, Vatican, lat. 3806, folio 2v (Photo: Bibl. Apost. Vat.)

Gaul Considered

The Issue of Narrative Painting

In this early period of manuscript production, it is exceedingly difficult to pinpoint artistic "schools," such as the so-called "Palace School" of the later Carolingian period. As John Lowden has shown, there are so few illuminated manuscripts to survive from the fifth century to the Carolingian period that no center can claim primacy, nor can a definitive "style" or format be assigned to a particular scriptorium of manuscript illumination, outside the Insular scriptoria.[79] Indeed, the diversity of these survivors is astonishing, indicating the fluidity and creativity in this early period of illuminated manuscripts. One cannot therefore argue for a Roman school of painting in a stylistic sense; for those who would try, the case of S. Maria Antiqua is a cautionary tale.[80]

Nevertheless, the extensive narratives found in the Ashburnham Pentateuch must be situated in a region that shows itself capable of producing expansive, detailed, and sophisticated pictorial narratives. Artistic customs are not easily toppled because, even when it can be shown that a new style is introduced, artists will typically translate the new dialect into the local vernacular. This phenomenon is well known in the Insular manuscripts.

Gaul has been a place of origin suggested by early scholars of the Ashburnham Pentateuch, so it is worthwhile to explore this region for its artistic habits. Merovingian manuscripts show a

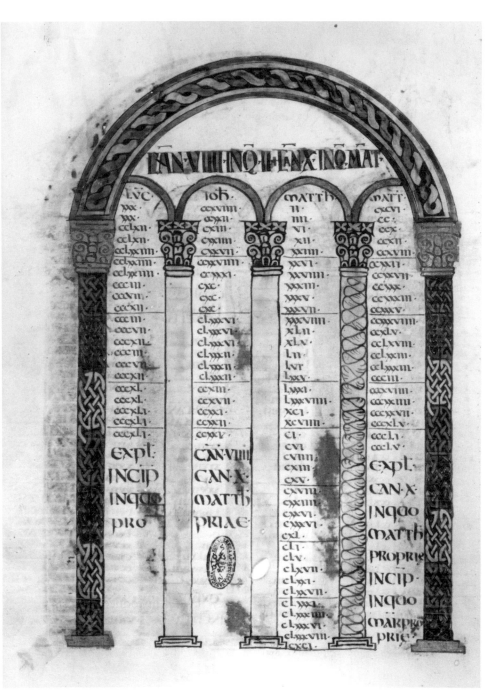

FIGURE 36, Canon table, Vatican, lat. 5465, folio 9r. (Photo: Bibl. Apost. Vat.)

179

remarkably different approach to manuscript illumination, more closely allied with indigenous artistic traditions in metalwork. In surviving manuscripts, extensive series of narrative illustrations derived from the biblical text are simply nonexistent; rather, the decoration found in these manuscripts is based on the principles of ornamentation, in which the script itself is enhanced through color and pattern.[81] In the Ashburnham Pentateuch, text and illustration are treated as separate entities on the folios; although there is a close correlation of visual exegesis on the text, it is a conceptual relation, not a compositional one. Working in a classical idiom, the artist and scribe are careful to maintain the integrity of the letterform and the spaces dedicated to pictures. With the exception of one decorated initial, a later addition probably added in Fleury – a case in point – initials and letters are completely lacking in decorative flourishes. This is antithetical to manuscripts with illuminations from north of the Alps. The most distinctive feature in Frankish manuscripts is the combination of the complex frames of arches, columns, and arcades with fish, birds, lions, and other more fantastic beasts. In these manuscripts, the arches are fanciful, showing none of the architectonic features in the *capitula* arches in the Ashburnham Pentateuch. Animals are sometimes used to make actual letters, in which their bodies are treated as an integral part of the design. The mid-eighth-century Sacramentary of Gelasianum (Rome, Vatican, MS. Vat. Reg. lat. 316), written near Paris, has whole pages filled with geometric details, animals, and plants; an initial letter of the Gellone Sacramentary (Paris, Bibl. nat., MS. lat. 12048), written at Meaux Abbey in the later eighth century, shows the same treatment.[82] The manuscripts are

characterized by lively patterns of animals, whimsical architectural features, foliage ornament, and geometric forms in jewellike tones of red, green, and yellow; the human figure is rarely shown, and narrative scenes are not evident. In the Ashburnham Pentateuch, on the other hand, nineteen narrative moments from Exodus alone remain in the pillaged manuscript, an Exodus series that would remain unchallenged in its scope until the twelfth century. That a northern scriptorium would create historical picture cycles on such a scale without precedence and then leave no trace of this type of painting stretches art historical credibility to the breaking point. Indeed, if the sarcophagus record is accurate, the early Christian narrative sarcophagi, similar to those found in Rome, made in the workshops of Southern France, were abandoned by the early fifth century, replaced by the gorgeous, but generally aniconic, sarcophagi.

The northern manuscripts reflect a rival aesthetic of ornamentation that was deeply rooted in continental Celtic and Germanic motifs, not in the narrative aesthetic associated with the late Roman Empire. In Rome, on the other hand, series of pictorial history enjoyed a venerable and long-standing tradition. The catacombs themselves attest to this and, although badly plundered and often in disrepair, their extensive series of paintings were still accessible in the sixth and seventh centuries.[83] The churches in Rome were valuable repositories of mosaic and fresco cycles that were easily accessible to any citizen and visitor in Rome; some of the more famous, in addition to those already cited, include the mosaics at S. Sabina and the frescoes at SS. Pietro and Paulo fuori le mura. This is not to say, however, that areas north of the Alps did not have

fresco cycles that depicted saints' lives and biblical history. Herbert Kessler has shown that they did exist, at least in Tours, and were used to further the mission of the church in sixth-century Gaul.[84] These, however, were exceptional rather than common in Gallic churches and found no surviving counterpart in manuscripts.

Although the survivors are scarce, the heritage of history and narrative painting, the separation of text from pictures, the lack of textual ornament, the integrity of the letter forms, and the use of simple frames is well known in Roman manuscripts from the fifth century, notably the Vergilius Vaticanus and the Quedlinburg Itala.[85]

Summary

In making my case for an Italian and Rome-inspired, if not Rome in fact, origin for the Ashburnham Pentateuch, I have endeavored to use the widest range of possible evidence as previous scholarship focused too narrowly on one type of evidence without fully considering other aspects. I have given more weight to the illustrations as an indicator of origin than to the script because the pool of comparanda is greater and the paleographical infrastructure of early manuscripts is not fully, or convincingly, mapped out.

What are the implications of a late sixth-century Italian scriptorium's producing this lavishly illustrated and iconographically rich manuscript? If it is Italian, it seems to fit between within the milieu of Gregory the Great (590–602) and Honorius I (625–638).

The strong liturgical component of the manuscript is not inconsistent with this formative period of liturgical codification. The manuscript provides visual evidence of liturgical practice in this crucial period between the fourth century and the eighth century when textual evidence does not exist. Sixth-century Roman liturgical practice is reconstructed by liturgical scholars who base their work on early texts such as Ambrose's *De sacramentis* and later texts such as the *Gelasian Sacramentary* (Vat. Reg. lat 316). These provide textual "bookends" for pictorial evidence.

The didactic and liturgical character of the Ashburnham Pentateuch is also found in the Corpus Christi Gospels, although what survives in the Gospels is much less sophisticated in both aesthetics and content.[86] Although the liturgy has been given a passing glance by art historians of the early medieval period, it must be taken far more seriously as a source for biblical imagery. The theater of the liturgy provided compelling visual imagery that was used exegetically to comment on the Old Testament text. In creating illustrations for the Bible, at least one early medieval artist turned to more than model books and monumental works of art.

7

A Roman Clergy

Accordingly, it is no hard task to give directions in regard to those truths which are instilled as articles of faith – where the narration should be begun and where ended; . . . But our chief concern is what means we should adopt to ensure that the catechizer enjoys his work; for the more he is able to do so, the more agreeable will he prove.

– Augustine[1]

Roman Clergy

This large, encyclopedically illustrated Pentateuch, with interpolations derived from contemporary liturgical practice, suggests that a particular audience was in mind when the manuscript was created. Despite its plentiful offerings of diverse characters and scenes, it is not a lavish manuscript. Purple vellum, silver ink, gold leaf, a dedication page, and elaborate ornament are noticeably absent, indicating that it was not meant as a presentation codex to impress a dignitary or to curry favor with an imperial

person. It is, in fact, a workhorse of an illuminated manuscript.[2] The large format and the copious illustrations with generous margins are optimal for study; the creative energy and resources were poured into the content and number of pictures. Many of the surviving folios show rough wear, such as might have been caused by fingers pointing out details in the illustrations; also, folios went missing at an early stage, especially folios with illustrations.[3]

Almost a century ago, Wladimir de Grüneisen first observed the didactic character of the Ashburnham Pentateuch illustrations when he compared them with the Vienna Genesis (Vienna, Öst. Nationalbibl. cod. theol. gr. 31),[4] noting that the two manuscripts seemed, at least to him, worlds apart.[5] More recently, Hans Gerstinger took a slightly different tack when he suggested, despite the luxury format, that the Vienna Genesis was intended as a schoolbook for a prince or princess.[6] John Lowden seconded this opinion and speculated that the same could be applied to the Cotton Genesis – that it too might have been an instructional aid.[7] Pierre Riché has suggested that the Corpus Christi Gospels, for which an Italian origin is assumed, was another such instructional manual.[8] Of the handful of surviving illuminated manuscripts from the late antique period, a surprising number of the biblical ones have been considered, at one time or another, a book with a didactic function. Increasingly, scholars of illuminated manuscripts are studying late antique codices in the light of instruction and teaching, although much of the work to date is conjecture rather than thorough study. Thus the Ashburnham Pentateuch is situated not only within a cultural framework of literary exegesis of scripture, but also within a tradition of late antique picture books whose

educational outlines are only now beginning to appear sharper and more defined.

Although the iconographical peculiarities have been remarked and commented on, these peculiarities should be taken more seriously and placed in a more positive light. Puzzling scriptural episodes, such as the Nephilim in the Deluge, are not avoided, but rather are actually embraced in the pictures. These narratives are comprehensively addressed through illustration and then through visual cues, reworked to direct the viewer away from interpretative error toward approved knowledge. The reader, for example, may wonder about the Trinity at Creation, but the viewer knows that the Trinity was present in all Three Persons because they see the Father, Son, and Holy Spirit separating the waters. Likewise, the giants are not omitted in the Deluge, as is the case in most other illustrations of this important biblical narrative, but are "front and center" where they can be examined and pondered over. The peculiar nature of the iconography – the Trinity at Creation, the giants, the liturgical interpolations, the retellings of the biblical narrative for moral lessons – indicate a concerted effort to elucidate the meaning of scripture. A learned audience, or at least one interested in teaching and learning, seems indicated. A provincial backwater seems hardly the place for this type of pictorial catechetics, especially when undertaken on such a comprehensive scale.

The iconography points toward a clerical audience, particularly those who bore the responsibility to teach and to instruct. The clues are throughout the manuscript. The three liturgical readings penned in the margins are the best indicators for whom the manuscript was planned. The most obvious is the lesson to

be read for the ordination of a deacon marked *lectio ordinationis diacanorum* on folio 125r (Numbers 8:4). The biblical passage describes the institution of the Levites to serve in the tabernacle. The identification of Christian deacons with the Hebrew Levites was common practice, and the passage is fitting for the ordination ceremonies.

The ordination lesson from the Book of Numbers begins with the order to light the seven lamps over the candlestick, a candlestick of beaten gold likened unto flowers. In a ninth-century tract from Reims (Rome, Vat. reg. lat. 845, MS lat., folios 94r–94v), which is thought by Roger Reynolds to be an instructional pamphlet for deacons, the apostolic seven deacons are likened to the seven candelabras and seven angels in the Book of Revelation 1:20 and 4:5.[9] Seven candelabras are often shown on the triumphal arches of apses in Rome, a reference to John's vision but also possibly to the Roman deacons.[10] Candles and candlesticks were the responsibility of the acolyte, who was an assistant to the deacon. The acolyte received a candlestick, candle, and bag (for the reserved host) at his ordination ceremony.[11] The reading starts at this point, not one verse later, which is a more natural starting point in the narrative flow, indicating that the ecclesiastical attributes of candles and candleholders were important enough to incorporate the verse in the reading that described the Levitical candles.

The two lessons for Easter, written in the margins of the manuscript, are also pertinent to the duties of the deacon and his subordinates. Leviticus 22:1 is marked *lectio pascae* on folio 109r, and what follows is a command from the Lord to Moses about the appropriate gifts to be offered at the altar. The passage then,

would have resonated with the deacons, who were responsible for receiving the gifts, the first fruits, from the laity, or the Israelites.

Numbers 9:1 is marked *lectio pascae* on folio 126r, a section that refers to the importance of keeping Passover by men who are defiled by contact with the dead or who cannot keep the Passover because of their travels. The chapter finishes with an account of the Pillar of Cloud that accompanied the wilderness tabernacle. Again, the scriptural passage is not directed to the people of Israel, but toward the Levites, whose Christian counterparts were often required to travel on administrative duties and to bring the *viaticum* to the dying. Thus the three lessons, given special emphasis by the notations, speak to the roles of deacons and their acolytes who were responsible for roles similar to those of the Levites in the passages to be read at Pasch and at their ordination.

As I have argued, many of the deviations from the biblical text and pictorial traditions are derived from typological and allegorical teachings and liturgical practice of the early medieval Church. The Paschal candle, the bringing of gifts to the altar, the diptychs, the seven deacons that surround the celebrant, and the ordination lection marking, all indicate a book that spoke to the work of deacons. Early medieval deacons were taking on greater duties at the altar, which included the receiving of the gifts, the offering of the chalice, the singing of the *Exultet*, writing the names in the diptychs, and assisting at the altar.[12] Isidore of Seville, who viewed deacons as contemporary Levites, says that on solemn feast days they assisted the bishop by shielding him from the view of the laity.[13] The Council of Trullo (692) noted that modern deacons also served at the mysteries as well as the charitable works that

distinguished Stephen and the six others who served the poor widows in Acts 6.[14]

The deacons were also responsible for the instruction in the doctrines and history of the church; this duty was typically shared by presbyters and by deacons.[15] Catechisms, epistles, and homilies provide much of the parallel and explicatory texts for understanding the illustrations. Cyril writes to clarify the meaning of scripture for Tiberius, a deacon from Palestine. Tiberius was trying to weed out the tares of troublemakers who raised awkward questions about scripture that disturbed the wheat of his brethren's faith. Deogratias, another deacon, asks Augustine's help to keep vibrant his instruction. Although this is evidence from Alexandria and Hippo, the cares would seem to be universal, rather than local, for deacons seeking to perform their duties. The Ashburnham Pentateuch seems to provide a visual catechism, or painted primer, to teach clergy the proper answers to those difficult questions and to derive the "right order of life" from those stories. Deogratias and Tiberius, the deacons who inquired from Augustine and Cyril of Alexandria about how to teach and what to teach, are but two examples of the deacon's need for pedagogical guidance.

The teaching role of the deacons is often indicated in their portraits. In the Mausoleum of Galla Placidia, Ravenna, for example, St. Lawrence carries an open book, whose sacred status is indicated by the open seals and ribbons, and an open cabinet containing Gospel codices.[16] St. Lawrence, in his role as deacon, is also portrayed on the triumphal arch of San Lorenzo fuori le mura, as he stands between Pope Pelagius II (579–590) and St. Peter. His care of the poor is indicated in the words from Psalm

111/112:9, which are written on the codex he carries: *dispersit dedit pauperibus*.[17] St. Stephen, believed to be the prototypical deacon as well as martyr, is also shown with an open book, standing between St. Paul and S. Ippolito. If Lawrence embodies the charitable work of the deacons, Stephen embodies the teaching role because he preached the sermon before his martyrdom, recapitulating heroes and events from Jewish scripture (Acts 7) in much the same way that Augustine's catechism used the Old Testament. Also contemporary with the manuscript is the Oratory of St. Venantius, built within the Lateran Baptistery under the patronage of Pope John IV (640–642). St. Septimius stands as deacon with a codex on the arch to the right of the Deesis lunette.[18] Within roughly contemporary monuments in Rome, there is an association of codices, deacons, and teaching in the art of early medieval Rome. The Ashburnham Pentateuch is possibly one of the codices that the deacons might have commissioned to aid in the training of new deacons, through the medium of pictures, correct church history, and the right order of their lives and their constituents. Ultimately then, the true audience was a lay one, as they would be the recipients of the knowledge and teaching to be gleaned from the Ashburnham Pentateuch.

The Tituli

Physical evidence in the Ashburnham Pentateuch supports the idea that the illustrations were the *raison d'etre* for the manuscript. A lengthy *titulus* accompanies each scene and figure.

This ensures that the illustrations are clearly identified because, no matter how familiar the reader may be with the story, the *tituli* provide the correct biblical text. One question remains: What is the purpose of the lengthy *tituli*, or captions, which accompany each and every scene? The scribe, or artist, first wrote a set of captions in ink, along with the ink underdrawings. This can be seen on folio 56 where water damage has washed away the opaque gouache, exposing the ink words and drawings. Curiously, the ink captions were taken from the Vetus Latina, or the Old Latin Bible, an umbrella term for myriad translations made from the Greek New Testament and from the Greek version of the Old Testament known as the Septuagint. Clearly the captions were intended to play an important part in the illustrations themselves because trouble was taken to "update" the captions. This is curious as the Vulgate was not yet the canonical translation, but the dominant one among many.[19] The captions are derived from the Vulgate text and, for the most part, reiterate the biblical text in order to identify a scene or person. When Noah disembarks from the Ark, for example, on folio 9, the caption states *hic dns ubi dicit ad Noe et filiis eius crescite et multiplicamini super terra* [here is where the Lord says to Noah and his sons increase and multiply upon the earth]. These are very different from those in the Quedlinburg Itala, a luxury manuscript made in Rome in the early fifth century. Here, the captions are simply directions to the artist on what figures and action should be included; hence the instructions begin with the latin *fecit*, "you make," not with *hic*, "here is." On folio 1r of the Quedlinburg Itala, for example, the caption reads "You make the tomb by which Saul and his servant stand and two men jumping

over pits speak to him."[20] The written words were never meant to be read in the finished product; it is only damage that has revealed them. Most scholars agree that these are directions to the artist for a new set of illustrations for a deluxe edition of the Books of Kings.

The *tituli* in the Ashburnham Pentateuch also differ from the captions found in other manuscripts, such as the seventh-century Corpus Christi Gospels. Here, an English scribe inked in the short captions that identify the telegraphic scenes; it is assumed that these were meant to ensure the proper identification of the scenes, indicating the necessity of captions for an audience that may have struggled with the iconography.[21]

The Moutier-Grandval Bible, created in Tours in the ninth century, also displays extensive *tituli*; however, these were planned as part of the illuminations. Here the captions are placed outside the pictorial field within the frames and describe the scenes above and below the *tituli*.

In all three of the previous manuscript examples, the Quedlinberg Itala, the Corpus Christi Gospels, and the Moutier-Grandval Bible, the *tituli* and the pictorial narratives are in complete agreement, with the misidentification of one scene in the Corpus Christi Gospels.[22] The artist followed the instructions, and the *tituli*, whether added later or planned as part of the illuminations, are in agreement with the illustrations. If the viewer is knowledgeable about the biblical narrative and the conventions of the iconography, the *titulus* is not necessary for proper identification, although even the most experienced iconographer is often grateful for the textual aids. This, however, is not always the case in the Ashburnham Pentateuch.

On folio 56r, in the upper right, the two Hebrew midwives stand before the seated Pharaoh (Fig. 2). From the illustration, it is difficult to determine whether this is the first or second audience before the Pharaoh. In the first, the Hebrew midwives are ordered to kill all male babies born to Hebrew women; in the second audience, the midwives are asked to account for the number of surviving male babies born to Hebrew women. The *titulus* informs the viewer that it is, in fact, the second audience: "Here is where the midwives say we are not like Egyptian women," a reference to their excuse that Hebrew women bear their children before the midwives arrive at the birthing. In this case the *titulus* is necessary to clarify the correct narrative moment.

In several of the scenes, the caption is a quotation derived from the biblical text, but the pictorial narrative portrays a variation, if not a contradiction, of the text. The clearest example is on folio 67r, where the *titulus* states, "Here is where they offer holocausts (Fig. 21)." Rather than the holocausts, or offerings completely consumed by fire, the altar contains the Eucharistic bread and chalice. This is also the case on folio 9r, where Noah's offerings of thanksgiving are depicted again as the Eucharistic chalice and bread. The holocausts and thanksgiving offering of the Hebrew scriptures, in other words animal sacrifices, have been superceded by the One Sacrifice, reenacted in each performance of the Eucharist. In other scenes, such as that of folio 65, the Tenth Plague, or the killing of all the Egyptian firstborn, human and animal, it becomes clear that the illustrations have radically departed from the script (Fig. 26). Although the biblical text is striking in its brevity, the illustration takes up two-thirds of the folio and gives a remarkably detailed

picture of the terror visited on the Egyptians, from the house of Pharaoh to the cattle within the enclosure. Significant deviations from the text are also apparent in the miniature, where the first-born and the fathers, with one exception, are portrayed as black Egyptians. Obviously the illustrator is attempting far more than the *titulus* indicates.[23]

In the Ashburnham Pentateuch the *tituli* and the illustrations play out in a complicated theater of basic identification, of clarification, of complication, and even contradiction. Indeed, the analogy to theater, or opera, has often struck me when I examined the illustrations: Architecture is used as backdrops, colorful scenery introduces various acts and characters, hair and costume define the status of the actors, and elaborate stage props add to the verity of the domestic interiors. Doors open and close while characters and animals march in and out of the margins. The vibrancy of the characters that populate the landscape and architectural scenery call to mind a stage set where the drama of history is acted out. The theater of the liturgy is portrayed in numerous scenes, giving a vivid portrayal of the reading of the diptychs and the offerings brought to the altar. The characters are lavishly dressed, and their costumes give clues to the audience what role they are playing. Levites are costumed as deacons, Eve is costumed as both good and bad mother, and the celebrant is both Moses and bishop. The illustrations collapse history into a seamless drama in which Jewish history is acted out in "contemporary" dress and settings.

The inscriptions, then, provide the play's script, or the opera's libretto, but the illustrations show the music, the movements,

gestures, and emotions of the actors and singers who bring to life the plot and the director's interpretations. Because the scenes are not in narrative sequence, the actors move in and out of the stage seemingly at will; the *tituli* provide a check, a kind of textual footnote for consultation. The type of careful checks and balances between the illustrations and the *tituli* suggests that great care was taken to ensure the appropriate reading and interpretation of scripture. Although I have placed the illuminations at the forefront of my study, the illuminations remain bound to the text, as it was divine scripture and the ultimate source of authority.

For Further Study

In my study, I have not attempted to examine each surviving folio with illustration, as it would be, I assume, a reiteration of the themes laid out in this book. There are nevertheless some observations about the remaining illustrated folios that may be worth mentioning, if only to spark the interest of future scholars.

Josef Strzygowski, at an early point in the Pentateuch studies, commented on the unusually high number of women depicted in the illustrations.[24] Not only do they appear where the text does not require their presence, but the *choice* of stories seems relatively expansive for women's narratives. In folio 68r, for example, where the Israelite men are murmuring against Moses and Aaron for taking them out of Egypt, the scene includes five striped tents filled with

the smiling faces of women and children. It is the most charming moment in the manuscript, yet the rationale for including them has eluded me. The composition, however, of the mother-with-child(ren) type of portrait is reminiscent of late Rome painting on panel and glass.[25] Out of the eighteen surviving illustrated folios, two exclusively tell the story of biblical women. The top half of folio 18r, for example, prominently feature Lot's daughters fleeing Sodom and hiding in the cave, where they trick their father into lying with them in order to become pregnant (Genesis 19). The most curious aspect of this illustration is the severed heads, which lie on the ramparts of the cities engulfed in flames. Surely it seems a "wages of sin" type of moment. Below and to the left, Sarah finds herself sitting beside the bed of Abimelech along with another woman identified as his queen (Genesis 20). The following sequence shows Abraham and Sarah hastily sent on their way, because God has told Abimelech that he will be destroyed if he has sexual relations with another man's wife. In the middle right of the folio Sarah and Hagar, along with their two sons, air their complaints to Abraham (Genesis 21). Although males play a role in the folio, the story is unfolded through the actions of the women. Folio 22r portrays a remarkable series of events taken from the story of Rebecca (Genesis 25:22–25); with her womb swollen from the twins she is carrying, she seeks God's advice. On a direct diagonal toward the lower left, a pictorial device created by a flight of white stone steps, Rebecca, on a birthing stool, gives birth to her twins with the assistance of midwives. Although the naked bodies of Esau and Jacob are difficult to discern, because of the rubbing

of many fingers, they make their entrance into the world with Jacob clinging to his brother's heel. It is, to my knowledge, the only depiction of an actual birthing scene in the early medieval period, although they are found in the late Roman period.[26]

I am also fascinated by the artist's use of architecture to define the stage setting and to move the viewer's eye from one act to another, as in the Rebecca folio. The sophistication of the architecture, both in its interior detail and its function within and around the action, is unprecedented in contemporary art such as the mosaics in Ravenna. At St. Apollinare Nuovo the beautifully rendered architecture is out of scale and a point of departure, not a backdrop that creates the mood such as that found in the Tenth Plague in the Ashburnham Pentateuch (Fig. 26). In the Pentateuch figures stride in and out of the scenes from stage left and stage right. Although I have not pursued this with the degree of research it so richly deserves, the architectural features of the illustrations hint at a legacy from the Roman stage where the *scaenae frons*, or architectural sets, and the *postscaenium* allowed the actors to move in and out of the stage.[27]

The remaining folios promise a rich field for investigation into myriad topics. Some potential areas that remain to be studied are the narratives of biblical women, the potential connection between late antique art and architecture, and the ability of the Ashburnham Pentateuch to act as a witness to the culture of early medieval Rome and Italy. The goal of this study was to place this fascinating manuscript within the mainstream of early medieval culture.

The Burden Shared

Moses conferring his spirit on the seventy elders (Fig. 10) is the final illustration in the codex and is in the best state of preservation, giving some idea of the original vibrancy of the remaining illustrations (folio 127v). The setting comprises three elaborate architectural structures with two towers and covered porticoes. The white and blue bricks complement the pink and orange roof tiles. In the foremost building a wooden altar is covered by a white, fringed cloth, ornamented with five gold and red circles, stands on a lavender platform. Although two golden angels hover above it in a manner similar to that of the golden cherubim of Exodus 25:18–21, the square compartment on the front panel suggests an altar with relics; thus an altar of the Latin western church. At the entrance to this building is a second stone altar, framed by blue curtains. The portico, the altars, the curtains, and the hanging pots all point to the sacred spaces of the church. In the lower left, the wooden doors are thrown wide open and the curtain is drawn back.

To the right, Moses, now balding, stands before the elders; behind him the Hand of God emerges from behind a white and green curtain to bless the aging leader. He turns his head to look at the Hand of God while he raises his right arm in benediction. Before him are fifty-nine male figures, a deviation from the text of Numbers 11, which calls for seventy elders, for which no satisfactory answer can be determined. The sequence is quite clear. Above

the scene the text, which shares the folio, begins with verse 16, in which God instructs Moses to assemble seventy elders, God promises Moses that he will take from Moses part of his Spirit and confer it on the elders, so that they can share the burden of care and leadership of the Israelites. God also promises to provide food for the people. The Spirit then enters the assembled elders, who immediately fall into ecstatic states of prophecy and teaching.

In the hierarchy of clerical orders, the deacons were directly responsible to the bishop, as they were the helpers of the bishop. The ordination prayers, first found in Hippolytus' *Apostolic Traditions* and again in the Veronensis Sacramentary, make clear that Moses, Aaron, and the Levites are types for the bishop and his deacons.[28] The text and the illustration provide a comprehensive picture of the duties and responsibilities of the Roman clergy, who viewed themselves as historically related to Moses and his Levites. The scene of Moses conferring his spirit to the seventy elders, who will feed the poor and teach within the structures of the early medieval Church, is a fitting *ex libris* for the Ashburnham Pentateuch.

Endnotes

A list of abbreviations used is given at the beginning of the Bibliography. Also, shortened versions of titles are given in these notes; for full titles, please refer to the Bibliography.

CHAPTER I

1 *Moralia in Iob* 1.4; CCSL 143. Translations are my own unless otherwise indicated.

2 Gebhardt, *Miniatures*, published black-and-white reproductions of the illuminated pages and transcriptions of the *tituli* within the illuminations. Sörries, *Christlich-antike Buchmalerei*, Vol. 2, gives small color reproductions.

3 On the question of visual language, see most recently Jolly, *Made in God's Image?*, 4–7; C. Hahn, "Seeing and Believing: The Construction of Sanctity in Early-Medieval Saints' Shrines," *Speculum* 72 (1997): 1079–1106; idem., "Picturing the Text: Narrative in the Life of the Saints," *Art History* 13 (1990): 1–33. D. Ganz, "'Pando quod Ignoro': In Search of Carolingian Artistic Experience," in *Intellectual Life in the Middle Ages: Essays Presented to Margaret Gibson* (London: Hambledon, 1996), 25–32. A fundamental work is A.C. Esmeijer, *Divina Quaternitas: A Preliminary Study in the Method and Application of Visual Exegesis* (Assen, The Netherlands: Gorcum, 1978).

4 *Epistles* 9.55 and 11.13; CSEL 140A., 9.209 and 11.10, 768, 873–6.

5 W.J. Diebold, *Word and Image: An Introduction to Early Medieval Art* (Boulder, CO: Westview, 2000); C.M. Chazelle, "Memory, Instruction,

Worship: 'Gregory's' Influence on Early Medieval Doctrines of the Artistic Image," in *Gregory the Great: A Symposium*, ed. J. Cavadini, Vol. 2 of Notre Dame Studies in Theology Series (Notre Dame/London: Univ. of Notre Dame Press, 1995), 181–215; idem., "Pictures, Books and the Illiterate: Pope Gregory I's Letters to Serenus of Marseilles," *Word & Image* 6 (1990): 138–53; L. Duggan, "Was art really the 'book of the illiterate'?," *Word & Image* 5 (1989): 227–51; M. Camille, "Seeing and Reading: Some Visual Implications of Medieval Literacy and Illiteracy," *Art History* 8 (1985): 26–49; N. Gendle, "Art As Education in the Early Church," *Oxford Art Journal* 3 (1979): 3–8.

6 Strzygowski, *Orient oder Rom*, 32–9.

7 M. Olin, *The Nation Without Art: Examining Modern Discourses on Jewish Art* (Lincoln, NE/London: Univ. of Nebraska Press, 2001), 19–20.

8 Weitzmann and Kessler, *The Frescoes,* 143–50; C.H. Kraeling, C.C. Torrey, C.B. Welles, B. Geiger, *The Synagogue. The Excavations at Dura Europos* (Final report 8, Pt. 1) (New Haven, CT: Yale Univ. Press, 1956).

9 Kogman-Appel, "Bible Illustration," 61–96, provides a succinct and cogent summary of the arguments.

10 C. Roth, "Jewish Antecedents of Christian Art," *Journal of the Warburg and Courtauld Institutes* 16 (1953): 24–244; C.O. Nordström, "Some Jewish Legends in Byzantine Art," *Byzantion* 25–7 (1955–1957): 502–8; O. Pächt, "Ephraimillustration, Haggadah und Wiener Genesis," in *Festschrift Karl M. Swoboda zum 28. Januar 1959*, ed. O. Benesch (Vienna: Rohrer, 1959), 213–21; T. Klauser, "Studien zur Entstehungsgeschichte der christlichen Kunst IV," *Jahrbuch für Antike und Christentum* 4 (1961): 136–45; Hempel, "Zum Problem"; idem., "Jüdische Traditionen"; K. Weitzmann, "The Question of the Influence of Jewish Pictorial Sources on Old Testament Illustration," in *Studies in Classical and Byzantine Manuscript Illumination*, ed. H.L. Kessler (Chicago/London: Univ. of Chicago Press, 1971), 76–95; M.D. Levin, "Some Jewish Sources for the Vienna Genesis," *Art Bulletin* 54 (1972): 241–4; S.-M. Ri, "Mosesmotive in den Fresken der Katakombe der Via latina im Lichte der rabbinischen Tradition," *Kairos* 17 (1975): 57–80; K. Schubert and U. Schubert, "Marginalien zur 'Sinai-Szene' in der Katacombe der Via Latina in Rom," *Kairos* 17 (1975): 300–2; K. Schubert, "Die Illustrationen

der Wiener Genesis im Lichte der Rabbinischen Tradition," *Kairos* 25 (1983): 1–17; M. Friedman, "On The Sources of the Vienna Genesis," *Cahiers archéologiques* 37 (1989): 5–17; Weitzmann and Kessler, *The Frescoes*. Essential to this discussion is the collection of reprinted essays, Gutmann, *No Graven Images*.

11 L.V. Rutgers, "The Jewish Catacombs of Rome Reconsidered," in *Proceedings of the Tenth World Congress of Jewish Studies, Jerusalem, August 16–24, 1989*, ed. D. Assaf (Jerusalem: World Union of Jewish Studies, 1990), 29–36, esp. 33; idem., *The Jews in Late Ancient Rome: Evidence of Cultural Interaction in the Roman Diaspora* (Leiden/New York: Brill, 1995).

12 K. Schubert, "Franz Rickerts Studien zum Ashburnham Pentateuch. Refutatio argumentorum," *Kairos* 32 (1991): 23–34; idem., "Jewish Pictorial," 237, n. 213. Schubert's accusation of "massive prejudice" on the part of Rickert is indefensible.

13 Schubert, "Egyptian Bondage," 31. Sed-Rajna, "Further Thoughts," 38, states that, ". . . the theme of oppression in the Ashburnham Pentateuch, [is] a subject of little interest for the Christian reader."

14 The Midrash is a verse-by-verse interpretation of Hebrew scriptures, consisting of homily and exegesis, by rabbis since approximately 400 B.C.E., The *Midrash halakah*, dealing with the legal portions of scripture, is less important for artistic studies than the *Midrash haggada*, dealing with biblical lore. Individual midrashic commentaries were composed by rabbis after the second century C.E., and they were mostly of an *aggadic* nature, following the order of the scriptural text. For an exhaustive account see H.L. Strack, with introduction by G. Stemberger, *Introduction to the Talmud and Midrash*, 2nd ed., trans., ed. Markus Bockmuehl (Minneapolis, MN: Fortress Press, 1996).

15 B. Bamberger, *Fallen Angels* (Philadelphia: Jewish Publication Society of America, 1952), 89–111.

16 Kogman-Appel, "Bible Illustrations," 61–96; Schubert, "Jewish Pictorial," 235–60, esp. 259, acknowledges the widespread popularity of Jewish legends.

17 For example, Schubert, "Jewish Pictorial," 239, argues that the stone circle (cairn) in Laban's Pursuit (folio 30r) corresponds only to the Hebrew whose roots are "to wheel" or "to roll" whereas in the Greek

and Latin the term is "hill" or "tumulus." In none of his examples is he able to point to comparanda in Jewish art, only to works such as the Via Latina paintings.

18 K. Weitzmann, *Illustrations in Roll and Codex: A Study of the Origin and Method of Text Illustration*, Studies in Manuscript Illumination 2 (Princeton, NJ: Princeton Univ. Press, 1970; first published 1947); Weitzmann and Kessler, *Cotton Genesis*, in which the method is applied; G. Sed-Rajna, "Haggadah and Aggadah: Reconsidering the Origins of Biblical Illustrations," in *Byzantine East, Latin West: Art-Historical Studies in Honor of Kurt Weitzmann*, eds. C. Moss and K. Kiefer (Princeton, NJ: Department of Art and Archaeology, Princeton Univ., 1995), 415–27, states that the search for the origins of Hebrew manuscripts illumination was not possible until "Roll and Codex."

19 Lowden, "Cotton Genesis," 40, 50; idem., *Octateuchs*, 1–8, 105–10, 114–17; Mary-L. Dolezal, "The Elusive Quest for the 'Real Thing': The Chicago Lectionary Project Thirty Years On," *Gesta* 35 (1996): 128–41. Essential to this discussion is L. Drewer, "Recent Approaches to Early Christian and Byzantine Iconography," *Studies in Iconography* 17 (1996): 1–65.

20 My own attempt in my doctoral dissertation met with limited success, see Verkerk, "Liturgy and Narrative," chap. 3.

21 Schubert, "Egyptian Bondage," 29–44.

22 Other Haggadot do show a ladder, see Schubert's article under discussion.

23 The iconographic connections to the Padua (Rovigo) Bible and to the San Paolo fuori le mura Bible are discussed at length in Verkerk, "Liturgy and Narrative," 188–91. Both manuscripts are linked to Rome, see S. MacMillan Arensberg, "The Padua Bible and the Late Medieval Bible Picture Book," (Baltimore: Johns Hopkins Univ., PhD dissertation, 1986), 246–8; H.L. Kessler, "Traces of an Early Illustrated Pentateuch," *Journal of Jewish Art* 8 (1981): 20–7; G. Vikan, "Joseph Iconography on Coptic Textiles," *Gesta* 18 (1979): 99–108; O. Pächt, "A Giottesque Episode in English Mediaeval Art," *Journal of the Warburg and Courtauld Institutes* 6 (1943): 51–70.

24 K. Kogman-Appel, "Der Exodyszyklus der Sarajevo-Haggada: Bemerkungen zur Arbeitsweise spätmittelalterlicher jüischer Illuminatoren und ihrem Umgang mit Vorlagen," *Gesta* 35 (1996): 111–27.

25 H. Strauss, "Jüdische Quellen früchristlicher Kunst: optische oder literarische Anregung?," *Zeitschrift für die neutestamentliche Wissenschaft* 57 (1966): 114–36; reprinted in Gutmann, *No Graven Images*; idem., "Jüdische Vorbilder früchristlicher Kunst," in *Atti del IX Congresso internazionale di archeologia cristiana: Roma, 21–27 settembre 1975*, Vol. 2 (Vatican City: Pontificio istituto di archeologia cristiana, 1978), 451–60; in this volume see also H. Brandenburg, "Überlegungen zum Ursprung der frühchrislichen Bildkunst," 331–60.

26 Gutmann, "Jewish Origin."

27 J. Gutmann, "The Dura Europos Synagogue Paintings and Their Influence on Later Christian and Jewish Art," *Artibus et historiae* 17 (1988): 25–30.

28 Rickert, *Studien*, 204–25.

29 Verkerk, "Exodus and Easter Vigil."

30 Kogman-Appel, "Bible Illustration," 61–96. On this term, see: M.J. Buss, "The Idea of Sitz im Leben – History and Critique," *Zeitschrift für die alttestamentliche Wissenschaft* 90 (1978): 157–70.

31 In general, see I. Illich, *In the Vineyard of the Text: A Commentary to Hugh's Didascalion* (London/Chicago: Univ. of Chicago Press, 1993); M.J. Carruthers, *The Book of Memory: A Study of Memory in Medieval Culture* (Cambridge: Cambridge Univ. Press, 1990); W. Ong, *Orality and Literacy: The Technologizing of the Word* (London/New York: Methuen, 1982).

32 Waetzoldt, *Die Kopien*, Figs. 463–85; W. Tronzo, "The Prestige of Saint Peter's: Observations on the Function of Monumental Narrative Cycles in Italy," in *Pictorial Narrative in Antiquity and the Middles Ages*, eds. H.L. Kessler and M.S. Simpson, Studies in the History of Art 16 (Washington, D.C.: National Gallery of Art, 1985), 93–112; H.L. Kessler, "Passover in St. Peter's," *Journal of Jewish Art* 12–13 (1986/87): 169–78.

33 Kessler, "Pictorial Narrative," 75–91; idem., "Pictures As Scripture in Fifth-Century Churches," *Studia Artium Orientalis et Occidentalis* 2 (1985): 17–31; Kitzinger, "The Role," 108–9.

34 Lowden, "The Beginnings," 58–60, provides a skeletal bibliography and outlines the main lines of the argument.

35 Origen, *Hom. Ex.* 2.3, SC 321: "Think rather that you are being taught through these stories that you may learn the right order of life, moral teachings, the struggles of faith in virtue." in R.E. Heine, trans., *Homilies*

on Genesis and Exodus, Fathers of the Church 41 (Washington, D.C.: Catholic Univ. of America Press, 1982), 245.

36 Sörries, *Christlich-antike Buchmalerei*, Plates 6, 8, and 12.

37 Sloane, "The Torah Shrine," 1–12; Gutmann, "The Jewish Origin," 55–72. On the *capitula* lists see Wright, "Canon Table."

38 Weitzmann, *Late Antique and Early Christian*, 118–25; see also Schubert, "Egyptian Bondage," 29–30.

39 Gutmann, "The Jewish Origin," 55–72. Gutmann follows C.R. Morey, "Lecture Notes on Early Latin Manuscripts," (New York University, n.d.), 54, who argued that the disturbed order derives from copying a rotulus or codex. I should like to offer my special thanks to Professor Gutmann for all his bibliographic help, encouragement, and advice.

40 Rickert, "Zu den Stadt- und Architekturdarstellungen," 1341–54.

41 Lowden, "The Beginnings."

42 Wormald, *The Miniatures*; CLA 2, No. 126; McGurk, *Latin Gospel Books*; Sörries, *Christlich-antike Buchmalerei*, 34–6.

43 H. Degering and A. Boeckler, *Die Quedlinburger Italafragmente* (Berlin: Cassiodor-Gesellschaft, 1932); CLA 8, No. 1069; Levin, *The Quedlinburg Itala*; Sörries, *Christlich-antike Buchmalerei*, 23–5.

44 See Lowden, "Cotton Genesis," 47–9, for discussion of the didactic character of this manuscript.

45 Christopher, *The First Catechetical*, 5; Harmless, *Augustine*, 107–54, gives the fullest discussion; see also B. Capelle, "Prédication et catéchèse selon saint Augustin," *Questions liturgiques et paroissiales* 33 (1952): 55–64; L.J. Van der Lof, "The Date of the De catechizandis rudibus," *Vigiliae Christianae* 16 (1962): 198–204; F. van der Meer, *Augustine the Bishop: The Life and Work of a Father of the Church* (London/New York: Sheed and Ward, 1961), 453–67; A.E. Cruz, "El de Catechizandis Rudibus y la metodologia de la ebangelización agustiniana," *Augustinus* 15 (1970): 349–68; T.T. Rowe, *Saint Agustine: Pastoral Theologian* (London: Epworth, 1974), 41–3.

46 L.D. Folkemer, "The Study of the Catechumenate," in *Conversion, Catechumenate, and Baptism in the Early Church*, eds. E. Ferguson, D.M. Scholer, and P.C. Finney, Studies in Early Christianity 11 (New York/London: Garland, 1993), 244–65.

47 *De catechizandis rudibus*, 8–10; G. Madec, *La première catéchèse = De catechizandis rudibus* (Cahors: Études Augustiniennes, 1991); Harmless,

Augustine, 108; W. Burghardt, "Catechetics in the Early Church: Program and Psychology," *Living Light* 1 (1964): 100–18.

48 Laistner, *Christianity*; L. Blake, "Appealing to Children," *Journal of Early Christian Studies* 5 (1997): 243–70.

49 *De catechizandis rudibus*, 3.5.

50 Ibid., 9.

51 See also P.G. Walsh, trans., *The Poems of St. Paulinus of Nola*, Ancient Christian Writers 40 (New York/Paramus, NJ: Newman, 1975), 291–3.

52 *De catechizandis rudibus*, 13.

53 Ibid., 2.3.

54 Laistner, *Christianity*, 59; SC 188. He agrees, 138, n. 32, with S. Haidacher, *Des hl. Johannes Chrysostomus Büchlein über Hoffart und Kindererzieheng* (Freiburg im Breisgau.: n.p., 1907) that "fair books" may be translated as illuminations in manuscripts; however, it may also simply refer to handsome scripts and decoration.

55 In general see W. Kemp, "Visual Narratives, Memory, and the Medieval esprit du system," in *Images of Memory: On Remembering and Representation*, eds. S. Kuchler and W. Melion (Washington, D.C./London: Smithsonian Institution Press, 1991), 87–108.

56 Augustine, *De doctrina cristiana*, 3.20, CCSL 32, suppl. B.

57 Grant, "Development," 32 49; Dujarier, *A History*; L. Turck, "Aux origines du catéchuménat," in *Conversion, Catehcumenate, and Baptism in the Early Church*, eds. E. Ferguson, D.M. Scholer, and P.C. Finney, Studies in Early Christianity 11 (New York/London: Garland, 1993), 266–77.

58 See, Synagogue, Dura Europos, Weitzmann and Kessler, *The Frescoes*, Fig. 74; the lost fresco, San Paolo fuori le mura, Rome, Waetzoldt, *Kopien*, Fig. 355; wooden door, Sta. Sabina, Rome, G. Jeremias, *Die Holztür der Basilika S. Sabina in Rom* (Tübingen, Germany: Verlag Ernst Wasmuth, 1980), Plate 20.

59 *De doctrina christiana*, 2.39,59.

60 The fourth-century pilgrim, Egeria, took Eusebius' onomasticon while on pilgrimage to the Holy Land. See D.E. Groh, "The Onomasticon of Eusebius and the Rise of Christian Palestine," *Studia Patristica* 18, Pt. 1 (1986): 23–31; T.D. Barnes, "The Composition of Eusebius' Onomasticon," *Journal of Theological Studies* 26 (1975): 412–15; E.Z. Melamed, trans., *ha-Onomastikon: The Onomastikon of Eusebius* (Jerusalem.

ha-Universitah ha-Ivrit, 1966); E. Klostermann, ed., *Eusebius. Das Ono-mastikon der biblischen Ortsnamen* (Hildesheim, Germany: Olm, 1966. Reprint); C.U. Wolf, "Eusebius of Caesarea and the Onomasticon," *The Biblical Archeologist* 27 (1964): 66–96; M. Noth, "Die topographis-chen Angaben im Onomastikon des Eusebius," *Zeitschrift des Deutschen Palästina-Vereins* 66 (1943): 32; P. Thomsen, *Loca Sancta. Verzeichnis der im 1. bis 6. Jahrhundert n. chr. erwähnten ortschaften Palästinas* (Halle, Germany: Haupt, 1907).

61 Riché, *Education and Culture*, 165.

62 CSEL, Vol. 31. T. O'Loughlin, "The Symbol Gives Life: Eucherius of Lyon's Formula for Exegesis," in *Scriptural Interpretations in the Fathers: Letter and Spirit*, eds. T. Finan and V. Twomey (Blackrock, CO/Dublin: Four Courts, 1995), 221–52.

63 G. Cremascoli, "Le symbolisme des nombres dans les oeuvres de Gré-goire le Grand," in *Grégoire le Grand. Chantilly, Centre culturel Les Fontaines, 15–19 septembre, 1982. Actes*, eds. J. Fontaine, R. Gillet, and S. Pellistrandi (Paris: Éditions du centre national de la recherche scien-tifique, 1986), 445–54; P.A. Cusack, "Numbers Games and the Second Dialogue of St. Gregory," *Studia Patristica* 15, Pt. 1 (1984): 278–84.

64 *Ep.*, 12.6.

65 Dudden, *Gregory the Great*, Vol. 2, 191.

66 Summaries are found in McKinnon, *The Advent Project*, 104–7; Hen, *Culture and Religion*, 43–54; E. Palazzo, *A History of Liturgical Books from the Beginning to the Thirteenth Century* (Collegeville, MN: Liturgical Press, 1993); C. Vogel, *Medieval Liturgy: An Introduction to the Sources*, trans. W.G. Storey and N.K. Rasmussen (Washington, D.C.: Pastoral Press, 1981). See also K. Levy, *Gregorian Chant and the Carolingians* (Princeton, NJ: Princeton Univ. Press, 1998).

67 A. Chavasse, "Le 'fermentum' instrument d'unité dans la liturgie de la ville de Rome (Ve–VIIIe siècle)," *Ecclesia Orans* 13 (1996): 435–8; Willis, *A History of Early Roman Liturgy*; idem., *Further Essays in Early Roman Liturgy* (London: SPCK, 1968); J. Baldovin, *The Urban Character of Christian Worship, The Origins, Development, and Meaning of Stational Liturgy* (Rome: Pout. Institutum Studiorum Orientalium, 1987).

68 Mohlberg, *Sacramentarium Vernonense*; D.M. Hope, *The Leonine Sacra-mentary: A Reassessment of Its Nature and Purpose* (London: Oxford Univ. Press, 1971).

69 Mohlberg, *Liber sacramentorum romanei aeclesiae.*

70 Most recently, R. McKitterick, "'Nuns' scriptoria in England and Francia in the Eighth Century," *Francia* 19 (1992): 1–35, argues for Jouarre; B. Bischoff, "Die Kölner Nonnenhandschriften und das Skriptorium von Chelles," in *Mittelalterliche Studien. Ausgewählte Aufsätze zur Schriftkunde und Literaturgeschichte* I (Stuttgart: Hiersemann, 1966–1967), 16–34, suggests Chelles.

71 A. Chavasse, *Le sacramentaire gélasien (Vaticanus Reginensis 316)* (Tournai, Belgium: Desclée, 1958).

72 Deshusses, *Le sacramentaire grégorien.*

73 For discussions of paired typological schemes, see A. Grabar, *Christian Iconography: A Study of Its Origins* (Princeton, NJ: Princeton Univ. Press, 1968), 137–46; O. Demus, *Romanesque Mural Painting*, trans. M. Whittall (London: Thames & Hudson, 1970), 24–5; M.A. Lavin, *The Place of Narrative: Mural Decoration in Italian Churches, 431–1600* (Chicago/London: Univ. of Chicago Press, 1990), 15–27; E.S. Malbon, *The Iconography of the Sarcophagus of Junius Bassus: neofitvs iit ad deum* (Princeton, NJ: Princeton Univ. Press, 1990), 32–4 and 42–4.

74 Grant, "Development," 32–49; J. Daniélou, "La catéchèse dans la tradition patristique," *in Conversion, Catehcumenate, and Baptism in the Early Church*, eds. E. Ferguson, D.M. Scholer, and P.C. Finney, *Studies in Early Christianity* II (New York/London: Garland, 1993), 279–92; idem., *The Bible and the Liturgy* (South Bend, IN: Univ. Notre Dame Press, 1960).

75 F.M. Young, *Biblical Exegesis and the Formation of Christian Culture* (Cambridge, England: Cambridge Univ. Press, 1997); idem., "Typology," in *Crossing the Boundaries: Essays in Biblical Interpretation in Honour of Michael D. Goulder*, eds. S.E. Porter, P. Joyce, and D.E. Orton (Leiden/New York/Cologne: Brill, 1994), 29–50.

76 See H.L. Kessler, "Pictures Fertile with Truth: How Christians Managed to Make Images of God without Violating the Second Commandment," *Journal of the Walters Art Gallery* 49–50 (1991/2), 53–65.

77 T.F.X. Noble, "Literacy and the papal government in late antiquity and the early middle ages," in *Uses of Literacy in Early Mediaeval Europe*, ed. R. McKitterick (Cambridge, England: Cambridge Univ. Press, 1990), 82–108.

CHAPTER 2

1 *Historiae Francorum* 2.17, MGH SS rer. merov. 1.1; L. Thorpe, trans., *The History of the Franks* (New York: Penguin Classics, 1974, reprinted 1983).

2 Wright, "Review," 245–55; idem., Canon Tables, 137–55; CLA 5, Nos. 693a, 693b; Quentin, *Mémoire*, 414.

3 Alexander, *Insular*, 32–5.

4 CLA 5, No. 693a; Lowe also observed the use of Notae Tironianae on folio 93v, which reads "de sa-cra-men-to" and another on folio 121. Ninth-century Notae are found on folios 70v, 71v, 76v, 118v, and 126v.

5 Narkiss, "Reconstruction," 22.

6 Quentin, *Mémoire*, Fig. 66.

7 Gebhardt, *Miniatures*, 9.

8 Quentin, *Mémoire*, 298–352; see also J.M. Bover, "La Vulgata en Espana," *Estudios Bíblicos* 1 (1941): 11–40, 167–85; idem., "Origen del Pentateuco Turonense (G)," *Biblica* 9 (1928): 461–3.

9 Chapman, "Families," 5–6; M.-J. Lagrange, "Review" in *Revue biblique* 33 (1924): 115–23; Burkitt, "Note on the Pictures," 414–15; E.K. Rand, "Dom Quentin's Memoir on the Text of the Vulgate," *Harvard Theological Review* 17 (1924): 197–264; F. Stummer, "Die neue römische Ausgabe der Vulgata zur Genesis," *Zeitschrift für alttestamentliche Wissenschaft* 4 (1927): 141–51; B.J. Roberts, *Old Testament Text and Versions, The Hebrew Text in Transmission and the History of the Ancient Versions* (Cardiff, Wales: Univ. of Wales Press, 1951), 261–2. H. Quentin, in "La critique de la vulgate," *Revue bénédictine* 36 (1924): 137–50, responds to the barrage of criticism.

10 Chapman, "Families."

11 Marsden, *Text of the Old Testament*, 14–18, provides a cogent summary of the debate that troubled the Benedictine enterprise in the early twentieth century.

12 *Cambridge History of the Bible*, ed. G.W.H. Lampe (Cambridge, England: Cambridge Univ. Press, 1969), Vol. 2, 113.

13 B. Fischer, "Bibelausgaben des frühen Mittelalters," in *La Bibbia nell'alto Medioevo, Settimane di Studio del Centro italiano di Studi sull'alto*

Medioevo, X, 26 April–2 May 1962 (Spoleto, Italy: Centro italiano di studi, 1963), 519–600, esp. 524. In the same volume, J. Gribomont "Conscience philologique chez les scribes," 601–30, esp. 605, 628, found it impossible to localize, and merely listed it with *"Manuscrits antiques."*

14 Narkiss, "Reconstruction," 20, n. 13.

15 Idem., 19–38. Quentin, in *Mémoire*, 424–5, conjectures sixty-two; Wright, in "Review," 251, sixty-five.

16 Sloane, "The Torah Shrine"; see also J.W. Williams, "A Castilian Tradition of Bible Illustration: The Romanesque Bible from San Millán," *Journal of the Warburg and Courtauld Institutes* 28 (1965): 66–85, who refutes Sloane's thesis that the frontispiece is based on a Torah niche.

17 Twenty-six volumes have been published in the series of known Vetus Latina texts: *Vetus Latina; die Reste der altlateinischen Bibel. Nach Petrus Sabatier neu gesammelt und hrsg. von der Erzabtei Beuron* (Freiburg, Germany: Herder, 1949–).

18 On folio 65r, an odd scribble of a stick figure is found in the lower margin, but the gestures do not correspond to any of the painted figures.

19 Wright, "Review," 255; idem., "When the Vatican Virgil Was in Tours," esp. 66, n. 10.

20 Kessler, *Bibles*, 139–43; Rand, *Survey*, 17, 82, suggests that the late antique manner of ruling was rediscovered in Tours with the arrival of the Ashburnham Pentateuch.

21 Gibson, *Bible*, 31.

22 Narkiss, "Towards," 50–1, 58–9.

23 Weitzmann and Kessler, *The Cotton Genesis*; Jolly, *Made in God's Image?*; Kitzinger, "The Role," 108–9.

24 Grabar, "Fresques romanes," 329–41; Cahn, "A Note," 203–7. Melville Weber first observed this connection, although he never published his findings, which are reported in A.K. Porter's *Spanish Romanesque Sculpture* (Florence/Paris: Pantheon, 1928), Vol. 1, 50, 113, No. 394.

25 J.J.G. Alexander, *Medieval Illuminators and Their Methods of Work* (New Haven, CT: Yale Univ. Press, 1992), 72–84.

26 S. Greenblatt, "Resonance and Wonder," in *Exhibiting Cultures. The Poetics and Politics of Museum Display*, eds. I. Karp and S. D. Lavine (Washington, D.C.: Smithsonian Institution Press, 1991), 42; L. Hunt,

ed., *The New Cultural History* (Berkeley, CA: Univ. of California Press, 1989).

27 Verkerk, "Roman Manuscript," 97–120. The most famous example is the Cassiodoran Codex Grandior, see Alexander, *Insular*, 33.

28 Rand, *Survey*, Plate III; CLA, VI, No. 802.

29 Ganz, "Roman Manuscripts," 615.

30 CLA 5, No. 693b; both Gibson, *Bible*, 20, and *I Goti*, 360, suggest Fleury, but offer no evidence.

31 CLA 5, Nos. 693a, 693b.

32 Gebhardt, *Miniatures*, 1–4, gives a detailed report of the manuscript's provenance as outlined in catalogues.

33 Ibid., 3, misspells Rodd as Road.

34 Maccioni Ruju and Mostert, *Life and Times*, 224.

35 Ibid., 202–31.

36 L. Delisle, *Notice sur les manuscrits disparus de la Bibliothèque de Tours pendant la première moitié du XIX siècle (Notices et extraits des manuscrits XXXI, I)* (Paris: Imprimerie nationale, 1883); idem., *Catalogue des manuscrits des fonds Libri et Barrois* (Paris: Champion, 1888). Repeated attempts have been made to rename the manuscript the Pentateuque de Tours, see Grabar, "Fresques romanes," 329; Narkiss, "Towards," 45; van Ginhoven, "Le Miniaturiste," 61.

37 Maccioni Ruju and Mostert, *Life and Times*, 325–31.

CHAPTER 3

1 *De catechizandis rudibus*, 3.5; CCSL 46; Christopher, *The First Catechetical*, 18.

2 Harmless, *Augustine*, 126–33.

3 Tyrer, *Historical Survey*, 156–7, gives the following list: Creation (Genesis 1), the Fall (Genesis 2, 3), the Flood (Genesis 6–8), Sacrifice of Isaac (Genesis 22), Jacob and Esau (Genesis 27), Passover (Exodus 12), Crossing the Red Sea (Exodus 13–15), Second Song of Moses (Deuteronomy 31, 32), Crossing the Jordan (Joshua 3, 4), Josiah's Passover (II Chronicles 34, 35), Call to Repentence (Isaiah 1), Song of the Vineyard (Isaiah 4, 5), Come to the Waters (Isaiah 54), Valley of Dry Bones (Ezekiel 37), Nebuchadnezzar and the Three Hebrews (Daniel 3), the Books of

Jonah, Habbakuk, and Baruch 3, which is found in the Books of the Apocrypha.

4 Ibid., 157–60. The Roman and Ambrosian collects are directly related to the lesson, whereas the Gallican and Mozarabic intercessory prayers are lengthy in their prayers for groups of people (e.g., virgins, catechumens, penitents, the sick).

5 Mohlberg, *Liber Sacramentorum*, 70–2.

6 The Creation page is out of order in the present state of the book: now folio 1v, it precedes the frontispiece, now found on folio 2r.

7 I have followed Gebhardt's inscriptions. In many cases, he was able to determine more of the inscription than I was able to do when viewing the manuscript over 100 years later.

8 Gebhardt, *Miniatures*, 11.

9 Cf. Cubiculum B, Via Latina in A. Ferrua, B. Nardini intro., and I. Inglis, trans., *The Unknown Catacomb: A Unique Discovery of Early Christian Art* (New Lanark, Scotland: Geddes & Grosset, 1991), Fig. 49; nave, Santa Maria Maggiore, Rome, in B. Brenk, *Die frühchristlichen Mosaiken in S. Maria Maggiore zu Rom* (Wiesbaden, Germany: Steiner, 1975); sanctuary, San Vitale, Ravenna in F. Deichmann, *Frühchristlichen Bauten und Mosaiken von Ravenna* (Baden-Baden, Germany: Grimm, 1958).

10 F. Boespflug and Y. Zaluska, "Le dogme trinitaire et l'essor de son iconographie en Occident de l'époque carlingienne au IVe Concile du Latran (1215)," *Cahiers de civilisation médiévale* 37 (1994): 181–240.

11 Narkiss, "Towards," 60.

12 R. McBrien, *Lives of the Popes* (San Francisco: Harper, 1997), Nos. 45, 59, 60, 61.

13 R.B. Eno, "Papal Damage Control in the Aftermath of the Three Chapters Controversy," *Studia Patristica* 19 (1989): 52–6.

14 The most exhaustive account is Hefele, *History*, Vol. 4, 229–365; concise accounts are given by Dudden, *Gregory*, Vol. 1, 199–210, and Markus, *Gregory the Great*, 125–42.

15 *Nicene and Post-Nicene Fathers*, ed. P. Schaff (Grand Rapids, MI: Eerdmans, 1980–1986. Reprint), Series 2, Vol. 12, letter to Flavian.

16 R. Grégoire, "L'Homéliare romain d'Agimond," *Ephemerides Liturgicae* 82 (1968): 257–305.

17 Markus, *Gregory the Great*, 125–42.

18 H. Percival, ed., *The Seven Ecumenical Councils*, The Library of Nicene and Post Nicene Fathers, 2nd series (New York: Scribners, 1990), Vol. 14, 3.

19 Volbach, *Elfenbeinarbeiten*, No. 119, Plate 63.

20 On Adoptionism, see J.C. Cavadini, *The Last Christology of the West: Adoptionism in Spain and Gaul, 785–820* (Philadelphia: Univ. of Pennsylvania Press, 1993).

21 G.B. Blumenshine, ed., *Liber Alcuini contra haeresim Felicis* (Vatican City: Biblioteca apostolica vaticana, 1980).

22 M.T. Lezzi, "L'arche de Noé en forme de bateau: naissance d'une tradition iconographique," *Cahiers de civilisation médiévale* 37 (1994): 301–24; R.W. Unger, *The Art of Medieval Technology: Images of Noah the Shipbuilder* (New Brunswick, NJ: Rutgers Univ. Press, 1991), 29–49; Rickert, *Studien*, Figs. 75–164.

23 Rickert, *Studien*, Figs. 80–84; Waetzoldt, *Kopien*, Plate 340.

24 ABD, 4, 1123–31.

25 Rickert, *Studien*, 171–5, questions the identification of these figures as giants, preferring to view them as either the result of various models, a rendering of different ages, or an inept attempt at compositional scale. The comparisons of the scorpions on folio 10r, the children on folio 65r, and the soldiers in the Red Sea on folio 68r are not compelling; therefore, the identification of the large figures as giants is upheld, especially because the scriptural text requires giants.

26 The Vienna Genesis also shows figures struggling in the rising waters; see Mazal, *Kommentar*, f. 3.

27 The same hand drew the Creator in the left margin of folio 1v and Isaac's hand in the lower margin of folio 25v.

28 The giants are discussed as witnesses to the influence of Jewish literature: see Schubert, "Jewish Pictorial," 253; Hempel, "Zum Problem," 350; Gutmann, "Jewish Origin," 64.

29 Fink, *Noe*, 7–8; Tonsing, "Interpretation," 24–6.

30 Early scholars cited the appearance of giants in the Ashburnham Pentateuch and the San Sever Beatus as evidence for a Spanish origin: see Berger, *Histoire*, 11–12; Neuss, *Apokalypse*, Vol. 1, 71–3. The San Sever Beatus was created for the French monastery of San Sever between 1028 and 1070: see E.A. van Moe, *L'Apocalypse de Saint-Sever, manuscrit Latin*

8878 de la Bibliothèque nationale (XIe siecle) (Paris: Edition de Cluny, 1943); Williams, *Illustrated Beatus*, Vol. 3, No. 13.

31 Translators have struggled for two millennia with this phrase and have interpreted it to read "sons of God," "angels of God," or "sons of the gods," indicating how problematic the phrase.

32 L. Ginzberg, "Noah and the Flood in Jewish Legend," in *The Flood Myth*, ed. A. Dundes, (Berkeley/Los Angeles/London: Univ. of California Press, 1988), 319–36, esp. 324, gives the various names of giants in Jewish literature: Emim (fear) [Genesis 14:5 and Deuteronomy 2:10–11]; Rephaim (one glance makes the heart grow weak) [Genesis 14:5, 15:20]; Gibborim (giants), Zamzummim (masters of war), Anakim (they touched the sun with their necks) [Deuteronomy 1:28, 2:10–11 and 21, 9:2, Joshua 11:21–22, 14:12 and 15]; Ivvim (like snakes, they knew the soil). The giants depicted in the Octateuchs are represented as fierce warriors; see Smyrna, Lib. Evang. School, A.1, folio 19r [D.C. Hessling, *Miniatures de* Evang. Sch., MS gr. A.1, folio 19r, D.C. Hessling, *Miniatures de l'octateuque grec de Symrne, manuscrit de l'École évangélique de Smyrne* (Leiden, The Netherlands: Sijthoff, 1909), Plate 10(29)]; Rome, Bibl. A post., Vat. gr. 746, folio 50r and Vat. gr. 747, folio 28r, unpublished; see Index of Christian Art, Princeton University.

33 Israel's enemies were sometimes characterized as superhuman in their stature: Numbers 13:33–34; Joshua 13:12. W.E. Stephens, "*De Historia Gigantum*: Theological Anthropology Before Rabelais," *Traditio* 40 (1984): 43–89.

34 D.J.A. Clines, "The Significance of the 'Sons of God' Episode (Genesis 6:1–4) in the Context of the 'Primeval History' (Genesis 1–11)," *Journal for the Study of the Old Testament* 13 (1979): 33–46; M. Delcor, "Le mythe de la chute des anges et de l'origine des géants comme explication du mal dans le monde dans l'apocalyptique juive histoire des traditions," *Revue de l'Histoire des Religions* 190 (1976): 3–53; Alexander, "The Targumim," 60–71; Robert, "Les fils de Dieu," 340–73, 525–52.

35 ABD, Vol. 2, 508–16.

36 BR 5, 2.; B. Bamberger, *Fallen Angels* (Philadelphia: The Jewish Publication Society of America, 1952), 90–3, discusses the disappearance of Enoch and the legend of the angels from rabbinic literature, not

because the rabbis did not know Enoch's apocryphal account, but because they purposefully suppressed it. Following this tradition, the Aramaic *Targum* translates "sons of God" (*bene ha-Elohim*) as "sons of nobles"; A. Tsukimoto, "Der Mensch ist geworden wie unsereiner – Untersuchungen zum zeitgeschichtlichen Hintergrund von Gen. 3, 22–4 und 6, 1–4," *Annual of the Japanese Biblical Institute, Tokyo* 5 (1979): 3–44.

37 *Chrono.* 2, PG 10.65; Alexander, "The Targumim," 63; Robert, "Les Fils de Dieu," 348–65.

38 *Responsiones ad Tiberium Diaconum* in *Sancti Patris Nostris Cyrilli Archiepiscopi Alexandrini in D. Joannis Evangelium*, ed. P.E. Pusey (Brussels: Culture et Civilisation, 1965), Vol. 3, 557–602; translated in L.R. Wickham, "The Sons of God and the Daughters of Men: Genesis vi 2 in Early Christian Exegesis," *Oudtestamentische Studiën* 19 (1974): 135–47.

39 Alexander, "The Targumim," 66, suggests that the Christian interpretation is then adapted by later Jewish exegetes.

40 Ibid., 135–6.

41 Ibid., 145.

42 The germ of this interpretation is found in Philo of Alexandria's *De Gigantibus* 13.58–15.67, who argues that Genesis 6:4 is not a fable; see C.D. Yonge, *The Works of Philo Complete and Unabridged* (Peabody, MA: Henrickson, 1993), 152–7.

43 Augustine is quoting the Apocryphal Book of Jubilees 3:26–28.

44 Alexander, "The Targumim," 61–2, states that authoritative Jewish texts, following R. Simeon's commentary that starts a widespread reaction against the Enoch tradition, also understood the "giants" as fair, or tall, or long lived, but not of superhuman stature or of angelic lineage.

45 The dichotomy is found in *De catechizandis rudibus* 1.31; Christopher, *The First Catechetical*, 127, n. 194, provides a synopsis of Augustine's use of the term *civitas*.

46 D.A. Young, *The Biblical Flood: A Case Study of the Church's Response to Extrabiblical Evidence* (Grand Rapids, MI: Eerdmans, 1995), 13–15; Lewis, *A Study*, 113; Tonsing, "Interpretation," 171–83; B. Reicke, *The Disobedient Spirits and Christian Baptism: A Study of 1 Pet. III.19 and its Context* (Copenhagen: Ejnar Munksgaard, 1946), 70–90.

47 *De catechizandis rudibus* 1.32.

48 Quentin, *Mémoire*, 412–23, believed that the artist was familiar with a particular breed of lion found in the mountains of modern Tunisia, Morocco, and Algiers.

49 Gebhardt, *Miniatures*, 13, views this raven as a mistake; the bird, according to him, should be a dove.

50 ABD, Vol. 4, 1072–3.

51 Lewis, *A Study*, 161–7.

52 *De sacramentis* 2.1.1, SC 25brs; Thompson, *St. Ambrose*, 58, emphasis mine.

53 See also the chalices depicted on the Riha paten and the mosaic of Theodora in S. Vitale, Ravenna; Braun, *Christliche*, Plate 6, No. 16, Plate 41, No. 146.

54 R. Suntrup, "Präfigurationen des Messopfers in Text und Bild," *Frühmittelalterliche Studien* 18 (1984): 468–528.

55 Rickert, *Studien*, 204–25; Tonsing, "Interpretation," 166–8, 184–93; J. Quasten, *Monumenta eucharistica et liturgica vetussima* (Bonn: 1935–1937), 118, 145. Fink, *Noe*, 15–18, argues that Noah is a figure of penance, linking him to the persecutions of the third and early fourth century.

56 *De myst.*, 3.10; B. Ramsey, trans., *Ambrose* (New York/London: Routledge, 1997), 148.

57 *De sacramentis* 1.4.11–12 and 1.6.23; *De myst.*, 8.45.

58 Thompson, *St. Ambrose*, 57.

59 For summaries of early Christian representations of the Crossing of the Red Sea, see J. Lassus, "Quelques Représentations du 'Passage de la Mer Rouge' dans l'art chrétien d'Orient et d'Occident," *Mélanges d'archéologie et d'histoire* 46 (1929): 159–81; and K. Wessel "Durchzug durch das Rote Meer" in *Reallexikon für Antike und Christentum*, ed. T. Klauser (Stuttgart: A. Hiersemann, 1959), Vol. 4, Cols. 370–90.

60 B. Narkiss, "Pharaoh Is Alive and Well and Living at the Gates of Hell," *Journal of Jewish Art* 10 (1984): 11–12, suggests that the dark-skinned figure on the horse in the upper left of the scene is the Egyptian Pharaoh. Pharaoh, however, is not shown as dark-skinned anywhere in the manuscript, although other Egyptians are frequently so depicted.

61 See also Exodus 14:19, 24; 33:9–10; Numbers 12:5; 14:14; Deuteronomy 31:15; Nehemiah 9:12, 19; Psalm 99:7.

62 J. Wilpert, *I sarcophagi cristiani antichi* (Rome: Pontificio istituto di archeologia cristiana, 1932), Vol. I, Plate LXXXXVII (4); Vol. II, Plates CCIX (3), CCX (1,2), CCXI (1,2), CCXVI (8).

63 Cubicula C and O in the Via Latina, Rome, both depict the Pillar of Fire with the scene of Moses on Mount Sinai, not in the scene of the Red Sea Crossing; Tronzo, *Via Latina*, 52–66.

64 G. Jeremias, *Die Holztür der Basilika S. Sabina in Rom* (Tübingen, Germany: Wasmuth, 1980), Plates 26, 28.

65 S. Dufrenne, *L'Illustration des psautiers grecs du moyen âge* (Paris: Klincksieck, 1966), Plates 14, 23, 39, 55.

66 M. Metzger, *La Haggada enluminé* (Leyden: Brill, 1973), 288–301, Plates 357, 381, 384, provides a survey of the Crossing in Haggadot.

67 A. Cutler, *The Aristocratic Psalters in Byzantium* (Paris: Picard, 1984), Figs. 107, 155, 229, 253, 326, 369; Lowden, *Octateuchs*, Figs. 133–136; Cavallo, *Exultet*, 281, 282, 404, 437; Avery, *Exultet Rolls*, Plates LXXIV, CLIX.

68 The combination of the pillar of fire and pillar of cloud is relatively rare, but is found in the Farfa Bible (folio 1v) and the fresco in the nave of St.-Savin; see H. Focillon, *Peintures romanes des églises de France* (Paris: Hartmann, 1938), Plates 32, 34, 35.

69 The term Pasch is derived from the Hebrew Pesach, or Passover; Dix, *Shape*, 338–40.

70 The length and the hour the vigil began often varied, although the tendency was to move from an all-night vigil to one that started earlier. The Old Gelasian Sacramentary states that the vigil should begin at the middle of the eighth hour.

71 Augustine, *Hom.* 219; see also 220 and 221 for the importance of keeping the Easter Vigil. Although Augustine does not specifically mention the pillar of fire as a symbol of Christ, the sermons are permeated with light imagery. One sermon, "Denis 1," of dubious Augustinian authorship, does make the connection between Christ and the pillar of fire emphatically clear; see P.T. Weller, *Selected Easter Sermons of Augustine* (St. Louis, MO: Herder, 1959). A. Wilmart, "Easter Sermons of St. Augustine," *Journal of Theological Studies* 28 (1926–27): 113–44, excludes "Denis 1" from his compilation; Muldowney, *Saint Augustine*, also excludes it from her translations, as does A. Kunzelmann, "Die Chronologie der

Sermones des hl. Augustinus," in *Miscellanea Agostiniana Testi et Studi,* Studi Augustiani II (Rome: Tipografia poliglotta vaticana, 1930), 417–520. The sermon is first found in a twelfth-century manuscript from the church of S. Severino, Naples (Vienna, Öst. Natbibl. cod. 651), and included as by Augustine in a partial publication of the manuscript by M. Denis, *Sancti Aurelii Augustini Hipponensis episcopi sermones inediti admixtis quibusdam dubiis,* 1792.

72 J. Daniélou, *The Bible and the Liturgy* (Notre Dame, IN: Univ. of Notre Dame Press, 1960), 86–98, gives a scholarly overview of the baptismal typology in the Crossing of the Red Sea; see also M. Haykin, "'In The Cloud and in the Sea': Basil of Caesarea and the Exegesis of 1 Cor. 10:2," *Vigiliae Christianae* 40 (1986): 135–44; J.P. Lewis, "Baptismal Practices of the Second and Third Century Church," *Restoration Quarterly* 26 (1983): 1–17; P. Lundberg, *La typologie baptismale dans l'ancienne église* (Leipzig: Lorentz, 1942); F.J. Dölger, "Der Durchzug durch das Rote Meer als Sinnbild der christlichen Taufe," *Antike und Christentum* 2 (1930), 63–9.

73 This reinterpreting of Jewish history and prophecy is derived from Luke 24:25–27, 44–46, in which Christ explains to his disciples all the passages in the Hebrew scripture that refer to him.

74 MacGregor, *Fire and Light,* 406–9.

75 Three variations developed: the Paschal candle lit directly from the new fire and carried in procession; the Paschal candle carried unlit in procession and then lit by a small candle; or, a small lit candle carried on procession to the Paschal candle that remained stationary by the altar. Ibid., 291–5.

76 Ibid., 299–308; Kelly, *Exultet,* 30–43.

77 *Ep. Ad Praesidium,* PL 30.188–194; Kelly, *Exultet,* 40–1, n. 9, provides the sources for the question of the letter's authenticity.

78 *Liber Pontificalis XLIII.* The interpretation of *parociae* is debated. Duchesne, *Christian Worship,* 252, and L.R. Loomis, *The Book of the Popes (Liber Pontificalis)* (New York: Columbia Univ. Press, 1916), 88, understood *parociae* to mean the suburban churches in the diocese of Rome; MacGregor, *Fire and Light,* 494–5, argues that it could be the seven suburbicarian doiceses within the immediate area of Rome, or to those regions that owed allegiance to Rome.

79 PL 63.258–262; J. Pinell, "La benedicció del ciri pasqual I els seus textos," in *Liturgica 2: Cardinali I. A. Schuster in memoriam*, Scripta et documenta 10 (Montserrat: Abbatia Montserrat, 1956), 1–119, provides the early texts.

80 Ep. 11.33, PL 77.1146; see Dudden, *Gregory the Great*, 1, 445–6.

81 MacGregor, *Fire and Light*, 427–8; see *Ordo* 11, *Ordo* 16, *Ordo* 23, *Ordo* 24, and *Ordo* 30b in M. Andrieu, *Le Pontifical Romain au Moyen-Age*. Vol. 1: *Le Pontifical Romain du XIII siècle* (Vatican: Biblioteca apostolica vaticana, 1938).

82 Bari, Arch. del cap. metro., Benedictional, Consecration of the font and Procession to the font; Bari, Arch. del cap. metro., Exultet 2, *Fratres carissimi*; London, Brit. Lib. Add. MS 30337, Exultet, *Sacrificium vespertinum*; Naples, Bibl. Naz., Exultet 1 of Mirabella-Eclano, Raising the candle, Montecassino, l'Abbazia, Exultet 2, Deacon and congregation. See Cavallo, *Exultet*, 148, 207, 261, 307, 386; Avery, *Exultet Rolls*, Plates XIX, XIII, XIV, L, LVI, LXVI.

83 Cavallo, *Exultet*, 148.

84 H. Belting, "Byzantine Art among Greeks and Latins in Southern Italy," *Dumbarton Oaks Papers* 28 (1974): 19. A depiction of the procession to the font in another medium that includes the Paschal candle is found on the baptismal font in Chiavenna; see F. Nordström, *Medieval Baptismal Fonts: An Iconographical Study* (Umeå, Sweden: Universitetet i Umeå, 1984), Fig. 61.

85 It is important to distinguish between the early *benedictio cerei*, also called the *laus cerei*, and the later, standard form, which is the beautiful and well-known Exultet composed of three parts: the *Exultet*, the *Sursum corda*, and the *Vere quia dignam*; see J. Juglar, "À propos de la Vigile pascale. La 'benedictio cerei,'" *Ephemerides Liturgicae* 65 (1951): 182–7.

86 The authorship of the Exultet has been hotly debated, probably because there are so many early versions. The problem is summarized by Dendy, *Use of Lights*, 128–9 and Cavallo, *Rotoli*, 3–7, who also provides an excellent bibliography.

87 The origin of the Resurrection symbolism can be traced to the *lucernarium* ceremony (the taking of the lighted lamp from the tomb) in Jerusalem; see G. Bertoniere, "The Historical Development of the Easter Vigil and Related Services in the Greek Church," *Orientalia Christiana Analecta* 193 (1972): esp. 22–5. Dix, *Shape*, 23, 87, 418, believes the

Paschal candle was originally a light for the reading of the vigil lessons and that the blessing is a survival of Jewish practice (*chaburah*) in Christian worship.

88 It was the high-sounding prose and the digressions into Virgil's *Georgics* in praise of bees – characteristic language for the blessing – that Jerome castigated in his famous letter to Praesidius (384 A.D.), the deacon who had asked Jerome to compose a *benedictio cerei*.

89 MacGregor, *Fire and Light*, 406–9.

90 Ibid., 156–60, outlines the Biblical texts from which all Easter Vigil lessons are drawn.

91 Biblical texts abound with the light/Christ metaphor: see, e.g., Isaiah 49:9; Matthew 5:14; John 8:12, 9:5, 12:35; Ephesians 5:14; I John 1:5.

92 G.B. Gray, in *Sacrifice in the Old Testament: Its Theory and Practice*, 2nd ed. (New York: Ktav, 1971), 4–7, 28–30, defines these two offerings as those that were burnt whole upon the altar and those that were partially burnt; the remaining part of the slain animal was distributed either among the priests or among the offerer and the priests.

93 Cambridge, Corpus Christi Coll. MS 286, folio 125; see Wormald, *Miniatures*, Plate I.

94 In his letter to Augustine of Canterbury, *Ep.* 64 (PL 77. 441), Gregory the Great answers the question of how the offerings of the faithful, which are received at the altars, should be used. Following Roman custom, they were to be divided into four parts for use by the bishop, the clergy, the poor, and for the repair of churches. This epistle also indicates that more than bread and wine was received from the people and that the gifts were placed on several subsidiary altars. Gregory, *Hom.* 5, also interprets the burnt offerings on a moral level, at which the Christian offers on the altar of the heart.

95 See Jungmann, *Mass*, Vol. 2, 1–9. Dix, *Shape*, 111, 120–3, emphasizes the fundamental difference between "receiving the offerings beforehand in the sacristy and receiving them at the chancel in the offertory," but insists that the East had an offertory procession of the people. R.F. Taft, "Toward the Origins of the Offertory Procession in the Syro-Byzantine East," *Orientalia Christiana Periodica* 36 (1970): 73–107; and *The Great Entrance: A History of the Transfer of Gifts and Other Pre-Anaphoral Rites of the Liturgy of St. John Chrysostom*, Orientalia Christiana Analecta 200 (Rome: Pontificium Institutum Studiorum Orientalium, 1978),

11–34, argues convincingly that in the East there was never an offertory procession of the faithful: the people's gifts were accepted by the deacons in the sacristy as they arrived; the Eucharistic bread and wine were brought from the prothesis to the altar in the solemn Great Entrance procession.

96 MGH conc. 1.166. The words echo the typological language of the canon of the Mass. The canon of 585 orders the return to the practice of offering the bread and wine at the Eucharist as it had fallen into disuse in the Gallican rite; see Bishop, "Diptychs," 115, and Steuart, *Development*, 136. Duchesne, *Christian Worship*, 204, is careful to differentiate between the *processio oblationis*, the bringing of the prepared bread and wine, and the offertory of the people, which he claims is a ceremony of Roman origin.

97 Mohlberg, *Liber Sacramentorum*, 33, 184. The following rubric adds, "*Et tacis. Et recitantur nomina virorum et mulierum, qui ipsos infantes suscepturi sunt.*"

98 See Chapter 1 for a discussion of the sacramentary.

99 Age, 595, Fig. 83.

100 On the early history of veiled women, see M.R. D'Angelo, "Veils, Virgins, and the Tongues of Men and Angels," in *Off With Her Head!: The Denial of Women's Identity in Myth, Religion, and Culture*, ed. H. Eilberg-Schwartz, (Berkeley, CA: Univ. of California Press, 1995), 130–45.

101 The numerous depictions of women, which are beyond the requirements of the text, is another unique feature of the manuscript. I cannot agree with Strzygowski, *Orient oder Rom*, 35, that the inclusion of women is a reflection of the practice of polygamy in the East.

102 The division between the north side of the church for women and the south side for men in the West is discussed by Jungmann, *Mass*, Vol. 2, 414. The practice of segregating women on the south side and men on the north side of basilicas in Constantinople is discussed by T. Mathews, *The Early Churches of Constantinople: Architecture and Liturgy* (University Park, PA/London: Univ. of Pennsylvania Press, 1971), 130–2.

103 Davies, "Deacons, Deaconesses," 1–15.

104 Cf. the depiction of women in folio 68r, where they are not veiled. The veiling of women in church was surely derived from 1

Corinthians 9:5,6, in which Saint Paul admonishes women to be veiled in church.

105 Dix, *Shape*, 111; and J. Coppens, "L'Offrande des fidèles dans la liturgie eucharistique ancienne," in *Cours et conférence de semaines liturgiques* (Louvain, France: Abbaye du Mont César, 1927), Vol. 5, 99–123. The people are usually referred to as the offerers; it is clear, however, that the laity bring the oblation, the deacons present it, and the celebrant offers it to God.

106 R.P.C. Hanson, *Eucharistic Offering in the Early Church* (Nottingham, England: Grove, 1979) provides a survey of the pre-Nicene Fathers. See also Stevenson, *Eucharist and Offering* (New York: Pueblo, 1986), 74–98; and Dix, *Shape*, 110–12.

107 *Dial. Try. Jud.* 13 (PG, 6.502); Justin quotes Amos 6:22, Psalm 40:6, and Jeremiah 6:20; see also Malachi 1:10–11.

108 *Hom.* 59.5; 58.1, PL 54.333, 340.

109 The covenant that was read to the children of Israel included the Ten Commandments and the ordinances outlined in Exodus 20–23. This is borne out by Hebrews 9:19–22, which refers to Exodus 24:3–8. See J. James, *The Law of the Covenant: An Exposition of Exodus 21 23* (Tyler, TX: Institute for Christian Economics, 1984), 46–61, and "Covenant," in ABD, Vol. 1, 1179–202.

110 Kessler, Bibles, 63, Figs. 87, 90, also identifies the object in Moses' hand as an open diptych.

111 DACL, Vol. 4, 1083–91. When the list of names exceeded the space on the diptych, the list would be continued in the sacramentary itself.

112 *Con. Faus. Man.* 15.5, PL 42.305–7.

113 DACL, Vol. 4, 1049. Bishop, "Diptychs," 112–14, differentiates between eastern and western practice. In the Latin rites the recital of the names of the living was prominent at an early period, whereas in the Greek rites, during the fourth century, the recital of names of the dead was customary. The addition of the names of the dead, constituting a proper diptychs (two lists naming the living and the dead), first appears in the Gallic and Mozarabic rites in the seventh century along with other eastern church practices. In Rome, the recital of the names of the dead was restricted to masses for the dead until the ninth and tenth centuries when the Roman rite adopts the proper diptychs of living and dead. See Dix, *Shape*, 502–11, and Steuart, *Development*, 145 6, who both prefer

the term "Names" – one list of living offerers – rather than the term "diptychs."

114 Steuart, *Development*, 135.

115 Bishop, "Diptychs," 109. The letter of Pope Innocent I to Bishop Decentius of Gubbio has created a knotty problem of translation among liturgists concerning the exact placement of the Names in relation to the canon. The bibliography is extensive, but the main lines of contention have been summarized by Steuart, *Development*, 135–45. See also R. Cabie, *La Lettre du pape Innocent I à Decentius de Gubbio (19 Mars 416). Texte critique, traduction et commentaire* (Louvain, France: Publications universitaires de Louvain, Bureau de la R.H.E, 1973), esp. 40–4.

116 These rubrics and prayer immediately follow the prayer cited in n. 87: *Item infra actionem. Hanc igitur oblationem, Domine, ut propitius suscipias deprecamur: quam tibi offerimus pro famulis et famulabus tuis, quos ad aeternam vitam et beatum gratiae tuae donum numerare, eligere atque vocare dinatus es. Per Christum. Et recitantur nomina electorum.* Mohlberg, *Liber Sacramentorum*, 33; R. Keifer, "The Unity of the Roman Canon: An Examination of Its Unique Structure," *Studia Liturgica* 11 (1976), 39–58, points out the interdependence of intercession and offering in the Roman canon.

117 That the Roman canon was used in the Ambrosian rite in Milan is indicated by Ambrose, *De sacramentis* 4.6, in his instructions to catechumens during Lent: "And the priest says: 'Therefore having in remembrance his most glorious passion and resurrection from the dead and ascension into heaven, we offer to thee this spotless offering, reasonable offering, unbloody offering, this holy bread and cup of eternal life: and we ask and pray that thou wouldst receive this oblation on thy altar on high by the hands of thy angels, as thou didst vouchsafe to receive the presents of thy righteous servant Abel, and the sacrifice of our patriarch Abraham, and that, which the high priest Melchizedek offered to thee'" (Thompson, *St. Ambrose*, 92–3). For the Roman origin of Ambrose's eucharistic prayer, see B. Botte and C. Mohrmann, *L'Ordinaire de la messe* (Paris: Éditions de Cerf, 1953), 17.

118 Eusebius, *Ecclesiastical History* 6.43.11, SC, 41, 55, 73; Jungmann, *Mass*, Vol. 2, 8, n. 32. The precedence of deacons over presbyters in Rome was due to their being limited to seven in number; Dudden, *Gregory*, Vol. 1, 131.

119 *De eccl. off.* 2.8, CCSL, 113.

120 H.B. Porter, *The Ordination Prayers of the Ancient Western Churches*, Alcuin Club Collections 49 (London: S.P.C.K., 1967), 11, 31, 33, 67, 69. The Spanish prayers that refer to deacons as Levites are derived from Rome, where deacons had greater prestige than presbyters. Ibid., 13, 59; see also Willis, *History*, 145; Dudden, *Gregory*, Vol. 1, 131.

121 Thompson, *St. Ambrose*, 48, n. 2.

122 The lesson begins with Numbers 8:4.

123 Willis, *History*, 141.

124 See the Aelfric Paraphrase (London, Brit. Lib. Cotton Claudius B. iv, folio 100r); C.R. Dodwell and P. Clemoes, *The Old English Illustrated Hexateuch*, Early English Manuscripts in Facsimile 18 (Copenhagen: Rosenkilde og Bagger, 1974); the Padua (Rovigo) Bible (London, Brit. Lib. MS Add. 15277, folio 12v); G. Folena and G.L. Mellini, *Bibbia istoriata padovana della fine del Trecento* (Venice: N. Pozza, 1962); and the Laud Mahzor, (Oxford, Bodl. Lib. MS Laud Or. 321, folio 127v); Sed-Rajna, "Further Thoughts," Fig. 1.

125 Hebrews 9:11–10: 25 is a reinterpretation of Exodus 24:1–8.

126 The altar with its white cloth with gold decoration and fringe closely resembles the one depicted in the offering of Abel and Melchizedek in S. Vitale, Ravenna. The cavity in the front also resembles extant altars with niches for relics; see Braun, *Christliche*, Plates 1, 6, 37, 38. Revel-Neher, *L'Arche d'Alliance*, 165, notes the opening in the face of the "ark," but does not describe it as a reliquary altar. She also identifies the gold circle in the center of the altar as a Eucharistic host, although it should be viewed as part of the decorative trim on the cloth.

127 This particular combination of tents pitched against a tabernacle can be found in a fourth-century Roman gold glass fragment; see A. St. Clair, "God's House of Peace in Paradise: The Feast of Taberna-cles on a Jewish Gold Glass," *Journal of Jewish Art* 2 (1984): 6–15. In the Utrecht Psalter (Utrecht, Bibl. der Rijk., Cat. Cod. MS Bibl. Rheno-traiectinae, I, nr. 32, folio 25); see E. Dewald, *The Illustrations of the Utrecht Psalter* (Princeton, NJ: Princeton Univ. Press, 1932), Plate XL.

128 Exodus 25:8 – "Make me a sanctuary and I will dwell among them . . ." – could also be used to explain the tents. However, other elements in the scene speak for a more complicated, typological explanation, which is provided by the texts cited.

129 See "Tabernacle" in *Harper's Bible Dictionary*, ed. P. J. Achtemeier (San Francisco: Harper's, 1985), 1013–14.

130 The number of Old Testament lessons could vary from four to twelve, although all of them were taken from a comparatively small cycle of passages, which concluded with Psalm 42 (*Quemadmodum*); Tyrer, *Historical Survey*, 156–60.

131 B. Kühnel, "Jewish Symbolism of the Temple and the Tabernacle and Christian Symbolism of the Holy Sepulchre and the Heavenly Tabernacle," *Journal of Jewish Art* 12/13 (1986/87): 147–68, discusses in detail the use of the desert tabernacle to symbolize the heavenly tabernacle of Revelation 31:3 and the heavenly Jerusalem. See also J. Chydenius, *Medieval Institutions and the Old Testament*, Societas Scientiarum Fennica. Commentationes Humanarum Litterarum 37.2 (Helsinki: n.p., 1965), 32.

132 Dudden, *Gregory*, Vol. 1, 51–2. The third Council of Braga, canon 5, describes the use of reliquary altars in processions in terms of the ark of the covenant being carried by the Levites (PL 84.589–90).

133 For other biblical texts that speak of the new heavenly tabernacle see Acts 7:44–50; Revelation 15:5–6, 21:1–4.

134 I Corinthians 3: 16: "Surely you know that you are God's temple, where the Spirit of God dwells." Augustine, *Cont. Faust. Man.* 19.10, PL 42.353–54, uses the Old Testament tabernacle as a type for the Christian in whom Christ dwells. See also Caesarius of Arles, *Hom.*, 200.20, CCSL, 103–4.

135 See also Psalm 51:9 and Isaiah 1:8, which are quoted by Ambrose, *De mys.* 7.34, 36 and 8.43.

136 Easter week was known as *hebdomada alba*, or white week; the Sunday after Easter was also known as *dominica in albis*. Caesarius of Arles, *Hom.*, 200.5; 201.2; 203.4; 201.4.

137 Augustine, *Hom.* 223, PL 38.1092; see Muldowney, *Saint Augustine*, 181–2.

138 *De sacramentis* 4.1. Ambrose is referring to Hebrews 9:6–10; he also quotes I Peter 2:5, 9.

139 See also Revelation 4:4, 19:14; and M.H. Shepherd, *The Paschal Liturgy and the Apocalypse*, Ecumenical Studies in Worship 6 (Richmond, VA: John Knox Press, 1960), 89–91.

CHAPTER 4

1 *Hom.* 2.3, SC 321; Heine, *Homilies*, 245.

2 Augustine, *De catechizandis rudibus* 4.7. On the transformative power of the catechism, see B. Stock, *Augustine the Reader: Meditation, Self-Knowledge, and the Ethics of Interpretation* (Cambridge, MA/London: Harvard Univ. Press, 1996), 181–90.

3 *De catechizandis rudibus*, 8–9.

4 *Moralia in Iob*, dedication, iv; *Reg. Pas.*, Pt. 3.

5 The two sets of brothers are often discussed together and viewed as sets of opposites: see for example, Ambrose, *De Cain et Abel* 1.1, who relied heavily on Philo of Alexandria's *De Sacrificiis Abelis et Cain*. On the prevalence of opposing dyads in biblical narratives see Niditch, *Underdogs*.

6 *An Address*, 39.

7 I John 3:11–12; see also Romans 9 and Hebrews 11.

8 Weitzmann, *Late Antique*, 118.

9 Wormald, *Miniatures*; CLA 2, No. 126; McGurk, *Latin Gospel*, 34–6; G. Henderson, "Losses and Lacunae in Early Insular Art," in *Studies in English Bible Illustration* (London: Pindar, 1985), Vol. 1, 1–33.

10 J. Duft, *Die Bibel von Moutier-Grandval, British Museum Add. MS. 10546* (Bern, Switzerland: Verein Schweizerischer Lithographiebesitzer, 1971). Most recently, P.E. Dutton and H.L. Kessler, *The Poetry and Paintings of the First Bible of Charles the Bald* (Ann Arbor, MI: Univ. of Michigan Press, 1997).

11 On early medieval color symbolism, see L. James, *Light and Colour in Byzantine Art* (Oxford, England: Clarendon, 1996); J. Gage, *Colour and Culture: Practice and Meaning from Antiquity to Abstraction* (London: Thames and Hudson, 1993); A. Petzold, "His Face Like Lightning: Colour as Signifier in Representations of the Holy Women at the Tomb," *Arte medievale* Series 2, Vol. 6 (1992): 149–56; J. Engemann, "Zur Schönheit des Teufels im Ravennatischen Weltgerichtsbild," in *Memoriam sunctorum venerantes: miscellanea in onore di Monsignor Victor Saxer* (Vatican City: Pontificio istituto di archeologia cristiana, 1992), 30–5; M. Pastoureau, *Couleurs, images, symboles: Etudes d'histoire et d'anthropologie* (Paris: Le Léopold d'Or, 1989); C. Eggenberger,

"Der Farbakkord Orange-Violett. Beobachtungen zur Farbwahl in der spätantiken und frühmittelalterlichen Buchmalerei," in *Von Farbe und Farben. Albert Knoepfli zum 70. Geburtstag,* ed. H.J. Albrecht (Zurich: Manesse, 1980), 283–91.

12 Gutmann, "Jewish Origin," 55–72, suggested that the ordering of scenes may be derived from Hebrew which reads right to left. See D.H. Verkerk, "The Moral Structure of the Ashburnham Pentateuch," in *Image and Belief: Essays in Honor of the 80th Anniversary of the Index of Christian Art,* ed. C. Hourihane (Princeton, NJ: Princeton Univ. Press, 1998), 71–88.

13 "Here is where Cain slays his brother Abel." On later representations of the first murder weapon, see M. Schapiro, "'Cain's Jaw-Bone That Did the First Murder'," in *Late Antique, Early Christian and Mediaeval Art: Selected Papers* (New York: Braziller, 1979), 249–65. First published in *Art Bulletin* 24, 1942, 205–12. An important correction is given by G. Henderson, "Cain's Jaw-Bone," in *Studies in English Bible Illustration* (London: Pindar, 1985), Vol. 1, 216–28.

14 K. Schubert, "Jewish Pictorial," 249–53; see also Hempel, "Zum Problem," 105, and "Jüdische Traditionen," 350.

15 *Genesis Rabba* 22.7 to Genesis 4:8 (Mirqin 1, 170); *Tanhuma, Bereshit* 9 (9b); *Midrash Gadol Genesis* 4:8 (118ff).

16 The theme of conflict is so widely discussed in secondary literature that a link to rabbinical literature is not necessary. See also R. Mellinkoff, *The Mark of Cain* (Berkeley, CA: Univ. of California Press, 1981) and idem., *Outcasts: Signs of Otherness in Northern European Art of the Late Middle Ages,* 2 vols. (Berkeley/Los Angeles/Oxford: Univ. of California Press, 1993), Vol. 1, 16–19.

17 P.-H. Michel, "L'iconographie de Caïn et Abel," *Cahiers de civilisation médiévale* 1 (1958): 194–9.

18 Adam and Eve, clothed in animal skins accompanied by Cain and Abel carrying their gifts, are also found in Cubiculum B, Via Latina, Rome; see R. Valabrega, "L'iconografia catacombale di Adamo ed Eva," *Rivista di storia e letteratura religiosa* 22 (1986): 24–55, Fig. 8; for the early history of the first family in art see D. Korol, "Zum Bild der Vertreibung Adams und Evas in der neuen Katakombe an die via Latina und zur anthropomorphischen Darstellung Gottvaters," *Jahrbuch für Antike und Christentum* 22 (1979): 175–90; A. Ulrich, *Kain und Abel in*

der Kunst: Untersuchungen zur Ikonographie und Auslegungsgeschichte (Bamberg, Germany: Universität Bamberg, 1981). For more general sources see "Abel et Cain" in DACL, I/1; Erffa, *Ikonologie*, 346–84, and M. Alexandre, *Le Commencement du livre Genèse I–V: La version grecque de la Septante et sa réception* (Paris: Beauchesne, 1988), provide invaluable catalogues of texts, exegetical sources, and art.

19 The use of animal and agricultural metaphors was a common teaching device, see Riché, *Education*, 148–52; Eucherius, *Formulae* 3–4; J.M. Petersen, "The Garden of Felix: The Literary Connection Between Gregory the Great and Paulinus of Nola," *Studia Monastica* 26 (1984): 215–30.

20 J.F. Moffitt, "Vitruvius in a Carolingian Eden: The Genesis Cycle from the Moûtier-Grandval Bible," *Source* 12 (1992). 7–12, contends, wrongly I believe, that the hut motif is derived from Vitruvius' *De architectura*.

21 Genesis 3.21: "And the Lord God made garments of skins for the man and for his wife, and clothed them." Gregory I, *Moralia in Iob*, 12.6, interprets Adam's clothes a metaphor for his innocence. On the contrast to the garments of paradise, see B. Murdoch, "The Garments of Paradise: A Note on the Wiener Genesis and the Anegenge," *Euphorion Zeitschrift für Literaturgeschichte* 61 (1967): 375–82; S. Brock, "Clothing Metaphors as a Means of Theological Expression in Syriac Tradition," in *Typus, Symbol, Allegorie bei den östlichen Vätern und ihren Parallelen im Mittelalter*, ed. M. Schmidt (Regensburg, Germany: Pustet, 1982), 11–38.

22 H.F.D. Sparks, *The Apocryphal Old Testament* (Oxford, England: Clarendon, 1984), 147–67. This connection was first made by Gutmann in "Jewish Origin," 55–72.

23 The Greek version is more often referred to as the *Apocalypse of Moses*.

24 Stone, *History*, 6–41; G.A. Anderson and M.E. Stone, trans., *A Synopsis of the Books of Adam and Eve* (Atlanta, GA: Scholars Press, 1994).

25 Stone, *History*, 42–74, surveys the main lines of the arguments; see also M. de Jonge and J. Tromp, *The Life of Adam and Eve and Related Literature* (Sheffield, England: Academic, 1997). In the quest to reconstruct the *Vorlage*, several scenarios have been proposed: an original Hebrew or Aramaic book, an original Greek book based on Jewish traditions, or a purely Greek original. Some scholars have simply declared that there was an Aramaic or Hebraic, first-century original without providing

evidence for this claim. Attempts to reconstruct a Hebraic or Aramaic original have proven inconclusive; however, evidence for Greek as the original language of the Adam Book is also inconclusive. Scholars suggest a date to the fourth century or earlier.

26 Stone, *History*, 75–83, 84–123, provides references to Adam Books and specific sources that include Gnostic, Mandean, Greek, Latin, Syriac, Ethiopic, Arabic, Armenian, Georgian, Coptic, Old Irish, Slavonic, and medieval Hebrew literature.

27 The Gelasian Decree, compiled in the sixth century, lists the *Liber qui appelatur paenitentia Adae, apocryphus*; see E. von Dobschütz ed., *Das Decretum Gelasianum, Texte und Untersuchungen zur geschichte der altchristlichen Literatur* 38 (Leipzig, Germany: Hinrichs, 1912), line 297.

28 The angels that appear in the Genesis frontispiece to the Grandval Bible are linked by Kessler, *Bibles*, 29–30, to the *Vita Adae et Evae*; see also M. Bernabò, "Searching for Lost Sources of the Illustration of the Septuagint," in *Byzantine East, Latin West: Art-Historical Studies in Honor of Kurt Weitzmann*, eds. D. Mouriki, C. Moss, K. Keifer (Princeton, NJ: Princeton Univ. Press, 1995), 329–38; idem., "La cacciata dal paradiso e il lavoro Dei progenitori in alcune miniature medievali" in *La miniature italiana e età romanica e gotica: Atti del I Congresso Storia della Minitura Italiana. Cortona 26–26 maggio 1978*, ed. G.V.S. Waldenburg (Florence: Olschki, 1979), 269–81.

29 Eve baring her breast for her son and wearing rough clothes is also found in the Moutier-Grandval Bible, folio 5v.

30 Philo of Alexandria, *De Sac. Abelis et Cain* 5.20–6.33, also discusses this dichotomy, which is allegorized as two women who live within each individual: One is called virtue and the other pleasure.

31 Gregory I, *Ep.*, 9.54, was firmly in favor of chaste nursing mothers as opposed to sexually active mothers who gave their children to wet nurses.

32 Willis, *History*, 30–1.

33 Cf. the apse mosaic of S. Apollinare in Classe, *Age*, No. 505, and the creation of plants, Cotton Genesis, Weitzmann and Kessler, *The Cotton Genesis*, Fig. 1.

34 W. Molsdorf, *Christliche Symbolik der mittelalterlichen Kunst* (Graz, Austria: Adademische Druck-u. Verlagsanstalt, 1926. Reprint, 1984),

111–13; G.B. Ladner, *Handbuch der frühchristlichen Symbolik: Gott Kosmos Mensch* (Stuttgart/Zürich: Belsner, 1992), 138–43. Erffa, *Ikonologie*, 101. Cf. Mosaic floor, synagogue of Hamman-Lif, Tunisia; gold glass bowl from Rome, Age, No. 344(a), No. 503.

35 Cf. the nave mosaics of S. Apollinare Nuovo, Ravenna; a silver fifth-century reliquary casket from Northern Italy, K.S. Painter and J.P.C. Kent, *Wealth of the Roman World AD 300–700* (London: The British Museum, 1977), 94, No. 157; and the Pola casket from Rome, H. Buschhausen, *Die spätrömischen Mettalscrinia und frühchristlichen Reliquiare: Katalog* (Vienna, Cologne, Graz: Hermann Böhlaus Nachf., 1971), 219–23, No. B10.

36 Matthew 23:35; Luke 1:51.

37 "Abel dans la liturgie," in DACL I/1, 62–6; J. Hennig, "Abel's Place in the Liturgy," *Theological Studies* 7 (1946): 126–41.

38 C. Ihm, *Die Programme*, Plates 5 (1,2), 6(1), 12(1,2), 26(3).

39 Ibid., Plates 9(2), 11(1); For Roman and Ravennate sarcophagi, see J. Wilpert, *I sarcophagi cristiani antichi* (Rome: Pontificio istituto di archeologia cristiana, 1929–1936), XXXIX; XLII (5); LXXXII; CXXXXI; CXXXXIX; CLIV; J. Kollwitz and H. Herdejürgen, *Die Sarkophage der westlichen Gebeite des Imperium Romanum: De Ravennatischen Sarkophage* (Berlin: Gebr. Mann, 1979), Vol. 2, Plates 24, 29, 31, 45, 48, 53, 60, 64, 67, 69, 72, 75, 81, 92.

40 "I listen for the downfall of my cruel foes. The righteous flourish like a palm-tree, they grow tall as a cedar on Lebanon; planted as they are in the house of the Lord," (Psalm 92:11–13).

41 "Either make the tree good and its fruit good, or make the tree bad and its fruit bad; you can tell a tree by its fruit . . . A good man produces good from the store of good within himself; and an evil man from evil within produces evil." See also Matthew 3:10; 7:15–20; Luke 3:9; 6:43–45; Jude 12.

42 *Formulae*, 3.

43 I use the term wheat, rather than corn, because the term corn is associated with maize, not the wheat/cereal grain of the Old World from which the term corn is derived.

44 K.M.D. Dunbabin, *The Mosaics of Roman North Africa: Studies in Iconography and Patronage* (Oxford, England: Oxford Univ. Press, 1978),

62, 119–21, 252; A. Merlin, "La mosaïque du seigneur Julius à Carthage," *Bulletin archéologique du Comité des travaux historiques et scientifiques* (1921): 95–114.

45 Corn and wheat have a venerable tradition joining them to the harvest and death. Both were associated with Demeter, identified in Italy as Ceres. As a deity of agriculture she is linked to sowing, reaping, threshing, and storing. Through her daughter Persephone she is also closely affiliated with the Underworld. See "Demeter," *Oxford Classical Dictionary*, 3rd ed., ed. S. Hornblower and A. Spawforth (Oxford/New York: Oxford Univ. Press, 1996), 447–8.

46 *De catechizandis rudibus* 7.11; 17.26; 19.31; 27.54; Eucherius, *Formulae*, 3, develops this metaphor; Chaff is blown in the wind: Job 13:25; 21:18; Psalms 1:4; 35:5; 83:13; Isaiah 13:17; 29:5; 33:11; 41:15; Jeremiah 13:24; Daniel 2:35; Hosea 13:3; Zephaniah 2:2.

47 Matthew 3:12; 13:24–30, and 36–43; Luke 3:17.

48 A. Ferrua, with an introduction by B. Nardini, *The Unknown Catacomb: A Unique Discovery of Early Christian Art*, trans. I. Inglis (New Lanark, Scotland: Geddes & Grosset, 1991), Figs. 27, 122, 123, 127.

49 Cf. Chromatius Aquileiensis, *Trac. Math.*, 11.111; Augustine, *Ennar. Ps.*, 100.12; *Hom.*, 223.53; Caesarius of Arles combines the fruit-bearing tree and the chaff, *Hom.*, 209; Gregory I, *Moralia in Iob*, 17.10; 27.30; *Hom.*, 22. Gregory, writing to Innocent, Præfect of Africa, *Ep.*, 10, 37, describes his *Moralia in Iob* as chaff compared with Augustine's fine wheat.

50 U. Koenen, "Die brennende Stadt: Sodom in spätantiken Darstellungen," *Actes du XIe Congrès International d'Archéologie Chrétienne Lyon, Vienne, Grenoble, Genève et Aoste (21–28 Septembre 1986)*, Vol. 2, Studi di Antichità Cristiana, Vol. 41 (Vatican City: Pontificio istituto de archeologia cristiana, 1989), 1355–67.

51 Niditch, *Underdogs*, 100–11, places the wise Jacob and the foolish Esau within the larger discussion of this motif in folktales.

52 T.L. Thompson, "Conflict of Themes in the Jacob Narratives," *Semeia* 15 (1979): 5–26.

53 The enlarged hand as a compositional/narrative device is found in the mosaic Parting of Lot and Abraham, Santa Maria Maggiore, Rome; Brenk, *Die frühchristlichen Mosaiken*, Abb. 38.1.

54 Jolly, *Made in God's Image?* 11–13, 14–15, 31–2; M. Barasch, *Gestures of Despair in Medieval and Early Renaissance Art* (New York: New York

Univ. Press, 1976); R. Brilliant, *Gesture and Rank in Roman Art: The Use of Gesture to Denote Status in Roman Sculpture and Coinage* (New Haven, CT: The Academy, 1963); I. Jucker, *Der Gestus des Aposkopein ein Beitrag zur Gebärdensprache in der antiken Kunst* (Zurich: Juris, 1956).

55 Hebrews 12:15 also deals harshly with Esau: "Look to it that there is no one among you who forfeits the grace of God, no bitter noxious weed growing up to poison the whole, no immoral person, no one worldly-minded like Esau. He sold his birthright for a single meal, and you know that although he wanted afterwards to claim the blessing, he was rejected; though he begged for it to the point of tears, he found no way open for second thoughts."

56 The parable is based on Ezekiel 34, which states that God will judge the sheep and the goats.

57 *Age*, 558, No. 501.

58 *Ep.*, 32.17

59 *An Address*, 44–51. The oracle of Malachi begins with God's love of Jacob and hatred of Esau and then continues, in Chap. 2:10–16, with the imperative to contract suitable marriages.

60 The prototypes are the parables of the Wise and Foolish Virgins (Matthew 25:1–13) and the Three Servants (Matthew 25:14–30).

61 *Ep.*, 59.

62 *Hom.*, 86.

CHAPTER 5

1 G.B. De Rossi, *Inscriptiones christianae vrbis Romae septimo saecvlo antiqviores* II (Rome: ex officina libraria pontificia, 1888), 6.3.

2 B. Ward-Perkins, in "Continuists, Catastrophists, and the Towns of Post-Roman Northern Italy," *Papers of the British School at Rome* 65 (1997): 157–76, discusses the ideological positions of those who see catastrophic decline versus those who see transformations in the early medieval urban landscape.

3 *Actes du XIe Congrès international d'archéologie chrétienne: Lyon, Vienne, Grenoble, Genève et Aoste (21–28 Septembre 1986)* Studi di antichità cristiana 41, eds., N. Duval, F. Baritel, P. Pergola (Rome: Ecole française de Rome, 1989); *La storia economica de Roma nell'alto Medioevo alla luce dei*

recenti scavi archeologici. Atti del Seminarios Roma 2–3 april 1992, eds. L. Paroli and P. Delogu (Florence: Edizioni All'Insegna del Giglio, 1993); *Early Medieval Rome and the Christian West: Essays in Honour of Donald A. Bullough*, ed. J.M.H. Smith (Leiden/Boston/Cologne: Brill, 2000).

4 Coates-Stephens, "Housing," 239–60; R.S. Valenzani, "Residential Building in Early Medieval Rome," in *Early Medieval Rome and the Christian West: Essays in Honour of Donald A. Bullough*, ed. J.M.H. Smith (Leiden/Boston/Cologne: Brill, 2000), 101–12.

5 Coates-Stephens, "Housing," 239.

6 Christ, *Handbook*, 64.

7 R. Beer, *Monumenta palaeographica vindobonensi. Denkmäler der Schreibkunst aus der Handschriftensammlung des Habsburg-Lothringischen Erzhauses* I (Leipzig, Germany: Hiersemann, 1910), 10.

8 R. Coates-Stephens, in "Dark Age Architecture in Rome," *Papers of the British School at Rome* 65 (1997): 177–232, discusses the problems of relying solely on the *Liber Pontificalis* for papal building projects. Documentary studies of early medieval ecclesiastical construction are G. Ferrari, *Early Roman Monasteries: Notes for the History of the Monasteries and Convents at Rome from the V Through the X Century* (Rome: Pontificio istituto de archeologia cristiana, 1957); and C. Hvelsen, *Le chiese de roma nel medioevo* (Florence: Olschki, 1927; reprint, Hildesheim/New York: Olms, 1975).

9 CBCR, II, 1–144.

10 CBCR, IV, 2,3,28; M.G. Barberini, *I Santi Quattro Coronati a roma* (Rome: Fratelli Palombi Srl, 1989).

11 CBCR, I, 197, 208–9.

12 *Historiae Francorum* 10.1.

13 *Gregory*, 4–5, 51–9.

14 J.N. Collins, *Diakonia: Reinterpreting the Ancient Sources* (New York/Oxford: Oxford Univ. Press, 1990), 66–9, clarifies that, although the terms deacon and *diaconia* are cognate, the *diaconiae* are not derived from the deacons, even though the deacons were the agents of public assistance. The term *diaconia*, of eastern derivation, first appears in Rome in the seventh century; F. Niederer, "Early Medieval Charity," *Church History* 21 (1952), 285–95; D.J. Birch, *Pilgrimage to Rome in the Middle Ages: Continuity and Change* (Woodbridge, England: Boydell, 1998), 123–5; 128–9; É. Hubert, "Les résidences des étrangers à Rome,"

Roma fra oriente e occidente 19–24 prile 2001 49 (Spoleto, Italy: Centro italiano di studi sull'alto medioevo), 173–204.

15 R. D'amico, "Alcuni aspetti storici e topografici nella rome dell'VIII se-colo: l'organizzione assistenziale; le diaconie," in *Roma e l'età carolingia: atti delle Giornate di studio, 3–8 maggio 1976* (Rome: Multigrafica ed-itrice, 1976), 229–36; O. Bertolini, "Per la storia dell diaconie romane," *Archivio della Società romana di Storia patria* 70 (1947): 1–145.

16 CBRC, II, 275–307; L. Cavazzi, *La diaconia de S. Maria in Via Lata e il monastero di S. Ciriac*o (Rome: Pustet, 1908).

17 CBRC, IV, 286.

18 CBRC, I, 244–65.

19 CBRC, III, 72–81.

20 F. Marazzi, "Il conflitto fra Leone III Isaurico e il papato tra il 725 e il 733, e il 'definitivo' inizio del medioevo a Roma: un'ipotesi in discussione," *Papers of the British School at Rome* 59 (1991): 231–58; D. Whitehouse, L. Costantini, F. Guidobaldi, S. Passi, P. Pensabene, S. Pratt, R. Reece, and D. Reese, "The Schola Praeconum II," *Papers of the British School at Rome* 53 (1985): 163–210.

21 Llewellyn, *Rome*, 93; A. Paul, "Early Medieval Amphorae, the Duchy of Naples and the Food Supply of Rome," *Papers of the British School at Rome* 61 (1993): 231–44.

22 P. Delogu, "The Papacy, Rome and the Wider World in the Sev-enth and Eighth Centuries," in *Early Medieval Rome and the Chris-tian West: Essays in Honour of Donald A. Bullough*, ed. J.M.H. Smith, (Leiden/Boston/Cologne: Brill, 2000), 197–220.

23 P. Mirti, A. Lepora, and S. Saguì, "Scientific Analysis of Seventh-Century Glass Fragments from the Crypta Balbi in Rome," *Archaeom-etry* 42 (2000): 359–74.

24 CBCR, V, 99, 174–175; since Krautheimer's publication see S. de Blaauw, *Cultus et decor* (Vatican City: Biblioteca Apostolica Vaticana, 1994); A. Arbeiter, *Alt-St Peter in Geschichte und Wissenschaft: Ab-folge der Bauten, Rekonstruktion, Architekturprogramm* (Berlin: Mann, 1988); C. Pietrangeli, ed., *La basilica di San Pietro* (Florence: Nar-dini, 1989). Markus, *Gregory the Great*, 122, characterizes the projects as modest.

25 CBCR, V, 259–61.

26 CBCR, I, 15.

27 CBCR, III, 153–77; L. Pani Ermini, "Testimonianze archeologishe de monasteri a Roma nel'alto medioevo," *Archivio della Società Romana de Storia Patria* 104 (1981): 25–47; J.M. Phillips, "A Study of Monastic Patronage in Rome from the Fifth Through the Eleventh Centuries," Ph.D. dissertation (Univ. of Washington, 1974), 15.

28 T.F.X. Noble, "Paradoxes and Possibilities in the Sources for Rome Society in the Early Middle Ages," in *Early Medieval Rome and the Christian West: Essays in Honour of Donald A. Bullough*, ed. J.M.H. Smith (Leiden/Boston/Cologne: Brill, 2000), 55–84; Ward-Perkins, *From Classical Antiquity*, 60.

29 CBCR, V, 174–175.

30 CBCR, I, 14–38.

31 CBCR, III, 153–77.

32 Ward-Perkins, *From Classical Antiquity*, 58–62.

33 CBCR, III, 61–2.

34 CBCR, III, 133.

35 Coates-Stephens, "Housing," 239–60.

36 Ward-Perkins, *From Classical Antiquity*, 61–5. He notes in the first section of his book that much of the decay had begun by the fourth century.

37 J. Osborne, "Textiles and Their Painted Imitations in Early Medieval Rome," *Papers of the British School at Rome* 60 (1992): 309–52.

38 Matthiae, *Mosaici*, Vol. I, 149–68, Vol. II, Figs. 89, 91–7, 101, 102; Oakshott, *Mosaics*, 145–6, Figs. 76–82; Osborne and Claridge, *Early Christian*, 118–21.

39 G. Matthiae, *SS. Cosma e Damiano e S. Teodoro* (Rome: Danesi, 1948); idem., *Mosaici*, Vol. I, 143–67, Vol. II, 79, 86–8; Oakshott, *Mosaics*, 147–8, Figs. 83–6; Osborne, *Early Christian*, 322.

40 Matthiae, *Mosaici*, Vol. I, 169–79, Vol. II, 90, 98–100; Oakshott, *Mosaics*, 149–50, Fig. 87.

41 Matthiae, *Mosaici*, Vol. I, 191–201, Vol. II, 104–24; Oakshott, *Mosaics*, 150–3, Figs. 95–105; C. Pietrangeli, *San Giovanni in Laterno* (Florence: Nardini, 1990).

42 C. Davis-Weyer, "Speaking of Art in the Early Middle Ages: Patrons and Artists Among Themselves," in *Testo e immagine nell'alto medioevo* (Spoleto, Italy: Presso la sede del centro, 1994), Vol. 2, 955–88.

43 Eps. 8.4 and 9. 11.

44 Ep. 14. 12.

45 G.C. Menis, ed., *I Longobardi* (Milan: Electa, 1990), 352–5; A. Merati, *Il duomo di Monza e il suo tesoro* (Monza, Italy: Comune di Monza, 1982), 266–8.

46 R. Balzaretti, in "Theodelinda, 'Most Glorious Queen': Gender and Power in Lombard Italy," *The Medieval History Journal* 2 (1999): 183–207, understands the term to mean an embroidered case, although no such example survives.

47 *Hist. Lang.* IV, 5.

48 J. Elsner, "Replicating Palestine and Reversing the Reformation," *Journal of the History of Collections* 9 (1997): 117–30.

49 Markus, *Gregory the Great*, 1.

50 Ep. 10.37.

51 Ep. 1. 41, 41a.

52 Ep. ad Eugenium. PL, Vol. 80, Cols. 723–28.

53 R. Valentini and G. Zucchetti, *Codice topografico della città di Roma* (Tipografia del Senato: Rome, 1942), Vol. 2, 168.

54 Llewllyn, *Rome*, 102.

55 Krautheimer, *Profile*, 62.

56 CLA 255, Petrucci, "L'onciale Romana."

57 Marsden, *Text of the Old Testament*, 12–15.

58 M. Walsh and D. Ó Crónín, *Cummian's Letter "De Controversia Paschali" Together with a Related Irish Computistical Tract "De Ratione Computandi,"* Studies and Texts 86 (Toronto, 1988), 93–5.

59 G. Plessi, "La Biblioteca della Chiesa Roman durante il pontificato di Papa Gregorio Magno," *L'Archiginnasio: bulletino della Biblioteca comunale di Bologna* 35 (1940): 267–75.

60 Lowden, "Beginnings," 43–5; Wright, "Canon Table," 137–55 ; McGurk, *Latin Gospel*, No. 3; Wormald, *Miniatures*, 1, 14–16; Lowe, CLA, Vol. II, No. 126.

61 H. Swarzenski, in "Unknown Bible Pictures by W. de Brailes and Some Notes on Early English Bible Illustration," *Journal of the Walters Art Gallery* 1 (1938): 55–67, made an early proposal that the miniatures were painted in England after a late antique original, a suggestion that has not found acceptance.

62 K. van der Horst, W. Noel, and W. Wüstefeld CM, eds., *The Utrecht Psalter in Medieval Art: Picturing the Psalms of David* (Westrenen, The Netherlands: HES, 1996); *Vollständige Faksimile-Ausgabe im*

Originalformat der Handschrift 32, Utrecht-Psalter, aus dem Besitz der Bibliotheek der Rijksuniversiteit te Utrecht, Codices selecti phototypice impressi 75 (Graz, Austria: Akademische Druck- u. Verlagsanstalt, 1982).

63 Wormald, *Miniatures*, 4–5.

64 *Vita sanct. abbat. mon.*, 4–6.

65 P. Meyvaert, "Bede and the Church Paintings at Wearmouth-Jarrow," *Anglo-Saxon England* 8 (1979): 63–77, esp. 67–8, 74; Verkerk, "Roman Manuscript," 101.

66 R.P. Bergman, D. de Grazia, and S.N. Fliegel, *Vatican Treasures: Early Christian, Renaissance, and Baroque Art from the Papal Collections* (Cleveland, OH: Cleveland Museum of Art, 1998), 28–9.

67 Bede, 369, 373.

68 J. Dyer, "The Schola Cantorum and Its Roman Milieu in the Early Middle Ages," in *De Musica et Cantu: Studien zur Geshichte der Kirchenmusik und der Oper. Helmut Hucke zum 60. Geburtstag,* eds. P. Cahn and Ann-K. Heimer (Hildesheim/Zurich/New York: Olms, 1993), 19–40; McKinnon, *The Advent Project,* 86–7.

69 Llewellyn, *Rome,* 109–25; E.G.C.F. Atchley, *Ordo Romanus Primus* (London: De La More Press, 1905), 117–19.

70 McKinnon, *The Advent Project,* 84–6.

71 Ibid., 64.

72 *Historiae Francorum* 10.1

CHAPTER 6

1 *Vita sanct. abbat. mon.* 11; King, *Baedae Opera,* 419.

2 Sörries, *Christlich-antike Buchmalerei,* Vol. 1, 26; for more comprehensive discussions of the lengthy and complex scholarship on the Ashburnham Pentateuch see Rickert, *Studien,* 19–42 and Verkerk, "Liturgy and Narrative," 17–36, 177–82, for an analysis of the Palmyrene/Coptic origin, not discussed here as the arguments date from Strzygowski's 1901 publication, which has not found general acceptance. For a shortened version of my arguments, see Verkerk, "Roman Manuscript."

3 *I Goti,* 360; Bischoff, *Latin Palaeography,* 193, thought it possibly came from Spain; Gibson, *Bible,* 20; Weitzmann, *Late Antique,* 118, 121;

F. Bucher, *Pamplona Bibles* (New Haven, CT: Yale Univ. Press, 1970), Vol. 1, 81, 131, n. 31.

4 Strzygowski, *Orient oder Rom*, 34–5; Springer, *Die Genesisbilder*, 665–733.

5 Cf. D.J. Birch, *Pilgrimage to Rome in the Middle Ages: Continuity and Change* (Woodbridge, England: Boydell, 1998); D. Ó Crónín, "Cummianus Longus and the Iconography of Christ and the Apostles in Early Irish Literature," in *Sages, Saints and Storytellers: Celtic Studies in Honour of Professor James Carney*, eds. D. Ó Corráin, L. Breatnach, and K. McCone (Maynooth, Ireland: An Sagart, 1989), 268–79; J. Sumption, *Pilgrimage: An Image of Mediaeval Religion* (London: Faber & Faber, 1975).

6 Berger, *Histoire*, 12.

7 Berger, *Histoire*, 11–12. Berger's betacism evidence is confusing, because his example substitutes a **u** for a **p**; usually, a **u** sound is made indistinguishable from a **b** sound in a spoken dialect.

8 Quentin, *Mémoire*, 422.

9 CLA 11, No. 1629; Bischoff, *Latin Palaeography*, 78, n. 182.

10 Reproduced in Quentin, *Mémoire*, 421, Fig. 66.

11 See CLA 11, No. 1629; CLA, 1, Nos. 1a, 34; CLA 3, Nos. 304, 319; CLA 5, Nos. 635, 658. See also S.J. Ehrle and P. Liebaert, *Specimina codicvm Latinorvm Vaticanorvm* (Bonn Marcus et Weber, 1912), Plate 7; Chapman, "Families," 369; A. Beccaria, *I codici di medicina del periodo presalernitano (secoli IX, X e XI)* (Rome: Edizioni di Storia e letteratura, 1956), No. 92; P. Petitmengin, "Que signifie la souscription 'contuli'" in *Les Lettres de Saint Augustin découvertes par Johannes Divjak. Communications présentées au collogue des 20 et 21 Septembre 1982*, ed. C. Lepelley (Paris: 1983), 365–74; Christ, *Handbook*, 58.

12 Bischoff, *Latin Palaeography*, 193.

13 A. Millares Carlos with J.M. Ruiz Asencio, *Tratado de paleografía espanola* 1, 3rd ed. (Madrid: Hernando, 1983), 27–8.

14 CLA 9, No. 1249.

15 CLA 1, No. 18. The third volume has not survived. R. Gregoire, "L'Homéliare romain d'Agimond," *Ephemerides Liturgicae* 82 (1968): 257–305.

16 Petrruci, "L'onciale Romana."

17 Ganz, "Roman Manuscripts," 608.

18 CLA 1, No. 114.

19 CLA 2, No. 164.

20 CLA 3, No. 278.

21 CLA 4, Nos. 438, 489a.

22 Petrruci, "L'onciale Romana."

23 Nordenfalk, *Early Medeival*, 22, also saw these motifs as indicative of Northern Africa.

24 For a full discussion of black Egyptians, see D.H. Verkerk, "Black Servant, Black Demon: Color Ideology in the Ashburnham Pentateuch," *The Journal of Medieval and Early Modern Studies* 31 (2001): 57–78.

25 See L. Bugner, ed., *The Image of the Black in Western Art*, I, New York, 1976; II, Parts 1 and 2 (Houston, TX: Menil Foundation, 1979). Blacks appear in biblical traditions such as the Byzantine Octateuchs; see F. Mütherich, "Geographische und ethnographische Darstellungen in der Buchmalerei des frühen Mittelalters," in *Popoli e paesi nella cultura altomedievale 23–29 aprile 1981* (Settimane di studio del centro italiano di studi sull'alto medioevo 29) (Spoleto, Italy: Presso la sede del Centro, 1983), Vol. 2, 709–50.

26 Rickert, in "Zu den Stadt," 1341–54, pointed out the futility of using the architecture depicted in the manuscript as an indication of origin; in *Studien*, 185–6, Rickert suggests that the exotic animals were perhaps derived from such works as the Ambo of Agnellus in Ravenna or zoological codices.

27 Quentin, *Mémoire*, 412–23.

28 Neuss, *Apokalypse*, 71–3; idem., "Ikonographische studien zu den Kölner Werken der altchristlichen Kunst II. Die blaue Schale aus Mungusdorf," *Zeitschrift für christliche Kunst* 29 (1916): 17–21. D. Miner, "Review," *Art Bulletin* 15 (1933), 388–91, was critical of Neuss's acceptance of Quentin's Northern African origin for the model. Neuss's reply follows on 391–3 and his defense by Pijoan, "Note on the Problem of the Apocalypse," 393–4. Neuss reiterated his position in "Die Illustrationen der Handschrift von Gerona im Lichte der übrigen Beatus-Illustrationen," in *Sancti Beati a Liebana in Apocalypsin Codex Gerundensis (Die Apokalypse von Gerona)*, eds. J.M. Casanovas, C.E. Dubler, and W. Neuss (Oltun, Switzerland: U. Graf, 1962), 44–63.

29 Nordenfalk, *Early Medieval*, 161, concurred with Quentin and Neuss.

30 Williams, *Illustrated Beatus*, Vol. 3, 44–54, provides cogent and insightful summary of the issues.

31 Werckmeister, "Pain and Death," 600–5; Rickert, *Studien*, 151–3, 181–4, any real link, suggesting that the figures of the giants could be traced to late antique types, such as those found on sarcophagi.

32 Werckmeister, "Pain and Death," 600–5.

33 Williams, in *Illustrated Beatus*, 44, suggests that a group of lay itinerant professionals created the San Sever Beatus.

34 Ibid., 44–6; however, Williams declines to give his opinion on the giants. In his "A Castilian Tradition of Bible Illustration: The Romanesque Bible from San Millán," *Journal of the Warburg and Courtauld Institutes* 28 (1965): 66–85, esp. 72–3, Williams states that the Ashburnham Pentateuch has no connection to the Spanish Bible pictorial traditions.

35 Gebhardt's less scientific evidence included such items as costumes and household implements, which are unreliable indicators of origin, see M.O.H. Carver, "Contemporary Artefacts Illustrated in Late Saxon Manuscripts," *Archaeologia* 108 (1986): 117–45.

36 CLA 5, No. 693a. Lowe included nearby Illyrium in his proposal. He cited for comparison the Valerianus Gospels in Munich (Ibid., IX, 1959, No. 1249). This conclusion found favor with David Wright, "Review," esp. 251.

37 CLA 1, Nos. 17, 32, 66, 113; CLA 2, Nos. 126, 255; CLA 3, Nos. 303a, 358, 359, 366, 388, 399; CLA 4, Nos. 436b, 492; CLA 6, Nos. 784, 838; CLA 9, No. 1388**40; CLA 10, No. 1455.

38 CLA 9, No. 299; CLA 5, Nos. 517, 681.

39 CLA 1, No. 93; CLA 2, No. 139; CLA 3, No. 372; CLA 5, Nos. 556, 564a, 564b, 647, 649, 671; CLA 6, No. 744; CLA 8, No. 1209; CLA 9, Nos. 1354, 1427; CLA 11, Nos. 1631, 1637, 1638.

40 CLA 2, No. 329; CLA 5, No. 682; CLA 6, No. 762; CLA 7, No. 904.

41 CLA 1, No. 93; Mohlberg, *Missale*, 1–57.

42 Mohlberg, *Missale*, xxi–xxiii, suggests Chelles; R. McKitterick, "Nuns' scriptoria," 20, suggests Faremoutiers or Rebais.

43 CLA 1, Nos. 17, 32, 66; CLA 2, Nos. 126, 255; CLA 3, Nos. 358, 359, 388, 399; CLA 4, Nos. 436b, 492; CLA 6, Nos. 784, 838; CLA 9, No 1388**40; CLA 10, No. 1455.

44 CLA 12, Nos. 1631, 1637.

45 See *Sozomenus Kirchengeschichte*, eds. J. Bidez and G. Hansen (Berlin: Akademie-Verlag, 1960), 331–2 (VII, 19). For the seven deacons of Rome see DACL, IV, Pt. 1, Col. 741. The now-lost frescoes in San Paolo fuori le mura depicted the Choice of the Seven Deacons, Waetzoldt, *Kopien*, Cat. No. 628, Fig. 366.; see L. Eleen, "The Frescoes from the Life of St. Paul in San Paolo fuori le Mura in Rome: Early Christian or Medieval?," *Revue d'art canadienne = Canadian Art Review* 12 (1985), 251–9, who argues that the thirteenth-century restoration by Cavallini followed the iconography of the fifth-century programme.

46 *Liber Pontificalis*, 126.

47 *Liber Pontificalis*, 148.

48 Davies, "Deacons, Deaconesses;" see also, P.A. Leder, *Die Diakonen der Bischöfe und Presbyter und ihre urchristlichen Vorläufer. Untersuchungen über die Vorgeschichte und die Anfänge des Archidiakonats* (Amsterdam: Schippers, 1963).

49 Eusebius, *The Ecclesiastical History*, ed. H. Lawlor, trans. J. Oulton, 2 vols. (Cambridge, Mass: Harvard Univ. Press/London: Heinemann, 1965–1973), Vol. II, 119.

50 *Ep.* 146.2; *Quaes. vet. et nov. test.*, 127.101.

51 Canon, 15; Hefele, *History*, Vol. 1, 334; see also the Council of Trullo, Canon 16, Vol. 5, 226.

52 L. Duchesne, *Le Liber Pontificalis; texte, introduction et commentaire*, 3 vols., 2nd ed., (Paris, 1955 [1981]), I, 118, 12.

53 Dudden, *Gregory*, Vol. 1, 120.

54 DACL, IV, Pt. 1, Col. 741; Olson, *One Ministery*, 50–66; J. Bligh, "Deacons in the West Since the Fourth Century," *Theology* 53 (1955): 421–9.

55 I am indebted to Thomas Forrest Kelly for sharing his cogent and invaluable draft of "The Exultet at Rome" which was read at the 32nd International Medieval Congress, Kalamazoo, MI, 1997.

56 Cavallo, *Rotoli*, 3–7; Dendy, *Use of Lights*, 128–9.

57 Kelly, *Exultet*, 40–1, n. 9, gives relevant bibliography for this letter.

58 *Liber Pontificalis*, No. 43.

59 The blessing is not mentioned until the eighth-century Ordines XVI and XXVI, which A. Andrieu, in *Les "Ordines Romani" du haut Moyen Age* (Louvain: Spicilegium Sacrum Lovaniense Administration, 1931), Vol. 3, 140, 321, 326, argues is Gallican along with the rubrics of the

Deus conditor mundi in the Gelasian Sacramentary. S.J.P. van Dijk, "The Urban and Papal Rites in Seventh and Eighth-Century Rome," *Sacris Erudiri* 12 (1961): 411–87, esp. 460–1, argues that the blessing rubrics in the Gelasian Sacramentary are certainly Roman, that Ordo XVI is seventh century and that Ordo XXVI refers to two blessings: the blessing of the candle and the blessing of the wax for the *Agnus Dei*. He states that the blessing mentioned by Pope Zozimus should be regarded as evidence that the *benedictio cerei* originated in Rome and then spread to Northern Italy. See also Dendy, *Use of Lights*, 128–38, who provides a cogent summary of the various arguments surrounding the blessing.

60 D.H. Verkerk, "Pilgrimage *ad limina Apostolorum* in Rome: Irish Crosses and Early Christian Sarcophagi," in *From Ireland Coming...*, ed. C. Hourihane (Princeton, NJ: Department of Art and Archaeology, Princeton Univ., 2001), 9–26.

61 Grabar, in "Report," 276–7; and "Fresques romanes," 339, theorizes that a Jewish model from Rome was the link among the frescoes at Dura Europos, the Ashburnham Pentateuch, and the Utrecht Psalter.

62 The social and liturgical implications of the tomb and the manuscript are more fully developed in D.H. Verkerk, *"The Font is a Kind of Grave*: Remembrance in the Via Latina Catacombs," in *Medieval Memory*, eds. E. Valdez del Alamo and C. Pendergrast (London: Ashgate, 2000).

63 Tronzo, *Via Latina*, 51–65.

64 K. Stevenson, *Eucharist and Offering* (New York: Pueblo, 1986), 78.

65 G. Grabka, "Christian Viaticum: A Study of Its Cultural Background," *Traditio* 9 (1953): 1–43; A. Rush, "The Eucharist: The Sacrament of the Dying in Christian Antiquity," *Jurist* 34 (1974): 10–35; A.C. Rush, *Death and Burial in Christian Antiquity* (Washington, D.C.: Catholic Univ. of America Press, 1941), 91–9; P. Browe, "Die Sterbekommunion im Altertum und Mittelalter," *Zeitschrift für Katholische Theologie* 60 (1936): 1–54, 210–40.

66 W. Stechow, "Jacob Blessing the Sons of Joseph – From Early Christian Times to Rembrandt," in *Gazette-des-Beaux-arts* 23 (1943): 193–208, reprinted in Gutmann, *No Graven*.

67 Waetzoldt, *Kopien*, Plate 340.

68 H.L. Kessler, "An Eleventh-Century Ivory Plaque from South Italy and the Cassinese Revival," *Jahrbuch der Berliner Museen* 8 (1966): 67–95, questioned the veracity of the Adam and Eve sequence.

69 Waetzoldt, *Kopien*, Plates 328, 329–33, 337, 338, 355. See, more recently, U. Koenen, *Das 'Konstantinskreuz' im Latern und die Rezeption frühchristlicher Genesiszyklen im 12. und 13. Jahrhundert* (Worms: Wernersche Verlagsgesellschaft, 1995), 93ff., and the study by Nees, "Problems," 165.

70 E.B. Garrison, "Note on the Iconography of Creation and of the Fall of Man in Eleventh- and Twelfth-Century Rome," *Studies in the History of Mediaeval Italian Painting* 4 (1961): 201–10, esp. 203, suggests the *Agnus Dei* is an interpolation; however, this would render the Creation scene heretical with only two Persons at the Creation, not three.

71 See Chapter 3, for my discussion of the dove.

72 Nees, "Problems," 165–72.

73 Ibid., Colourplate XII, and Fig. 22.

74 As Narkiss pointed out, in "Towards," 45–59, the figure of the Christ Logos has been painted out three times and the First Person once, leaving only one Creator for the three days of creation depicted on folio iv. Narkiss argues that Carolingian anti-Adoptionist attitudes were responsible for painting out the Creator figures. The erasure of the figures within the context of eighth- and ninth-century heresies is understandable; however, the original inclusion of the Christ Logos and the First Person at Creation is highly orthodox in the context of earlier Christological heresies and does not suggest a Spanish origin as Narkiss implies.

75 M. Dulaey, "L'exégèse partistique de Gn 13 et la mosaïque de la séparation d'Abraham et de Lot à Santa Maria Maggiore (Rome)," *Studia Patristica* 30 (1997): 3–7, shows that this multivalent interpretation is at work in monumental public art in Rome by the fifth century.

76 M. Vieillard-Troiekouroff, "Tables de canons et stucs carolingiens," in *Lo Stucco – Il mosaico studi vari. Stucchi e mosaici alto medioevali (Atti dell'ottavo Congresso de studi sull'arte dell'alto Medioevo)* (Milan: Ceschina, 1962), Vol. 1, 154–78, esp. 159.

77 Wright, "Canon Tables," 137–55, esp. 147ff.

78 Rickert, *Studien*, 91, 93, compares the frontispiece to the title page for the Cosmography of the Julius Honorius (Paris, Bibl. nat. lat. 2769, folio 23v). This stylistic comparison is less convincing. In the catalogue of Italian manuscripts, F. Avril and Y. Zauska, *Manuscrits enluminés d'origine italienne, Vol. 1, VIe–XIIe siècles* (Paris: Bibliothèque Nationale, 1980), No. 5, tentatively assigned the manuscript to Ravenna. Rickert

approaches the idea of an Italian origin for the Ashburnham Pentateuch, but declines on the scarcity of comparable manuscripts to make a final judgment. A. Grabar, *The Golden Age of Justinian from the Death of Theodosius to the Rise of Islam*, trans. S. Gilbert and J. Emmons (New York: Odyssey, 1967), 214–15, also found an Italian origin possible, by linking the style to Roman mosaics.

79 Lowden, "Beginnings," 1–60.

80 S. Lucey, "The Church of Santa Maria Antiqua, Rome: Defining the Contexts" Ph.D. dissertation (Rutgers University, 1999); P.J. Nordhagen, *The Frescoes of John VII (A.D. 705–707) in S. Maria Antiqua in Rome*, Acta ad archaeologiam et artium historiam pertinentia 3 (Rome: l'Erma and Spoleto: Panetto & Petrelli, 1968).

81 I use the term ornamentation in the sense defined by A. Coomaraswamy, "Ornament," *Art Bulletin* 21 (1939): 375–82.

82 A. Dumas and J. Deshusses, eds., *Liber sacramentorum Gellonensis*, CCSL 159159A (Turnhout, Belgium: Brepols, 1981).

83 J. Osborne, "The Roman Catacombs in the Middle Ages," *Papers of the British School at Rome* 53 (1985): 278–328.

84 Kessler, "Pictorial Narrative," 75–91.

85 D.H. Wright, *The Vatican Vergil: A Masterpiece of Late Antique Art* (Berkeley, CA: Univ. of California Press, 1993); A. Geyer, *Die Genese narrativer Buchillustration: der Miniaturenzyklus zur Aeneis im Vergilius Vaticanus* (Frankfurt am Main: Klostermann, 1989); Levin, *Quedlinburg*.

86 Riché, *Education*, 490, suggests that the Corpus Christi Gospels were used to teach.

CHAPTER 7

1 *De catechizandis rudibus*, 1.2.4; Christopher, "First Catechetical," 17.

2 I became acutely aware of this distinction while in the Salon de manuscrits, Bibliothèque national de France, when the Ashburnham Pentateuch lay side by side with a series of luxurious Carolingian manuscripts that my colleague was studying.

3 Narkiss, "Reconstruction," 21, 24–31; Quentin, *Mémoire*, 415–18; Wright, "When the Vatican Virgil was in Tours," 53–66, observed that some of the figures in the illustrations were traced with a stylus.

4 Mazal, *Kommentar*.

5 Grüneisen, *Sainte*, 343–81.

6 H. Gerstinger, *Die Wiener Genesis: Farbenlichtdruckfaksimile der griechischen Bilderbibel aus dem 6. Jahrhundert n. Chr. cod. vindob. theol. graec. 31* (Vienna: Filser, 1931), 178.

7 Lowden, "Cotton Genesis," 50.

8 Riché, *Education and Culture*, 490.

9 Reynolds, "Early Medieval Tract," 100.

10 Cf. C. Petrangeli, *Santa Maria Maggiore a Roma*, Chiese monumentali d'italia (Florence: Nardini, 1988), 132–3.

11 R. Reynolds, "Image and Text: The Liturgy of Clerical Ordination in Early Medieval Art," *Gesta* 32 (1983): 27–38.

12 Reynolds, "Early Medieval Tract," 100; Davies, "Deacons, Deaconesses," 1–15; J. Bligh, "Deacons in the West Since the Fourth Century," *Theology* 53 (1955): 421–9; P.A. Leder, *Die Diakonen der Bischöfe und Presbyter und ihre urchristlichen Vorläufer. Untersuchungen über die Vorgeschichte und die Anfänge des Archidiakonats* (Stuttgart: 1905).

13 *De Eccl. Off.* 2.8.

14 Canon 16; Hefele, *History*, Vol. 5, 227.

15 Caesarius of Arles, *Hom.* 2, suggested that deacons should preach to rural churches, whereas presbyters taught in urban centers.

16 B. Ramsey, "Saint Lawrence and His Book in the Mausoleum of Galla Placidia," in *Diakonia: Studies in Honor of Robert T. Meyer*, eds. T. Halton and J.P. Williman (Washington, D.C.: Catholic Univ. of America Press, 1986), 308–16. G. Mackie, "New Light on the So-Called Saint Lawrence Panel at the Mausoleum of Galla Placidia, Ravenna," Gesta 29 (1990): 54–60, identifies the "Lawrence" as St. Vincent of Saragossa, another deacon martyr popular in early medieval Italy. Mackie seems unaware of Ramsey's discussion of figure's role as deacon, emphasized by the book and the book cupboard. F.W. Deichmann, *Ravenna: Hauptstadt des spätantiken Abendlandes. Vol. 2, Kommentar* (Weisbaden, Germany: Steiner, 1969), 77–8, connects the books to the deacon's role as caretaker and reader of the Gospels, see also: H. Dütschke, *Ravennatische Studien* (Leipzig: Engelmann, 1909), 266, 272.

17 Pelagius II built the church in response to the great numbers of pilgrims, many of whom were poor, at the tomb, see CBCR 2, 1–144; Krautheimer,

Profile, 85–6; G. Matthiae, *S. Lorenzo fuori le mura* (Rome: Marietti, 1966), Fig. 43, shows the dedicatory inscription.

18 C. Pietrangeli, *San Giovanni in Laterano*, Chiese monumentali d'italia (Florence: Nardini, 1990), 56–9.

19 ABD, 6, 799–803.

20 Lowden, "Beginnings," 43.

21 The disparity between the captions and the illustrations is discussed by C.F. Lewine in "'Vulpes Fossa Habent' or the Miracle of the Bent Woman in the Gospels of Augustine, Corpus Christi College, Cambridge, MS 286," *Art Bulletin* 56 (1974): 488–504.

22 C.F. Lewine, Ibid., 488–504; G. Henderson, "'The Foxes Have Holes', Once Again," *Wiener Jahrbuch für Kunstgeschichte* 46–7 (1993–1994): 245–54.

23 For a discussion of the black Egyptians, see D.H. Verkerk, "Black Servants, Black Demons: Color Ideology in the Ashburnham Pentateuch," *Journal of Medieval and Early Modern Studies* (2001): 57–77.

24 *Orient*, 35.

25 Veyne, *From Pagan Rome*, 294; W. Schuller, *Frauen in der römischen Geschichte*, Konstanzer Bibliothek 4 (Constance, Germany: Universitätsverlag Konstanz GmbH, 1987), 2, 15.

26 Veyne, *From Pagan Rome*, 10.

27 E. Frézouls, "Aspects de l'histoire architecturale du théâtreromain," *Aufstieg und Niedergang der römischen Welt*, XII/i/2 (Berlin/New York: de Gruyter, 1982), 343–441; F.B. Sear, *Roman Architecture* (London: Batsford Academic and Educational, 1982); R. Leacroft and H. Leacroft, *Theatre and Playhouse* (London/New York: Methuen, 1984); C. Courtois, *Le Bâtiment de scène des théâtres d'Italie et de Sicile* (Providence, RI: Brown Univ., Center for Old World Archaeology and Art, 1989); R.C. Beacham, *The Roman Theatre and its Audience* (London: Routledge, 1991).

28 D.M. Hope, *The Leonine Sacramentary: A Reassessment of Its Nature and Purpose* (London: Oxford Univ. Press, 1971), 91–5.

Bibliography

ABBREVIATIONS

ABD
: *The Anchor Bible Dictionary*, 6 vols., eds. D.N. Freedman, assoc. eds. G.A. Herion, D. Graf, and J.D. Pleins (New York: Doubleday, 1992).

Age
: K. Weitzmann ed., *Age of Spirituality: Late Antique and Early Christian Art, Third to Seventh Century* (New York/Princeton, NJ: The Metropolitan Museum of Art and Princeton Univ. Press, 1977).

BR
: Theodor, J., trans., *Bereschit Rabba: mit kritischem Apparat und Kommentar*, 3 vols. (Jerusalem: Wahrmann, 1965).

CBCR
: R. Krautheimer, S. Corbett, and W. Frankl, *Corpus Basilicarum Christianorum Romae. The Early Christian Basilicas of Rome (IV–IX cent.)* (Vatican City: Pontificio istituto di archeologia cristiana, 1937–1977).

CCSL
: *Corpus Christianorum. Series Latina* (Turnhout, Belgium: Brepols, 1953–).

CLA
: E.A. Lowe, *Codices latini antiquiores: A Paleographic Guide to Latin Manuscripts Prior to the Ninth Century* (Paris/Oxford: Clarendon, 1950–1966).

CSEL
: Corpus Scriptorum ecclesiasticorm Latinorum, (Vienna: Hoelder-Pichler-Tempsky, 1866–).

DACL F. Cabrol and H. Leclerq, *Dictionnaire d'archéologie chrétienne et le liturgie*, 15 vols. (Paris: Letouzey et Ané, 1907–1953).

MGH conc. W. Wattenback, ed., *Monumenta Germaniae Historica. Concilia. Leges sectio III, Concilia*, 2 vols. (Hanover: Impensis Bibliopolii Hahniani, 1893–1908).

MGH SS rer. merov. B. Krusch and W. Levinson, eds. *Monumenta Germaniae Historica. Scriptores rerum merovingicarum*, 7 vols. (Hanover: Impensis Bibliopolii Hahniani, 1885–1920).

PG J. Migne, ed., *Patrologia cursus completus, Series Graeca* (Paris: 1856–1866).

PL J. Migne, ed., *Patrologia cursus completus, Series Latina* (Paris: 1844–1855).

SC *Sources chrétiennes* (Paris: Les Editions du Cerf, 1958–).

PRIMARY SOURCES

Christopher, J.P., trans., *The First Catechetical Instruction [De catechizandis rudibus]*, Ancient Christian Writers 2 (Westminster, MD: Newman, 1946).

Deshusses, J., *Le sacramentaire grégorien, ses principales formes d'après les plus anciens manuscrits* (Fribourg: Éditions universitaires, 1971).

Heine, R.E., trans., *Origen. Homilies on Genesis and Exodus*, The Fathers of the Church 71 (Washington, D.C.: Catholic Univ. of America Press, 1982).

King, J.E., trans. *Baedae Opera Historica* (Cambridge, MA: Harvard Univ. Press, 1963), vol. 2.

Laistner, M.L.W., *Christianity and Pagan Culture in the Later Roman Empire Together with An English Translation of John Chrysostom's Address on Vainglory and the Right Way for Parents to Bring Up Their Children*, The James W. Richard Lectures in History, 1950–1951 (Ithaca, NY: Cornell Univ. Press, 1951, reprint 1967).

Mohlberg, L.C. *Sacramentarium Veronense*, Rerum ecclesiasticarum Documenta, series major 1 (Rome: Herder, 1956).

————, *Liber Sacramentorum Romanei Aeclesiae Ordines Anni Circuli (Cod. Vat. Reg. lat 316/Paris, Bibl. nat. 7193, 41/56) Sacramentarium Gelasianum)*, Rerum ecclesiasticarum Documenta, series major 4 (Rome: Herder, 1968).

Muldowney, M.S., *Saint Augustine. Sermons on the Liturgical Seasons*, Fathers of the Church 17 (New York: Fathers of the Church, 1959).

Thompson, T., trans. with introduction by J.H. Strawley, *St. Ambrose on the Sacraments and on the Mysteries* (London: S.P.C.K., 1950).

SELECT BIBLIOGRAPHY

Alexander, J.J.G., *Insular Manuscripts 6th to the 9th Century* (London: Harvey Miller, 1978).

Alexander, P.S., "The Targumim and Early Exegesis of 'Sons of God' in Genesis 6," *Journal of Jewish Studies* 23 (1972): 60–71.

Avery, M., *The Exultet Rolls of South Italy* (Princeton, NJ: Princeton Univ. Press, 1936).

Berger, S., *Histoire de la Vulgate pendant les premiers siècles du moyen âge* (Paris: Hachette, 1893).

Bischoff, B., *Latin Palaeography: Antiquity and the Middle Ages*, trans. D. Ó Cróinin and D. Ganz (Cambridge/New York: Cambridge Univ. Press, 1990).

Bishop, E., "The Diptychs. Appendix 3," in R.H. Connolly, trans., *The Liturgical Homilies of Narsai* (Cambridge, England: Cambridge Univ. Press, 1909), 97–117.

Braun, J., *Das Christliche Altargerät in seinem Sein und in seiner Entwicklung* (Munich: Hueber, 1932).

Brenk, B., *Die frühchristlichen Mosaiken in S. Maria Maggiore zu Rom* (Wiesbaden, Germany: Steiner, 1975).

Burkitt, F.C., "Note on the Pictures in 'The Pentateuch of Tours,'" *Journal of Theological Studies* 24 (1922–1923): 414–15.

Cahn, A.S., "A Note: The Missing Model of the Saint-Julien de Tours Frescoes and the "Ashburnham Pentateuch" Miniatures," *Cahiers archéologiques* 16 (1966): 203–7.

Cavallo, G., *Rotoli di Exultet dell'italia meridionale* (Bari, Italy: Adriatica, 1973).

Cavallo, G., *Exultet: Rotoli liturgici del medioevo meridionale* (Rome: Istituto poligrafico e zecca dello stato libreria dello stato, 1994).

Chapman, J., "The Families of Vulgate MSS in the Pentateuch," *Revue bénédictine* 37 (1925): 5–46, 365–403.

Christ, K., *The Handbook of Medieval Library History*, trans. T.M. Otto (Metuchen, NJ/London: Scarecrow Press, 1984).

Coates-Stephens, R., "Housing in Early Medieval Rome, AD 500–1000," *Papers of the British School at Rome* 64 (1996): 239–60.

Davies, J.G., "Deacons, Deaconesses and the Minor Orders in the Patristic Period," *Journal of Ecclesiastical History* 14 (1963): 1–15.

Deichmann, F.W., G. Bovini, and H. Brandenburg, *Repertorium der christlich-antiken Sarkophage: Rom und Ostia*, 2 vols. (Wiesbaden, Germany: Steiner, 1967).

Dendy, D.R., *The Use of Lights in Christian Worship*, Alcuin Club Collections 40 (London: S.P.C.K., 1959).

Dix, G., *The Shape of the Liturgy*, 2nd ed. (London: Dacre, Press, 1964).

Duchesne, L., *Christian Worship Its Origin and Evolution: A Study of the Latin Liturgy up to the Time of Charlemagne*, 5th English ed., trans. M.L. McClure (London: Society for Promoting Christian Knowledge, 1927).

Dudden, F.H., *Gregory the Great: His Place in History and Thought*, 2 vols. (London/New York/Bombay: Longmans, Green, and Co., 1905).

Dujarier, M., *A History of the Catechumenate: The First Six Centuries*, trans. E.J. Haasl (New York: Sadlier, 1979).

Erffa, H.M. von, *Ikonologie der Genesis: De christlichen Bildthemen aus dem alten Testament und ihre Quellen* (Munich: Deutscher Kunstverlag, 1989).

Fink, J., *Noe der Gerechte in der frühchristlichen Kunst* (Münster, Germany/Cologne: Böhlau-Verlag, 1955).

Ganz, D. "Roman Manuscripts in Francia," in *Roma fra oriente e occidente. 19–24 aprile 2001 Settimane di stuio del centro italiano di stdi sull'alto medio-evo*, 49 (Spoleto, Italy: Presso la sede del centro, 2002).

Gebhardt, O. von, *The Miniatures of the Ashburnham Pentateuch* (London: Asher, 1883).

Gibson, M.T., *The Bible in the Latin West* (Notre Dame/London: Univ. of Notre Dame Press, 1993).

Gill, I.R., "The Orthography of the Ashburnham Pentateuch and Other Latin Manuscripts of the Late Proto-Romance Period – Some Questions of Palaeolgraphy and Vulgar Latin Linguistics," *Institute of Classical Studies Bulletin* 23 (1976): 27–44.

Ginhoven, H.J. van, "Le Miniaturiste du Pentateuque de Tours ou Pentateuque d'Ashburnham et se méthode de travail (Paris, Bibliothèque nationale, nouv. acq. lat. 2334)," *Cahiers archéologiques* 42 (1994): 65–74.

I Goti. Milano, Palazzo Reale 28 gennaio–8 maggio (Milan: Electa Lombardia, 1994).

Grabar, A., "Report" in E. Josi, "Séance du 6 juillet. Découverte d'"une série de peintures dans un Hypogée de la voie latine, par M. Enrico Josi," *Comptes-rendus des séances de l'Académie des Inscriptions et Belles-Lettres,* 1956, 275–9.

————, "Fresques romanes copiées sur les miniatures de Pentateuque de Tours," *Cahiers archéologiques* 9 (1957): 329–41.

Grant, R.M., "Development of the Christian Catechumenate," in *Made, Not Born: New Perspectives on Christian Initiation and the Catechumenate, from the Murphy Center for Liturgical Research* (Notre Dame, IN: Univ. of Notre Dame Press, 1976).

Grüneisen, W. de, *Sainte Marie Antique* (Rome: Bretschneider, 1911).

Gutmann, J., "The Jewish Origin of the Ashburnham Pentateuch Miniatures," *The Jewish Quarterly Review* 44 (1953–1954): 55–72.

————, ed., *No Graven Images: Studies in Art and the Hebrew Bible* (New York: Ktav, 1971).

Harmless, W., *Augustine and the Catechumenate* (Collegeville, MN: Liturgical Press, 1995).

Hefele, K.J. von, *A History of the Church Councils from the Original Documents*, trans. W.R. Clark, 5 vols. (Edinburgh: T&T Clark, 1883–1896. Reprint).

Hempel, H.L., "Zum Problem der Anfänge der AT-Illustration," *Zeitschrift für die Alttestamentliche Wissenschaft* 69 (1957): 103–31.

————, "Jüdische Traditionen in frühmittelalterlichen Miniaturen," in *Beiträge zur Kunstgeschichte und Archäologie des Frühmittelalters. Akten zum VII. Internationalen Kongress für Frühmittelalterforschung, 21–28. Sep. 1958*, ed. H. Fillitz (Graz, Austria: Böhlaus, 1962), 53–65.

Hen, Y., *Culture and Religion in Merovingian Gaul A.D. 481–751* (Leiden/New York/Cologne: Brill, 1995).

Ihm, C., *Die Programme der christlichen Apsismalerei vom 4. Jahrhundert bis zur Mitte des 8. Jahrhunderts* (Stuttgart: Steiner, 1992).

Jolly, P.H., *Made in God's Image?: Eve and Adam in the Genesis Mosaics at San Marco, Venice* (Berkeley/Los Angeles/London: Univ. of California Press, 1997).

Jungmann, J.A., *The Mass of the Roman Rite: Its Origins and Development (Missarum Sollemnia)*, trans. F.A. Brunner, 2 vols. (Westminster, MD: Christian Classics, 1986).

Kelly, T.F., *The Exultet in Southern Italy* (New York/Oxford, England: Oxford Univ. Press, 1996).

Kessler, H.L., *The Illustrated Bibles from Tours, Studies in Manuscript Illumination 7* (Princeton, NJ: Princeton Univ. Press, 1977).

———, "Pictorial Narrative and Church Mission in Sixth-Century Gaul," in *Pictorial Narrative in Antiquity and the Middle Ages*, eds. H.L. Kessler and M.S. Simpson, Studies in the History of Art 16, (Washington, D.C.: National Gallery of Art, 1985), 75–91.

Kitzinger, E., "The Role of Miniature Painting in Mural Decoration," in *The Place of Book Illumination in Byzantine Art*, eds. K. Weitzmann et al. (Princeton, NJ: Princeton Univ. Press, 1975), 108–9.

Kogman-Appel, K., "Bible Illustration and the Jewish Tradition," in *Imaging the Early Medieval Bible*, ed. J. Williams (University Park, PA: Pennsylvania State Univ. Press, 1999), 61–96.

Krautheimer, R., *Rome: Profile of a City 312–1308* (Princeton, NJ: Princeton Univ. Press, 1980).

Levin, I., *The Quedlinburg Itala: The Oldest Illustrated Biblical Manuscript* (Leiden, The Netherlands: Brill, 1985).

Lewis, J.P., *A Study in the Interpretation of Noah and the Flood in Jewish and Christian Literature* (Leiden, The Netherlands: Brill, 1978).

Llewellyn, P., *Rome in the Dark Ages* (London: Constable, 1993).

Lowden, J., "The Beginnings of Biblical Illustration," in *Imaging the Early Medieval Bible*, ed. J. Williams (University Park, PA: Pennsylvannia State Univ. Press, 1999), 9–60.

———, *The Octateuchs: A Study in Byzantine Manuscript Illumination* (University Park, PA: Pennsylvania State Univ. Press, 1992).

———, "Concerning the Cotton Genesis and Other Illustrated Manuscripts of Genesis," *Gesta* 31 (1992): 40–53.

Maccioni Ruju, P.A. and M. Mostert, *The Life and Times of Guglielmo Libri (1802–1869): Scientist, Patriot, Scholar, Journalist, and Thief. A Nineteenth-Century Story* (Hilversum, The Netherlands: Verloren, 1995).

MacGregor, A.J., *Fire and Light in the Western Triduum: Their Use at Tenebrae and at the Paschal Vigil* (Collegeville, MN: The Liturgical Press, 1992).

Markus, R.A., *Gregory The Great and His World* (Cambridge/New York: Cambridge University Press, 1997).

Marsden, R., *The Text of the Old Testament in Anglo-Saxon England* (Cambridge, England: Cambridge University Press, 1995).

Matthiae, G., *Mosaici medioevali delle chiese de roma* (Rome: Istituto poligrafico dello stato, 1967).

Mazal, O., *Kommentar zur Wiener Genesis, Faksimile-Ausgabe des Codex theol. gr. 31 der Osterreichischen Nationalbibliothek in Wien* (Frankfurt am Main: Insel, 1980).

McGurk, P., *Latin Gospel Books from A.D. 400 to A.D. 800* (Paris and Brussels: Erasme, 1961), no 3.

Mckinnon, J., *The Advent Project: The Later-Seventh-Century Creation of the Roman Mass Proper* (Berkeley: Univ. of California Press, 2000).

Narkiss, B., "Towards a Further Study of the Ashburnham Pentateuch (Pentateuque de Tours)," *Cahiers archéologiques* 19 (1969): 45–59.

———, "Reconstruction of Some of the Original Quires of the Ashburnham Pentateuch," *Cahiers archéologiques* 22 (1972): 19–38.

Nees, L., "Problems of Form and Function in Early Medieval Illustrated Bibles from Northwest Europe," in *Imaging the Early Medieval Bible*, ed. John Williams (University Park, PA: Pennsylvania State Univ. Press, 1999), 121–78.

Neuss, W., *Die Apokalypse des hl. Johannes in der altspanischen und altchristlichen Bibel-Illustration*, Spanische Forschungen der Görresgesellschaft, Reihe II, 2 and 3, 2 vols. (Münster in Westfalen, Germany: Aschendorff, 1931).

Niditch, S., *Underdogs and Tricksters: A Prelude to Biblical Folklore* (San Francisco: Harper & Row, 1987).

Nordenfalk, C., *Early Medeival Book Illumination* (Geneva: Skira, 1957. Reprinted 1988).

Oakshott, W.F., *The Mosaics of Rome from the Third to the Fourteenth Century* (Greenwich, CT: New York Graphic Society, 1967).

Olson, J.E., *One Ministery Many Roles: Deacons and Deaconesses Through the Centuries* (St. Louis, MO: Concordia, 1992).

Osborne, J. and A. Claridge; with contributions by C. Bartoli and E. Kinghan, *Early Christian and Medieval Antiquities. Volume One. Mosaics and Wallpaintings in Roman Churches* (London: Harvey Miller, 1996).

Petrucci, A., "L'onciale Romana. Origini, sviluppo e diffusione di una stilizzazione grafica altomedievale (sec. VI–IX)" Studi medievali 12 (1971): 75–134.

Pijoan, J., "Note on the Problem of the Apocalypse," *Art Bulletin* 15 (1933): 391–4.

Quentin, H., *Mémoire sur l'établissement du texte de la Vulgate, Ière partie Octateuque*, Collectanea Biblica Latina 6 (Rome: *Desclée*, 1922).

Rand, E.K., *A Survey of the Manuscripts of Tours* (Cambridge, Mass.: Mediaeval Academy of America, 1929).

Revel-Neher, E., *L'Arche d'alliance dans l'art juif et chrétien du second au dixième siècles: Le signe de la recontre: (Ve-no'adeti lekha sham)* (Paris: Association des amis des études archéologiques byzantino-slaves et du christianisme oriental, 1984).

Reynolds, R.E., "An Early Medieval Tract on the Diaconate," *Harvard Theological Review* 72 (1979): 97–100.

Riché, P., *Education and Culture in the Barbarian West from the Sixth Through the Eighth Century*, 3rd French ed., trans. J.J. Contreni (Columbia, SC: Univ. of South Carolina Press, 1976).

Rickert, F., *Studien zum Ashburnham Pentateuch (Paris, Bibl. nat. NAL. 2334)*, Ph.D. dissertation, University of Bonn, 1986.

———, "Zu den Stadt- und Architekturdarstellungen des Ashburnham Pentateuch (Paris, Bibl. nat. NAL 2334)," in *Actes du XIe congrès international d'archéologie chrétienne*, vol. 41, Studi di antichità cristiana (Rome: Pontificio istituto di archeologia cristiana, 1989), 1341–54.

Robert, C., "Les fils de Dieu et les filles des hommes," *Revue biblique* 4 (1895): 340–73, 525–52.

Schubert, K., "Jewish Pictorial Traditions in Early Christian Art," in *Jewish Historiography and Iconography in Early and Medieval Christianity*, eds. P.J. Tomson and P.A. Cathey (Assen/Maasticht and Minneapolis: Van Gorcum and Fortress, 1992), 141–260. Revised and translated from "Die Miniaturen des Ashburnham Pentateuch im Lichte der Rabbinischen Tradition," *Kairos* 18 (1976): 191–212.

Schubert, U., "Egyptian Bondage and Exodus in the Ashburnham Penta-teuch," *Journal of Jewish Art* 5 (1978): 29–44.

Sed-Rajna, G., "Further Thoughts on an Early Illustrated Pentateuch," *Journal of Jewish Art* 10 (1984): 29–31.

Sloane, J.C., "The Torah Shrine in the Ashburnham Pentateuch," *The Jewish Quarterly Review* 25 (1934): 1–12.

Sörries, R., *Christlich-antike Buchmalerei im Überblick* (Wiesbaden, Germany: Ludwig Reichert Verlag, 1993).

Springer, A., *Die Genesisbilder in der Kunst des frühen Mittelalters mit besonderer Rücksicht auf den Ashburnham-Pentateuch*, Abhandlungen der phil.-hist. Classe d. königl. sächs. Gesselschaft der Wissenschaften Bd. 9, No. 6 (Leipzig: Hirzel, 1884), 665–733.

Steuart, K., *The Development of Christian Worship: An Outline of Liturgical History* (London/New York: Longmans, Green, 1953).

Stone, M.E., with an excursus by G. Bohak, *A History of the Literature of Adam and Eve* (Atlanta, GA: Scholars Press, 1992).

Strzygowski, J., *Orient oder Rom: Beiträge zur geschichte der spätantiken und frühchristlichen Kunst* (Leipzig: Hinrichs'sche, 1901).

Tonsing, E.F., "The Interpretation of Noah in Early Christian Art and Literature," Ph.D. dissertation (Santa Barbara, CA: University of California, 1978).

Tronzo, W., *The Via Latina Catacomb: Imitation and Discontinuity in Fourth-Century Roman Painting* (University Park, PA/London: Pennsylvania State Univ. Press, 1986).

Tyrer, J.W., *Historical Survey of Holy Week, Its Services and Ceremonial*, Alcuin Club Collections 29 (London: S.P.C.K., 1932).

Verkerk, D.H., "Liturgy and Narrative in the Ashburnham Pentateuch," Ph.D. dissertation (New Brunswick, NJ: Rutgers University, 1992).

———, "Exodus and Easter Vigil in the Ashburnham Pentateuch," *Art Bulletin* 77 (1995): 94–105.

———, "Roman Manuscript Illumination 400–700 AD and the Ashburnham Pentaeuch," in *Imaging the Early Medieval Bible*, ed. J. Williams (University Park, PA: Pennsylvannia State Univ. Press, 1999), 97–120.

Veyne, P., ed., *From Pagan Rome to Byzantium*, trans. A. Goldhammer, History of Private Life, Vol. 1, eds. P. Ariès and G. Duby (Cambridge, MA: Belknap Press of Harvard University Press, 1987).

Volbach, W.F., *Elfenbeinarbeiten der Spätantike und des frühen Mittelalters*, 3rd ed. (Mainz, Germany: Von Zabern, 1976).

Waetzoldt, S., *Die Kopien des 17. Jahrhunderts nach Mosaiken und Wandmalereien in Rom* (Vienna/Munich: Schroll, 1964).

Ward-Perkins, B., *From Classical Antiquity to the Middle Ages: Urban Public Building in Northern and Central Italy AD 300–850* (Oxford, England: Oxford University Press, 1984).

Weitzmann, K., *Late Antique and Early Christian Book Illumination* (New York: Braziller, 1977).

Weitzmann K. and H.L. Kessler, *The Cotton Genesis (British Library Codex Cotton Otho B.VI)*, The Illustrations in the Manuscripts of the Septuagint 1 (Princeton, NJ: Princeton Univ. Press, 1986).

———, *The Frescoes of the Dura Synagogue and Christian Art*, Dumbarton Oaks Studies 28 (Washington, D.C.: Dumbarton Oaks, 1990).

Werckmeister, O.K., "Pain and Death in the San Sever Apocalypse," *Studi medievali* 14 (1973): 565–626.

Williams, J., *The Illustrated Beatus: A Corpus of the Illustrations of the Commentary on the Apocalypse. Vol. 3, The Tenth and Eleventh Centuries* (London: Harvey Miller, 1998).

Willis, G.G., *A History of Early Roman Liturgy to the Death of Pope Gregory the Great* (Rochester, NY: Boydell, 1994).

Wormald, F., *The Miniatures in the Gospels of St. Augustine (Corpus Christi College MS. 286)* (Cambridge, England: Cambridge Univ. Press, 1954).

Wright, D., "Review of A. Grabar and C. Nordenfalk, *Early Medieval Painting from the Fourth to the Eleventh Century*," *Art Bulletin* 13 (1961): 245–55.

———, "Canon Table of the Codex Beneventanus," *Dumbarton Oaks Papers* 33 (1979): 137–55.

———, "When the Vatican Virgil Was in Tours," in *Studien zur mittelalterlichen Kunst 800–1250. Festschrift für Florentine Mütherich zum 70. Geburtstag*, eds. K. Bierbrauer, P.K. Klein, and W. Sauerländer (Munich: Prestel-Verlag, 1985), 53–66.

Index

DATE DUE

GAYLORD		PRINTED IN U.S.A.